Describe the Moment

Describe the Moment

A Collection of Literary Works from Gallery 37
Volume 4

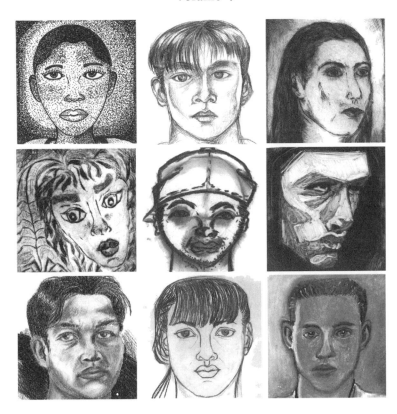

Edited by Haki R. Madhubuti and Gwendolyn Mitchell

THIRD WORLD PRESS
CHICAGO

Third World Press
Publishers since 1967
P.O. Box 19730
Chicago, Illinois 60619

 RR DONNELLEY & SONS COMPANY

A special thanks to R.R. Donnelley & Sons Company
for their generous underwriting of the production
and printing of this anthology.

Special acknowledgment to the Chicago Community Trust
for their support of the Gallery 37 1998 literary programs.

Describe the Moment is a collection of poetry, prose, playwriting and
screenwriting created by apprentice artists in literary programs conducted
in the Gallery 37 Schools Program in the Spring and Fall of 1998,
as well as the 1998 Summer Downtown and Neighborhood Programs.

Gallery 37 is a program of the Chicago Department of Cultural Affairs
with private funding made possible through
The Arts Matter Foundation, a 501(c)3 non-profit organization.

Library of Congress Card Catalog Number 99-75731

ISBN 0-88378-221-9

Printed in the United States of America.

Book Design: Greg King

Cover Art:
(top row) Massiel Fierro, 16; artist unknown; Lauren Ball, 17
(middle) Monique DuPree, 17; Chris Bickhem, 16; Justine Stewart, 16
(bottom) Nordan Delizo, 20; Chanel Patton, 18; Nick Kryczka, 17

Back Cover:
(top row) Dariusz Cyrulik, 19; Sakeena Walton, 17; Winnie Tsang, 15
(middle) Julita Karpinska, 15; Jennifer Norton, 18; Robin Blankenship, 17
(bottom) Jacob Raye, 15; Howard Winters, 16; Megan Sullivan, 14

About Gallery 37

Gallery 37 is an award-winning jobs program that provides Chicago youth on-the-job training in the visual, literary, media and performing arts. It has become an international model that has been replicated throughout the United States, and in Australia and England. Initiated in 1991, the program is designed to provide meaningful employment and arts education to Chicago youth, and to increase public awareness of the arts as a tool for learning, critical thinking, building self-esteem and molding career choices. Gallery 37 has brilliantly captured the imagination of young people throughout the city, while transforming the Loop, neighborhoods, parks, youth centers and schools into workshops of artistic discovery. In its eight years, Gallery 37 has employed nearly 11,000 apprentice artists in the Downtown, Neighborhood and Schools Programs, and has employed over 1,100 professional artists.

City of Chicago
Richard M. Daley, Mayor

Department of Cultural Affairs
Lois Weisberg, Commissioner

Gallery 37 Committee
Maggie Daley, Chair

Gallery 37
Elaine Rackos, *Director*

The following organizations are literary participants in Gallery 37 activities:

Beacon Street Gallery

Boulevard Arts Center

Chicago Center for Film Development

Columbia College Chicago

Robert Morris College

CONTENTS

A letter from the Chair of Gallery 37
x

Preface
xiii

section one – prose	lines drawn in the glass	1
Dream Girl	Brian Burton	3
Bulletin	Keinika Cooper	5
Austin 09454066	Shon P. Harris	7
If You Only Knew That I'm Not Mexican	Edith Bucio	9
Outsider	Laurél Kaish	11
But I Could No Longer Hold On	Jessica Carrillo	13
The Memory Letter	Sheryl L. Bacon	14
The Con Artist	Patrick Babbin	17
Window Pain	Angela Pena	20
Wasabi	Robi-Nichole Mraz	23
Halo 8: Excerpt from Casper's Story	Billy Reilly	25
The Letter	Sam Negron	28
Evening News Story	Albert Murphy	34

section two – poetry	Poetry just on the other side	37
Caramel Candy Hue	Maria Gonzalez	39
Stifled	Monica Alcaraz	42
The Promise	Cynthia McKissick	43
The Wish	Marissia Garno	44
Cover Girl	Melodie O'Dowd	46
My Tierra	Guadalupe Ortega	47
An Exclusive One	Raul Rangel Abounce	48
The Snow	Jamesa Rhodes	50
Inside the Cover	Loretta Trevino	51
My Neighborhood	Lisa Varney	52
Water	Lucy Repta	53
Let us...	Miriam Medina	54
If	Ana Luisa Garibay	55
LIFE	Angela Zakrzewski	56
The Spirit	Georgene Ford	58
Ode II My V Senses	Adriana Diaz	59

Ironing With My Cousin	Nova Benway	60
Sestina for those who Fly	Temeka Johnson	61
section three – prose	"I didn't know what to say."	65
Strange Fruit	Selly Thiam	67
Ruben	Kareema Cruz	70
Father to Son	James Vickery	73
Dream	Yelena Shtern	76
Scared	Andrea Thomann	79
Esperanza	Rocio Vallejo	80
section four – screenwriting	Scenes From Any Yesterday	83
Chris and Mary	Jesus Trzek	85
This One Time	Mary Mikel	89
Just Look Deep in Your Heart	Aracely Sandoval	95
Making Choices	Jose A. Toledo	100
Secret Embrosia	Crystal Carlson	106
section five – poetry	back to the quietness	115
Alone, Myself	Kenneth Collier	117
Enveloped	Richard N. Roberts III	118
Do You See What I Feel?	Erica Early	120
Picnic in the Ghetto	Falyn Harper	121
Taste What I Touch	Xica Henley	122
A Trio of Triplets	Marilyn Piggee	123
Remember Me	Janet Feder	124
"5 Senses" Writing	Martin Pumphrey	126
Quietness	William Watson	127
The Tavern– Part 2	Antoinette Wiley	128
Chicago	Yinka Giwa	130
Where I Wanted to Be	Saveth Som	131
A Dream	Seth Sher	132
Cat	Mom Dy	133
That Raining Morning	Luz Maria Navares	134
Mother, Shoes	Keo Sok	135
Rap Music	Victor Duprey	136
Extremes	Semha Ogorinac	137
The Hood Never Sleeps	Shateila Slater	138
Homeless Woman Sestina	Donni Saphire-Bernstein	139

section six – playwriting The Phone is Ringing 143

Certain Needs Moses Harris 145
Use a Loveless Eye Brandi Jackson 151
Nopales on Augusta Boulevard Olga Chavez 157
The Phone Is Ringing Najah Charlton 162
The Moon-Priestess of Printier Jessica M. Johnson 168
Me, Myself and I Chasiah T. Haberman 177

section seven – playwriting "We come bearing gifts." 185

Tightrope Sarah Koteles 187
Night Visitors Judith Disterhoft 195
Decided Jennifer Gorman 203
Party Favors Joanna DuFour 208

section eight – playwriting The Things We Don't Know 217

The Things We Don't Know Onzsalique Wright 219
Inside Looking Out Andrea Gargano 225
Mia Baby Kyra Termini 231
The Coat Check Girl Mandy Vainer 237
Tofu Ham Donald Stewart 245
Negatives Allison Staiger 251
We Still Have Daddy Bela Sarah Resnicoff 258

Gallery 37 Apprentice Artists and Teaching Artists 265
Third World Press Information and Editor Biographies 269
Picture Credits 271

The Wish

My only wish,
It's quite different,
To live the free life,
To have the purest soul,
I want the courage of the bear,
I want the feet of the eagle,
I want the heart of the earth,
I want the view of the pines,
I want to run with the deer,
I want to fly with the hawk,
I want to sleep with the flowers,
I wish I were part man,
I wish I were part earth,
That is my wish.

–Marrisia Garno

Dear Friend,

It is with true pleasure that I introduce *Describe the Moment*, the fourth annual anthology of literary work by Gallery 37 apprentice artists. The plays, short stories and poems in this collection were written by Chicago youth, ages 14-21, who participated in Gallery 37's job training programs in the literary arts. Conducted downtown, in Chicago Public Schools and in neighborhood sites citywide, Gallery 37's programs annually employ more than 3,500 Chicago youth, allowing them to create original artwork, literature and performance, while learning vital job and communication skills.

Gallery 37 apprentice artists emerge from every neighborhood and ethnicity in Chicago, and, as you will see, their experiences and imaginings are as varied as their backgrounds. They write of love and family, struggle and disappointment, and the specific hurtles and joys of growing up in the city at the end of the twentieth century. They both challenge us as readers, and give us hope, assuring us that today's youth are not only absorbing their reality, but are synthesizing

their observations and emerging with new ideas and original voices for the future.

The literature in this anthology emerged because of dedicated professional writers who served as both teachers and mentors to Gallery 37's apprentices. We would like to thank the teaching artists in our partner organizations, Beacon Street Gallery, Boulevard Arts Center, Chicago Center for Film Development, Columbia College Chicago and Robert Morris College for guiding our apprentice artists to find voices and visions they can call their own. And we are also tremendously grateful to Third World Press for giving flight to the inner voices of these talented young people.

You, our reader, can be part of this wonderful creative process, as well. Pass this anthology along to friends and family. Visit the Gallery 37 retail store and take home one of its many treasures. Or envision your own artistic possibility and commission one of our young artists to bring it to life. There are so many ways to get involved and to help our young artists leave their colorful mark on the world.

Sincerely,
Maggie Daley
Chair, Gallery 37

PREFACE

While many teenagers are struggling with issues of identity, self-esteem and self-expression, there is an innovative group of young people who have already defined their creative voices and seem to be at ease with who they are (at least on paper). They have already defined one important aspect of their lives–they are creative artists.

They have found the value in telling a good story, and they know the power of words. Many of the apprentice artists showcased in this book will continue to pursue their interest in creative arts and writing. Third World Press is delighted to have had a second opportunity to nurture and encourage these voices with this year's anthology *Describe the Moment: A Collection of Literary Works from Gallery 37.*

We found this year's "class" of writers to be ready to explore intimate subjects, sometimes without restrain. They are more willing to push beyond the limits of the page. This is both refreshing and reassuring. As this world prepares to move into the next century and as these young people set their course into the new millennium, we can say with some accuracy that they are ready, because they are equipped with strong voices and fresh visions.

We must thank Gallery 37 for its consistent mission to keep the arts accessible to Chicago's youth. The Gallery 37 lead artists teach by example, they share their passion and push for excellence. They expect the same discipline from every apprentice artist in the program.

The works that you see here are already tucked away in last year's portfolios, their creators have gone on to other projects and poems. This volume is what these young people leave behind, this is what will move them forward. We ask you to read their words, listen to their voices, challenge their perspectives and then share it with a friend.

–Haki R. Madhubuti
and Gwendolyn Mitchell

Describe the Moment

section one

lines drawn in the glass

Dream Girl

Hi, my name is Jimmy and I saw the most beautiful girl on the train yesterday. I live on the Southside of Chicago on one of its main streets, and I ride "the El" to and from work everyday. Anyway, man this girl was fine. I mean she had short brown hair that seemed to caress her face with all the sensitivity of a lover. Her eyes, a sort of caramel color, seemed full of laughter, full of life. Her smile could make the coldest heart melt and make even a gay brother go like, "Damn! She was fine as hell." When she got on the train, the gears of time stopped turning, reality was pushed to the side, and if only for that second when her eyes met mine, my life was complete. Before her, I was just existing but with a simple glance as many before her had done, I knew what it was to be alive. I had made up my mind to go over and talk to her, when just as the doors were about to close, hands like that of a gorilla reached through, pried them open, and a big kong sized brute stepped through the doors and hugged my woman! She smiled and I sat there, heartbroken and dejected. Every so often, I would let my eyes wander to where she was but her eyes would turn away and meet his. The man-mountain began to realize something was up when she kept turning her gaze onto me when she didn't think he was looking. He tolerated this about ten minutes, before he pushed her aside and advanced toward me and said those famous fighting words, "You lookin' at my woman?" At this point, I had a choice, to either cower down to this punk and lose face in front of "her," or stand up for myself for once and at least try to behave like a man. I chose the latter and replied, "Yeah, and as I recall, she was lookin' at me too." His eyes filled with blood and he pulled his fist back and tried to hit me with a right cross but I saw that coming, so I ducked. Unfortunately I didn't see the left uppercut coming and when he connected, and as my head hit the ceiling of the train car, all I could hear

3

was the theme to those Looney Tunes cartoons. And although I was dazed, I felt the train come to a stop, and I saw the brute dash out of the train car with my dream girl in tow. But to my surprise, she tore away long enough, to get back on the train and give me the most passionate kiss of my life. That was the longest ten seconds ever in the history of mankind, and though she left the train with that hulk, I knew that she had given me something in that kiss that she would never and could never give to him, sincerity.

Brian Burton

The bell over the barber shop door chimes as Kris enters. He spots Mr. Jimmy, his barber, and goes to sit in his chair. Before he sits down, he pulls some mail out of his back pocket: bills and more bills, except for one. One of the envelopes contains a letter from his little brother Tarrell. He hasn't heard from Tarrell in almost three years. Kris urgently opens the letter and begins to read:

Dear Kris,

What's up man! You are probably having a heart attack from receiving a letter from me. I'm sorry I don't write more often, but you know how things can get around here. Anyway, I have something very important to tell you. Pops is sick. Real sick. The doctor says he hasn't been eating like he should and now he has an enlarged heart. This problem of his has gotten real bad. Now, he's on life support. A couple of days ago, while I was visiting, Pops decided to cut off the life support, but he won't do it until he sees you one last time. Now, me and Momma have something else planned for you. Since you are his oldest and favorite, we wanted you to try and talk him out of it. Please, man, I'm begging. I don't want to see Pops go and momma can barely handle visiting him in the hospital. Uncle Ruben can't do it. He's so drunk that he don't know if he going or coming. You are our last hope. There is a plane ticket inside so you can fly out here on Friday. Me and cousin Nikki will be at the airport to pick you up and you can stay with me and Momma. Don't let us down, man. We're counting on you.

Yo' lil' brother,

Tarrell

P.S. Momma says "hi" and don't forget to pack clean socks.

5

As Kris folds the letter up, a tear comes down on the envelope smearing the return address. Mr. Jimmy tells him he is finished and his cut will be ten dollars. Kris gets up and pays Mr. Jimmy, and then offers a fake smile. He checks his 'fro in the mirror and leaves the barbershop leaving the bills behind in the chair.

Keinika Cooper

"All right ladies, lights out!" screams the guard from down the hall as an unseen man hits the power switch that lit up all the cells. It was only 7:30 p.m. and inmate Austin 09454066 (his "new" name) thought to himself, "Damn, I ain't been put to bed this early since I was ten years old." He was now eighteen years old, serving a three to nine in the state penitentiary after reoccurrence for assault and having, not one but two, unlicensed hand guns in his possession. This was the first day of his sentence and oh, what a day it was...

It started at 5:30 in the morning. He had made it there, from the county, with a handful of other newcomers, just in time for "breakfast" (he would later find out this was nothing like grandma's cooking). When he entered the building, the other inmates, who thought enough of them to get up a half of an hour early to give them a warm welcoming, were yelling and screaming, "Yeah fresh meat, I'ma make you my girlfriend," others frantically saying "Ugonebe-minetonightFreshmeat," with hope in their eyes that the guard would put him in the cell with them. His senses seem to come under attack, the building smelled of what he thought to be an ammonia-bleach concoction. The air was thick with humidity; this prompted Austin 09454066 to tell the guard who was leading the group down the corridor, "Feels like I'm breathing through mud in this mutha."

"You better get used to it convict, you'll be here a long time," the guard answered back with a snicker. Austin 09454066 didn't understand why the guard would snicker. This wasn't funny to him. "He laughing 'cause he get ta go home at the end of his shift, and I gotta stay in this hole," he thought to himself. They finally got to the end of the corridor, the guard signalled to an unseen man to open the two doors

that stood before them. Once inside the room they were told to line up along the wall, then the "white shirt" walked in barking, "There will be no noise, keep your head and eyes facing straight ahead, do not turn your head to look in any direction, and do not make any sudden movements. If any of the rules I have just mentioned go un-heeded you will suffer the consequences. Welcome to Ridgeland Penitentiary." Two inmates thought it was a joke, and once he was through with his speech they began breathing hard from their noses, looking all around the area they were in, as sign of defiance to authority, the same way a child does when they are told to do something not to their liking. This caught the attention of the "white shirt." He whistled and in came a group of four or five men, whom Austin 09454066 would later find out was labeled the Dog Pound, that made examples of the two "nonconformists." Needless to say, there were no more of these defiant outbreaks within the room thereafter. Once the show was over (it wasn't much of a show), most of the new inmates didn't dare turn their heads to see the action, from fear that they might get the same treatment. They were told to stand on a yellow line and strip. This was especially embarrassing for the ones who were defiant, because this exposed all the bruises that were inflicted by the Dog Pound. "Pick up your nuts," screamed the "white shirt." All of the new inmates simultaneously lifted up their sacks. Then a man entered from the back of the room. He wore a white lab coat and he snapped on his white medical gloves, forcing the delousing powder to float from his gloves into the air like cigarette smoke. There is more, but I just wanted to tell you the good parts.

Shon P. Harris

If you only knew that I'm not Mexican.

She drags me to the bailes sometimes, cause her boyfriend's really jealous and he only lets her go out when she's with me. I guess he thinks she won't cheat that way, but he's pretty stupid, cause she ends up making out with someone all the time. But the point is that when I'm with Lety, I'm Mexican. We talk the talk, you know the one, like when you say "oh man, hayer I saw that ugly b— from la lavanderia" or the ever so famous spanglish terms such as "watchale" and "parkear" and "blocke." When we go to the beach in the middle of September, and it's cold but it's all good cause Fer over here brought forties this time. Or when we stand on Milwaukee and Rockwell while all the cars honk and honk on the dieziseis de Septiembre, honoring men who died centuries ago, men like Don Miguel Hidalgo, and even Zapata and many more we don't know crap about– that's when I'm Mexican. But then I start high school, and Lety doesn't get to wear plaid, and buttoned-up shirts like I do, and something changes. It ain't like the old days anymore–she says–and she's right. Somehow our lives take different ways. She stays with her bailes and her Primitivos and Julianitos and Carlitos...but me, I go down to Mexico to visit the town I stayed at when I was ten. There I see Pati and Erika and their little brother, the one who flunked the first grade four times, they take me to the Grito and laugh at me as I try to be Mexican...as I scream that grito all them get to scream even if they're not so proud of it, it makes them mad I think, seeing me try to cry for those men, for all that dark blood that was shattered in a revolution no one thought would be resolved, but it was, and here I am, in a land of laughter, where there ain't no trees to give you a break from a sun that don't mind burning off your back, where tears should be what it finds, but it's not. Go to

Mexico on a Sunday and you'll see what I mean, you'll have your uncle Guile dancing la quebradita with you, and you'll get to eat jelatina with Rompope and Romeritos– like your grandfather made them you're told–but Erika, she looks at my Nikes and Addidas shirt and grabs onto my virgensita bathed in gold, shaking her head as I drink from the Zuba on my hand. She rips the chain off my neck, making me gag. Erika whose knees ache after an hour of kneeling in front of flickering candles, asks me if I've ever cried virgin tears. Do you even go to church Pendeja? Have you ever had to pray day after day, asking that tomorrow your father can find a job somewhere, so that your brothers can have a decent meal the next day? You can come here all dressed pispiri nice, with brand names up your a— thinking that just because your nalgas are as brown as mine you are one of us. Let me tell you something Elena: You're not Mexican, she says dropping our Lady of Guadalupe onto a muddy puddle of water. The mayor stands on the balcony of Morelia's only hotel and wearing a blue striped suit he waves at the crowd and screams "VIVA MEXICO!" "QUE VIVA!" the crowd roars back.

Edith Bucio

You wonder why you're such a goody-goody, why nobody ever asked you to have a beer, a smoke, or pushed drugs on you. But then you think to yourself, "I'm too good for that, and besides, getting f—— up is so mainstream." But then you still wish that you could've been used, been somebody's whore.

Your life is so dull that walking half a mile to the local 7-11 for a Slurpee is a thrill for you. At school you hear someone complaining about how she isn't allowed to go out by herself, and you think, "Thank god there's still some innocence left in this world." The druggies on the El always sit next to you, and you wonder if it's an attraction or that they just feel safe 'cause you're so damn innocent-looking.

You wish that somebody would really love you, really care, you wish that you had perfect friends. Friends who'd realize that extreme individuality is the key to a happy existence, but would always let you be the leader of the unique. Friends who'd take you to wild places, teach you how to get high but never force anything on you. Friends who'd never try to be cool around you. Friends who'd never trash your beliefs, say "My bad" or listen to mixes by DJ Whoever in your presence. Friends who you could feel comfortable around, who'd understand everything immediately, who'd never criticize or stereotype you but would let you be the person you really are.

You've got your own friends, innocent ones. Ones who never smoke or drink and always listen to their parents. Ones whose idea of a good time is eating pizza while watching terrible TV movies. Ones who you hang out with for the sole reason that they'll never do anything more interesting than what you do. Despite all this, you love them.

You go sit in a corner and hope that nobody sees you cry. Then that feeling, that left-out still-sober feeling just

crawls up on you and makes you regret, feel ashamed that you're not one of them. And so you just leave, just leave all those stoned assholes to their own world, and you remain an outsider.

Laurél Kaish

I was surround by water, tiny white and red things swam around me. I remember a long red tube in my stomach which gave me food, every time I got hungry. I was so warm, soft and comfortable, and mama gave me so much love, life was good. I remember when she read me stories, the one about the three little pigs, oh and sleeping beauty, that was my favorite. She loved me so much, but I never understood why she cried all the time, every night she'd rock back and forth in her big green chair, the one grampa gave her; her arms tight around her stomach, she'd sing to me but every time she said I love you she'd let out a violent cry, and whispered, it's gonna be alright mama's here to protect you. I felt so safe inside her.

I remember the night when I vowed never to leave her again, it was cold that day mamma had spent all day crying and arguing. I could hear grampa's voice, well I think it was grampa's voice. I heard mamma say 'daddy please, daddy, it's my baby,' I guess she was referring to me, grama was there too and some other men who didn't seem to be too nice, how could anyone be mean to mama, she was so beautiful with her long brown hair and hazel eyes. Mama screamed and screamed but no one really seemed to care much about what she said, it was as if we were there but not really. I remember the last words I heard from grampa, she's sick and she can't take care of a baby, she does not have the intelligence to care for a baby, she doesn't even realize she's pregnant. Then some man in a white suit came in and took us away. If only I would have known what was to come, I might have held on tighter I wouldn't have let them take me out. The room felt so cold even though mama's warmth surrounded me, for the first time I felt alone. Mama's cries filled the entire room, and somehow I knew something terribly wrong was going to happen.

Jessica Carrillo

Latoya shifted the baby to her left arm as she tore open the envelope with her teeth. The baby cooed softly as she leaned back against the pillows she had taken from the couch. She began to rock as she unfolded the daintily creased letter and began to read.

"Dear Toya," it read.

What's up? I heard you finally had that baby? What did you have? I'm pissed at you for not calling me. I had to hear it from ol' nosy Schwana. I was so glad when I heard it was okay. I had been worrying because of that night at the beach, before we knew you were pregnant. You remember? I sure as hell do. I can hold onto good memories like they happened yesterday. Do you even remember how it all started? I know those epidurals probably clouded your memory. Antonio, do you remember Tony? He was the one who told us to come to the beach in the first place, talking about, "Everybody and they mama is gon' be there! Y'all need to go ahead and come through." Candace had the car, and we had a full tank of gas and nothing else to do, so we decided to go. Why not? Man, we rolled up, the five of us in Candace's mom's little Geo like chitlins in a tub. We jumped out looking to party, but wasn't nobody there. "Man, they sent us off," I said. "Let's bounce." "Man, hell naw," said Candace. "This was too long a way to have come to just turn around and drive back. We got the weed, and the booze, so let's just sit out here and chill." We all reluctantly agreed. "We look like a bunch of lezzies," mumbled Lisa. We cut on Candace's car radio, and got down to business.

A half-hour later, we were messed up, laying on the blanket. In retrospect, you didn't smoke any weed, but you shouldn't have drank. But then again, none of us, not even you, knew you were knocked up. One day we were getting splifted, and the next thing I know, I hear you're about to have a baby. But the thing about that night that stayed with me, was after we got all high, and we laid there on the beach, getting sand all

in our weaves, and we talked. I mean, you know how we are, we talk all the time –never stop. But it was like being out there, hearing the water and smelling the breeze, with the soft sand beneath our backs, plus the dizzying spell of all the weed and gin, I guess it just freed us. We talked like we always do, but nothing like we ever do. We vibed about what life is all about. Forget school, and forget niggas, and forget jealous b——. We talked about our boyfriends, and why they cheat, and why we cheat. We talked about what we all had in common. We all wanted to get out there, into the world outside of the ghetto. In a way, we did. Me and Lisa are going to college. Candace is in the army, or navy, or one of those now, and you and Tiffany moved away. I was kinda surprised when you left, because out there on that beach, you had said you planned to marry Lavell, and have lots of babies. Only it looks like the babies came first and kind of messed everything up, huh? Schwana told me that y'all broke up after he found out about you being pregnant. If that's true, f— Lavell. You ain't need his sorry ass anyway. If not, tell him I send all my best wishes.

Remember when we went around in the circle, and everybody told what they expected to do by their twenty-first birthday? I said, "Be in love," and Tiffany said "Be a beautician." Lisa's turn came, and all we heard was snoring. So we started laughing and clowning her, and I decided to put sand in her mouth, only I couldn't because I was laughing so hard, and she woke up and said she would beat our hoe asses if we didn't leave her alone. And we kept going in the circle, and Candace said, "I want to stop getting high and drinking." And we all laughed because Candace is the biggest hype out of all of us. But you, Toya, you said "I want to be on my way to the top." And we all stopped and thought about being on our way to the top. And I looked over at you, and the look in your eyes was so serious. I wasn't used to it, because it looked like you were about to cry or something, and everybody knows ghetto girls are tough, and strong, and don't cry. At least that's what everybody thinks.

Man, Toya, that's probably a night I will never forget. We were so real with each other. Up until you decided you didn't want to tell me you had your baby! But seriously though,

Toya, I miss you a lot. Come up here and visit me one day soon. Stay sweet and kiss the baby for me.

Love always,
Sheryl."

Toya laid the put the letter down and wiped away the tear. Laying the sleeping baby down flat on the bed before her, she reached over and opened her drawer, and gently tucked the letter away.

Sheryl L. Bacon

"I pick noses," he said.

"What...?!" she said, obviously angry and about to shut the door in his face.

"I pick noses," the salesman repeated.

"Why would I want YOU, let alone anyone else pick MY nose?" she asked.

"You see," he said "I am here to warn you about a terrible menace threatening both the prosperity and safety of this great nation we live in."

"What menace?" she asked.

"The Canadian nose weevil has been detected to have been steadily moving south from Canada, infesting many states, from Michigan, to Illinois, to Wisconsin, and even to parts of Oregon and California." The salesman paused to let that all sink in, and then continued with his often spoken monologue. "Once the nose weevil infests a habitat, it invades its host organism where it lays its eggs and..." he did not continue.

"And what?" the housewife asked, her curiosity awoke. Before he continued, he produced grisly photographs of supposed nose weevil victims (they could have been car crash victims) and charts and graphs of nose weevil financial damages (in the trillions).

"Well, first nothing. Then after a period of about two weeks, the eggs hatch and the larvae wriggle about the nose looking for nourishment. They travel up the nose into the cranial cavity where they attach to the frontal lobe of the brain and they feed on the tissues there. After a period of up to seventy-two hours, the nose weevil experiences exponential growth, in reaction to the frontal lobe tissues. Then it swells up to eight hundred and nineteen times its current size, causing the victim's head to explode."

"I see," said the woman paling visibly. "What can I do

to stop this menace?" she asked fearfully. He sighed and then spoke.

"Not much, but I can decontaminate your entire family for five hundred dollars a person."

"Please! Do that, DO ANYTHING!! JUST SAVE ME!!" she said, once again growing frantic.

"Okay," he said. "I can do it right here on your front porch." The man produced a small pair of forceps out of his left pants pocket and inserted them into the woman's nose. She gripped the porch rail in an attempt to keep from screaming.

"Please shut your eyes so the nose weevils don't attempt to escape through your eyeballs and cause further damage," he said. She shut her eyes, not daring to open them, lest the nose weevil hordes come streaming out of her eye sockets. He wriggled the tweezers around for a good fifteen minutes while listening to the woman's high pitched wail. Finally, he looked at his watch. Enough time had gone by so that the woman would believe that something had happened. He took a jar out of the same left pocket and shook some of the contents of it into his hand. The label on the bottle read Uncle Bob's Peppercorns.

"It's done," he said.

"How did it go?" she asked.

"There were some difficulties, but they were all in egg form," he said, displaying the peppercorns. She glanced past the salesman to a group of kids walking by the enclosure of her front porch and he crushed the peppercorns under the heel of his shoe. She looked back at him and he said, "That will be five hundred dollars, please." She pulled out her wallet and pulled out a crisp five hundred dollar bill. She paused and then put the bill back in her wallet.

"Wait", she said. "I want my entire family decontaminated, the gold fish, my hamster..." She continued a long list of names containing, but not limited to, grandparents, cousins, uncles, aunts, friends, pets, enemies, Mafia dons, insurance

salesmen, mental patients, brain surgeons, firemen, paramedics, doctors, teachers, astronauts, dentists, hoochie mammas, airplane pilots, comedians, students, terrorists, and purple dinosaurs from PBS educational programming. The man took a calculator out of his pocket and pressed the buttons feverishly.

"That will be two hundred trillion dollars." he said solemnly.

"Two hundred trillion dollars!?!" she said, trying not to let smoke come out of her ears. Then, regaining her composure, she said, "Let me get my cheque book."

"I can be back next week to decontaminate your colleagues," he said. She took the cheque book out of her purse, and with a small squiggle of her pen, signed over two hundred trillion dollars to a man who stuck tweezers up peoples noses. "Thank you," he said, trying to keep from laughing. "Here is my card," he said as he passed her the smooth white rectangle. The card read: Mr. Happy's Nose Weevil Service, 1 Main Street, Chicago, IL 60600 (312) 555-5555. He left the house and went back to his rusty brown Pinto. He gunned it for the highway, sending a wake of blue smog out of the muffler. This was southern Illinois, where the poor preyed upon the rich and stupid.

Patrick Babbin

It was back in '95, the weather was cold. Nobody ever wanted to be outside on those cold, cold days. Tiffany always got out of work around eight o'clock at night. It only took Tiffany ten minutes to get to home because she worked in the clothes store down the street. Tiffany lived in a great suburban area. Crimes never happened around there– nothing crazy that would go on the news. Everybody in town always stayed to themselves. It was a very peaceful town. Tiffany lived on the fourth floor of her apartment building. She loved living in high places. It made her feel like she was on top of the world. Tiffany shared the apartment with a friend named Jamie, both were in their teens. They had known each other since kindergarten. They always enjoyed each other's company.

One day Tiffany decided to work overtime so instead of getting out at eight o'clock she got out at ten o'clock. Tiffany finally closed the store after a long day of work. She got home at 10:15. It was cool in her apartment so she went around the house to check and sure enough Jamie left the living room window wide open before she left for her date with James. They weren't going to be home until late that night. Tiffany cooked herself a small meal. She watched TV, and ate her dinner. After she finished eating she went to her room to get undressed and put on her night clothes to get ready for bed. It was colder now. She guessed she didn't feel it sooner because she was cooking. She didn't understand why it was so cold. Tiffany turned up the heat thinking it would get warmer in the middle of the night. Tiffany got into her bed, stayed awake for a half an hour reading her favorite book from V.C. Andrews called *Heaven*. She finally dozed off to sleep. She slept close to an hour when she woke up because of the coldness of her room. She looked the windows over again but none of them was open. Finally she realized it

must be Jamie's window. She dashed to her room and flung open the door. Tiffany was right. She walked to the window, tired to shut it, but it was stuck. Tiffany noticed both the storm and the screen window were open. She tugged and tugged on the window she finally gave it all she had. The storm window came out causing Tiffany to lose her balance and fall forward and out the window. She fell four stories down to the ground. Tiffany hit the concrete causing her body to bounce twice. Tiffany didn't realize she was hurt. She thought she was fine. Tiffany tried to move but couldn't. Tiffany told herself, okay, I'm just going to rest for a while and then I'll know for sure that I'm fine.

She closed her eyes for five minutes. She opened her eyes, realizing she was still on the ground. Tiffany's face felt weird. It felt wet and thick. She went to wipe whatever it was off her face with her hand. Tiffany realized she couldn't feel her nose shape– just wetness. She took her hand away and saw a lot of blood on her hand. That's when it finally hit her that she was hurt and she needed to call for help. Tiffany softly began to scream for help and every time she did nobody heard her she even waved her arms and hands hoping some-one would see her. Tiffany could see cars passing by but none of them stopped. Finally she gave it one last shot to ask for help. She waved her hands and as she did, a man on the opposite side of the street driving in a red van spotted Tiffany. Tiffany tried to yell for his attention; she thought he didn't see her, she got nervous. When he drove off, she started thinking she was going to die out there all by herself. Then, just in the nick of time, the man in the van was back and by her side. He tried to help her up but it was no use. She was in too much pain. The man didn't notice all the blood until she rolled her face towards his. The man took one glance and let out, "Oh sweet Jesus." The man pulled off his jacket and wrapped it around Tiffany. The man told her not to worry. "My sweet child, I'll be back with help." The man dashed off to find help. Within five minutes, he returned and the ambulance

arrived. They rushed Tiffany to the hospital. They didn't let the man ride with her so Tiffany never caught his name. Soon she was at the hospital. Her family showed up minutes later. Everybody was crying and praying that everything would be okay.

Angela Pena

Wasabi

The scissors feel cold against her scalp as she pushes them toward her head and cuts off a large piece of hair. She breathes deep and looks at herself in the crystal-rimmed mirror and smiles for she is pleased with the outcome of her sudden burst. She runs her hands through the remaining hair on her head. She exhales, closes her eyes, and shakes her head and laughs. She looks down to see the long curly locks that had been brushing up against her back ten minutes ago now on the cold tile floor. She scoops up her hair with her hands and throws it into the garbage.

Standing in front of the mirror admiring herself, she whispers "dye it red or orange?" "Both!" She smiles. Pleased at her decision. She reaches down and picks up her navy blue North Face bag from the seat of the toilet and pulls out two bottles of hair color she had gotten the previous day from the salon. Both bottles were labeled in black marker. One said "Orange" and the other "Red." She lays both bottles on the bathroom sink and looks at herself in the mirror and runs her midget-like fingers through her new haircut. She bends over and looks through her bag again and pulls out two vanilla-colored gloves and sets them down by the bottles of thick liquid.

She places her hands to the bottom of her polo shirt, grabs a piece of fabric with both, and pulls it up and over her head and throws it onto the ground where the strands of hair used to lay. She lets the gloves engulf her hands and she picks up the bottle that is labeled "orange" and opens it. She parts a chunk of hair and oozes the thick liquid upon the chunk and rubs it all in. She does the same process of the grabbing and oozing with the red and finds herself to be having fun.

When finished she looks at herself again and then pulls the gloves up and off of her palm and fingers. She then plops herself down on the toilet seat cover and brings the bag to her lap. She searches through and pulls out a tattered

book with big lettering on it, *The House on Mango Street* it read. She turned to the page she had left on. She found her page, 45, then read the title of the chapter aloud: "hair." This tickles her for the title seems as if it's implying her. She let the book take her away. She finished the vignette in three minutes flat and smiled to herself again ear to ear.

Her whole life is full of change now. She is so pleased with herself. Finally, she controls everything. It isn't her family or her friends or anyone else. It is just her, and it feels so good. For once in her life, sitting there waiting, she feels free. Before, she knew she was different than all the other kids. They didn't understand her, they didn't even know who she was. To them she was the short Japanese girl that no one would dare get close to because she was so negative about the way she looked. And no one wanted to deal with that but only her true friends. But now she is someone totally different. Someone new. She is no longer called by her name Kimiko, she is Wasabi to a new group she hangs out with. Wasabi means Japanese mustard. It's hot and green and is great on sushi. She is called this because she has these green eyes that could glow in the– oh, wait, times up. She stops her rambling mind and hops up from her seat and to the sink where she smiles and makes playful faces at herself. She then turns on her faucet and bends over into the running water. The water bleeds the color from her hair. After a while she grabs a towel that hangs next to her and puts it over her head, still bending over. She rubs it all over her head realizing that she doesn't need to take a long time for it to towel dry because... she has hardly any hair. She raises her upper half of her body up and finger-combs her hair in front of the mirror, looking at the bright features of orange and a bright red that lay upon her head. She can't help but let out a small squeal of joy as she tousles her hair into a raging group of spikes and small curls.

Robi-Nichole Mraz

See a tunnel full of dead faces. Skin the color of the cement walls, baby blue lips, cold noses, light lilac eyelids, ghost white ears. Think of my invisible friends, the ones that watch you with a bird's eye view, and the things they left to see and talk of. More empty places like dustbowl highways. I miss them. Summer gives sleepy warmth. She holds me with the soft undersides of her arms and lets her slow humid breath slide off my cheek like Mom would do when she need-ed someone to hold. Mother liked pickles and pictures of desert sunrises. She was a teacher who wore pastel polos and big denim skirts. She taught fourth graders English and Science. Didn't much care for normal toys, always got me bead games, wooden train tracks, building blocks, animal maps, all of them educational. Didn't much care for normal people, always surrounded herself with other teachers "people with substance, intelligence." Didn't much care for normal food, she liked fiber and soy, stuff that drove her taste buds to new meanings of bland, guess she liked that. Never got a husband...only a few assholes and a son... still looked, though. Car accident killed her. Semi-truck found its way to... I was only nineteen... a boy, twenty-two now, four years with a nee-dle. Aunt Ruth wanted me staying with her... Summer said "Let me take care of you. You'll be o.k. with me... I'll take care of you." She was just the pretty college girl back then, Julliard actress, big eyes, blonde hair, little little nose, she took me to New York with a pack of cigarettes and a habit.

Stare at the shadow the painting makes. It's an impressionistic sort of thing... hazy blotches of color where goats and sheep graze... lovers on a blanket twisting grass just to feel the drops of morning dew... tra la la... cobblestone roads... five cent movies the rhythmic whirl of the projector... silver screens and ticker tape parades... harbors full of hope...

big buttons with politicians' names... round hats with small brims... place where Mother slept... smell of play-dough puts me to sleep more so than counting sheep... laugh of comfort tease of peace... into the land of forget... just rowing merrily merrily merrily, life is but a dream:

Playground... monkey bars tires for swings... rocket ship jungle gyms... smell of woodchips... bright shiny slides that get hot in the sun... undisturbed innocence... the caress of sand run over by a thousand happy feet. A dog howls in a distant suburb... Dipi smiles... old evil man waves a conductor's wand... the green soldiers squash their homes, neighborhoods, dogs, children, friends... choppers crackle in the distance... urban filth strangles the playground... the pulse of doom squashes the happy feet... the desolate blue and green men lick their lips...

Billy Reilly

The Letter

She held her mail loosely in one hand. With her other hand she swept old newspapers and magazines to make room for the mail. The old junk fell on to the blue carpeting of her dining room. She set the mail down on the oak table, and stared at it. I know what you are, she muttered darkly, you're bills, and junk mail. The urge to rip the mail to shreds almost over came her. The first envelope was a bill. "End of the month mail is a b—," she shouted, as she saw how much the electric bill was for. A lot of the mail was junk mail, and she tossed that around the small four walled dining room. She was down to the last letter. She reached for the letter wondering if it was another bill. Credit card maybe., she thought sarcastically, but it was neither bill nor junk mail. The neat obviously male hand writing on the envelope was unmistakable. "Well, Richard. So you've decided to write to me," she whispered softly. She shook a little with the pain of loss, renewed at the sight of this letter. She sat on the edge of the table, and opened the letter. She removed the stapled sheets, and with tears in her eyes she began reading:

Dear Carrie,

It's been a while since I've last seen you. I figure it at just over two years. It's been some time since I cared about time. Leaving you tore me up inside. I haven't written you because I thought a clean wound heals fastest. You must have felt the same way, for you have not written me either. It is almost like that psychic link our friends always kidded us about. However, what I've written here has to be said, perhaps it will even help. I'm going to tell you about a day that happened two months ago on the second-year anniversary of our departure.

I was walking down Belmont not caring about much, just wanting to walk. The people around me were giving me a claustrophobic feeling, and my mood was only getting worse.

The sun beat down on my head giving me a dull headache. People jostled me from side to side, and cars emitted plumes of choking exhaust as they roared by. Pointless bits of conversation, and hideous laughter surrounded me in an almost suffocating manner.

I was beginning to think my walk was a mistake when clouds suddenly obscured the sun. Drizzle fell in sporadic drops and distant thunder filled the air. Everyone began finding places where they would not get wet; I continued walking. I appreciated the effect storms had. My claustrophobic feeling eased as the drizzle turned to a heavy rain and people ducked for cover. After only about ten minutes the sky was releasing its water burden at full force. The thunder was no longer far off, but booming loudly. Lightning crackled in the air and the last of the people vacated a drowning Belmont.

I breathed easier now that the people were gone and the rain seemed to smother car exhaust, but I still walked with my head down. I stared at the gray pavement before me and counted the cracks I saw. I had no wish to look at the dull ugly colors that surrounded me. The combined efforts of the stratosphere and my mood made for an ugly world. The rain running down the McDonald's golden arches made it look like congealed piss. The Burger King across the street looked forbidding. I continued down Belmont in an even darker mood than I think I've had before.

Suddenly I paused as the figure of a man in the window of a jewelry store caught my attention. He wore all black, even his hair and eyes were black. He looked intimidating just standing there, giving me one of those glares like "So something bad happened to you. Why the hell can't you move on." The look can also be taken as the "What is your problem" look, but I somehow knew that he knew more than a little about me. His pale hand reached up to draw his glittering nails across the glass. I gasped as lines of imperfection followed in the wake of his diamond nails. They had to be diamond, nothing else could mar glass like that. He was drawing a line that eventually branched off into another and another and another until both his hands were working over the glass to make the most stunningly beautiful tapestry of lines. The lines made an intricate

29

pattern in which they joined others, then parted, then met another. Even though the lines when he was done never met another line it still looked somehow perfect in its way– as if even the lonely lines had their place. I strode away thinking about what I had just seen.

My thoughts were so deep that I was not looking where I was going, and when a woman standing before me said something, I jumped. I asked her to repeat herself. She asked me why I was walking in the rain with no protection. I only half-heard her. She looked just like you, Carrie. Long, athletic legs, a perfectly proportioned body, strong-looking arms, and a sharp-chinned, high cheek-boned face. Only her eyes were different, they were a piercing green in her dark tan face. I swear, Carrie, she could have been your twin but for those eyes. Even her long, dark-brown hair– which sparked memories of me tugging at yours when we were children.

In the second it took me to size her up I answered her saying that she also had no protection. She smiled getting that same twinkle you get in your blue eyes, "I have no protection, but I'm going home," she said. "You look like you are going to walk forever." I took a step back, bowed and said, "How perceptive of you lady." I was still a little taken a back by her appearance, so it surprised me that I could make a smart-alec comment. It did not surprise me however that I had missed her Irish accent. Her voice was also different than yours. Besides the accent her voice was deeper, and more powerful sounding than your soft gentle voice. "I've seen you around," she said. "I'm your neighbor." I gasped for I knew I would remember someone like her. She noted my expression, then said roguishly, "I just moved in." I just nodded. She poked my shoulder, "Why don't you walk me home?" I shrugged, then offered my arm. She took it, and I began walking her towards home. For some reason her deep voice made me only think more of yours. I could hear you teasing me in the back of my mind, "I'm not afraid of the dark. Are you?" "I've been in Ireland all my life," she spoke conversationally. "I came to the U.S. because I heard it's better here." I looked around at the grubby looking small businesses, with the big name stores dominating beside them. Sears, Best Buy, Nate and Bill's hot dog stand. Then I thought

of the periodic bombings going on in Ireland. "I suppose it is better," I said. "You bet," she said, laughing.

Suddenly she stopped, jerking me to a stop as well. "Look at those gorgeous diamonds," she said in wonder. I turned to look where she was pointing. It was through the flawless window of a jewelry store. I was so shocked to see no markings on the glass that sounds seemed far off and only the glass held my attention. I turned with bafflement still on my face, and as I did so my eyes met hers. In her eyes the mystery of the lines unraveled in my mind. Lines staying together for a short while then parting. Like us being together for a time, but then parting. Though both lines in the tapestry had parted, both had met another further down their length. "Aren't they lovely?" she said happily. I thought about the dark, imposing man, and his nails carving a hidden message in the glass window of a nameless jewelry store. "They're beautiful," I said softly. She nodded in agreement, the gripped my arm and we continued to walk towards home. I looked up and down the unoccupied sidewalk and smiled for the first time in a long time. I didn't know why I smiled, I just did. Then she began telling jokes, and I laughed. It had been even longer since I had done that and it felt good. We turned down a side street and walked for a few more blocks, stopping before our houses. She stood before her walk that led up to the front of her house. "It was nice talking with you," I paused questioningly. She had not given me her name. "Marie," she said. I nodded; "It's been nice talking, Marie. I hope I will have the chance again." "I suspect you will," she said dryly. "And what might be your name, stranger?" I grinned. "It's Richard," and then I strode to my house.

I did speak to her after that day. We went out to dinner, and have taken walks in the park where you and I used to walk. Not too long ago she told me I was a great guy, and kissed me. I thought about those lines meeting other lines. People falling in love. Carrie, I'm sure that if you went out and had some fun, you'd feel a lot better. You'll probably find someone else, and even if you are one who never finds anyone again, remember that you don't need a lover to be happy. All you need are friends who you love and who love you. Perhaps one

day when a little more time passes and you are happy, we can
see each other again and have the relationship we had when we
were young.

Love,
Richard

When she was done with the letter she placed it on
the table beside her. Move on, she thought dully. That was
easier said than done. She looked around her at the more
than cluttered dining room. The blue, unclean carpet was
barely visible under the old magazines and newspapers.
There were even cans of pop on the floor. She had never
been so dirty in her life. She was usually clean and orderly.
Order had turned to disorder when Richard had left, howev-
er. She gazed at the four stained walls, and at the doors
which led to an equally dirty kitchen, and living room. On
the wall before her was the only adornment she had allowed
herself to place on the walls. It was a picture of her and
Richard. Richard, standing next to her, was only slightly
taller than her six foot one inch height. That picture had been
taken shortly before they had split up. They were both twen-
ty-four then, and still happy. Richard's wolf grin shown, as
did her slightly more gentle one. The photo brought back
memories. Memories of that last day.
 She got off the table to walk to the picture hanging
from its nail on the wall. She lifted it off its perch, and held it
in her hands. She kissed the image of her twin brother, then
walked back to the table to retrieve his letter. She walked to
her bedroom which separated the living room from the dining
room. She waded across her discarded old clothing laying on
the floor of her bedroom, over to her dresser. She bent to
open the bottom drawer that she never used, and placed her
burden into it. She closed the drawer, then straightened to
look at herself in the mirror hanging over the dresser. Her
face was haggared, and more pale than it had been. Her eyes

were rimmed by dark circles. "You look like a bitter woman," she said aloud to herself. The message in Richard's letter ran through her mind. Move on, Carrie. Move on. Well, today was her birthday. It was as good a day as any to begin her moving on process. She tried to smile, but it came out weak and tired. The phone rang. She lifted her hand to the telephone on top of the dresser. "Hello?" she said. "Hey" Anna's voice said on the other end. "Did you think the members of Machine Gun would forget it was your birthday?" "I wasn't sure," Carrie answered. "Well we didn't!" Anna shouted. The other members of the band and I want to take you to a club tonight." "Well," Carrie said uncertainly. "It's on the house," Anna added. "Move on," Carrie thought. "Tonight sounds good," she agreed.

Sam Negron

One summer day a ten-year-old boy was walking down the street in his neighborhood. He noticed a shiny object in the grass near the playground where he played with his friends. So he grabbed the object and tucked it directly in the front pocket of his shorts. He was quite anxious about what he found so now he ran home. Minutes later he was at the front door of his home. He knocks at the front door, leaning down because he was exhausted from running trying to catch his breath. His mom came to the door then loudly said "Who is it?" He responded, "Tommy." Without hesitating, she opened the door. He walked in. As she closed the door behind them she began to question him. "Where have you been?" she asked. "At the park with my friends," said Tommy. "Go up to your room, change those clothes and get ready for dinner," she said. "O.K. mom," he said. He ran up the stairs which led to his room. He looked around to see if anyone was watching. Grabbing the door knob he then twisted the knob slowly and opened the door. He quietly entered his room and gently closed the door. He sat down right behind the door so no one could get in. He slowly reached down into his pocket. He then pulled out a nickel plated 9mm. The boy was in shock. "What am I going to do with this? If I get caught with this I'll be in deep trouble. I'd better hide it until I can get rid of it," the boy thought.

Then a loud womanly voice yelled, "Tommy, come down and eat dinner. And you better have on clean clothes and make sure you wash your hands." "O.K. mom," he responded quickly. "I have to hide it, but where?" he thought. I'll put it in my treasure chest at the very bottom he said. Then dumping all of his G.I. Joes and other toys on the floor, he buried the gun in his treasure chest. After that he quickly slipped on a clean T-shirt and matching shorts then raced to the bathroom and washed his hands.

He made his way down the stairs to the kitchen where him and his two parents ate dinner. He pulled his chair across the hard marble floor and then slowly sat on it. His mom brought him and his pops a plate of food filled with steak, gravy and mashed potatoes. "While you're up, please turn on the T.V.," his father requested. She turned on the set and handed him the remote. He flipped channels looking for the local news. They all began to eat. Tommy had almost finished his plate, so his mom asked him if he would like seconds. He said, "Yes, please." She then quickly made him another plate. He continued eating. "Hey, there's a special bulletin coming up next," his father said. "I wonder what it will be," commented his mom. Tommy finished his second plate and as he walked over to the garbage can to scrape all the little scrapes off his plate, he heard the special bulletin. *"Around on hour ago in the friendly neighborhood of Melrose, there was a body found in the bushes of a local playground."* "Oh my god," his mom said. "Weren't you over there?" He responded, "Yes, I play there all the time." "You can't play around there any more," his pop cut in. "I don't see why this has to happen. This is a good neighborhood." The voice from the T.V. continued. *"A man by the name of Michael Harris was shot four times in the chest. There was evidence of the bullets. They have found four 9mm shells. The gun has not been recovered. There were no witnesses and no one knows how long this man had been lying in the bushes. We will be back to talk with the parents, family, and friends of this young man. We will bring more information later on in the hour."*

Tommy had started to shake. He then ran up the stairs and locked the door and began to panic. He was very scared. He took the gun from the treasure chest. He messed around with it until he finally got the clip out. He counted how many bullets were suppose to be there and how many were gone. He knew that he had the missing gun. The next morning he woke up and began to get dressed. He grabbed the gun from his treasure chest and put it in his pocket. He

ran down the stairs and he almost ran into his mom. "Where are you going so early," she asked. "To my friends house," is the only thing he could come up with. "This early?" she said. "Mom, please, can I go? I told him I'd be over in the morning." "Who?" "Damon," he said. "O.k., but I don't want you by the park." "O.k. mom." Then he slammed the door and started to run. He did not stop until he got to the park. He took the gun from his pocket and threw it back in the grass where he found it. He turned around to make sure no one was behind him or in his view. He kicked the gun after he dropped it on the grass. He then ran from the scene as fast as he can. He ran to Damon's door step and rang the bell. "What are you doing here?" Damon asked after opening the door. "Oh nothing. I have a secret to tell you." "Wait, hold on," said Damon. "Follow me," he said. "O.k., what was it that you had to tell me?" "Well," said Tommy, "you know that guy who was found dead at the park?" "Yeah," said Damon. "Well," he continued, "they said that they could not find the gun at the scene of the murder." Tommy continued, "I found the gun." Damon said loudly, "What did you do with it?" "Well, I put it back where I got it from. I did not tell my parents because they will kill me themselves if they found out that I had it. They don't want me to hang around that park anymore. What should I do?" asked Tommy. "What else can you do. You can either keep this between us and don't tell nobody or call the police." "Well, I think I should call the police. I would feel so bad if I didn't. That's the least I can do. Help the police by telling them where the gun is, and then the case will be solved." "You do what you want," said Damon. "You know what's best." "I'm going home," said Tommy. "O.k. I'll see you later," said Damon.

Albert Murphy

section two

Poetry just
on the other side

Caramel Candy Hue

Idle dizziness,
Nauseous confusion,
Frustration.
Complicated structure.
Knotted heart.
Overwhelmed and,
finally
lost,
To the question: "Who am I?"
Caught between power struggles of
Black and White
and yellow,
and red,
But mostly brown.
They all have their own shade of brown,
unevenly blended
Showing off a
light
caramel candy hue

"Mixed babies are the sweetest
Mixed boys are the cutest
Mixed girls are the prettiest."
And, "they got the best of both worlds,"
With "They're so lucky to be culturally diverse."
Am I?
Are we really?
"Lucky?"
Forced to choose one side over the other.
Mexicans say I'm black.
Blacks say I'm Mexican.
Always darker
or lighter.
Never just the same.
With, "What's it like to be...?"

And, "No offense to you but,..."
Constant voices
always there.
Dress White.
Talk Black.
Look Puerto Rican.
But I'm not one ounce Boriqua.
People constantly trying to change you.
Dress preppy,
act ghetto
and vice-versa.
No one's ever satisfied.
I find myself in oblivion
never knowing
yet,
always wondering why
a God so loving would
bestow upon me
such a wretched privilege.
Sometimes I'm left out
Or,
I'm the center of attention
used as the median
because
what's my opinion?
Stuck in the middle
of a razor blade fence,
that cuts deep into my brown, browner,
flesh.
And with each gush of blood
flowing from that wound,
I lose
another part
of
who I am.

Maria Gonzalez

Stifled

Drowning in my staleness
Surrounded by your absence
Where did the romance go to
Where are the feelings of love for you
Did they leave with your sleep
Or fall down the misty mountain steep
Why is it I who feels the pain
Like a black whole stain
I put my love on the head of a pin
And at the time it was no sin
You let me see the moon with one eye closed
And you were just a water-based hologram
Covered by the red oozing jam
I need that laugh that brightened the darkest moon
I want to see that smile soon
Like a small child I wait by the counter
To see that name that keeps me up after
But in the space where time is faltered
Our love is somewhat altered
It's not that we don't feel the same
We just don't feel enough, we're tame
Separated by a tragic situation
And by a great space in this nation
My blood pumping, oxygen breathing thing
Feels cold, numb and slight sting
Every second that tricks away through the day
Knowing that someday will not want to stay
In my dreams my baby dies
Covered by a blanket of lies
Don't let me drown this life away in the night
And it won't help if you turn on the light

Monica Alcaraz

The Promise

After three days of labor, she finally gave birth to a baby
Girl.
After a short silence the doctor then said, "It's a beautiful baby
Girl,"
As tears of joy ran down her face,
Her aunt holding her hand the whole time, not knowing
What was in store for her young niece.
My mom overcome by what she had just produced.
As she sat in the hospital room while I slept,
She thought about my first step, my first tooth.
She was a baby having a baby,
But still her life didn't end there.
She made sure she was going to be somebody
So that her little girl could have a role model
That day she made a promise to her little Girl
"I promise to always be by your side and
Never let you down,"
And 'til this day she has always been by
Her little Girl's side.

Cynthia McKissick

The Wish

My only wish,
It's quite different,
To live the free life,
To have the purest soul,
I want the courage of the bear,
I want the feet of the eagle,
I want the heart of the earth,
I want the view of the pines,
I want to run with the deer,
I want to fly with the hawk,
I want to sleep with the flowers,
I wish I were part man,
I wish I were part earth,
That is my wish.

Marissia Garno

Cover Girl

One day, sitting & pondering as I do
I noticed a girl off on her own
Sitting in her
So seemingly belonged spot.
"Who is this girl?" I asked myself.
"She looks irritated, possibly bored or sad."

It seemed that she repeated a sad memory in her
mind.
She was pale that day; red hair at a standstill.

"Maybe she's an introvert."
I smiled at her when she seemed to
Stare at me... no reaction.

"Conceited bitch!" I almost said aloud,
Getting frustrated by now.
All of the sudden my expression seemed to burst
the bubble of her thought.
She tilted her head & said hello.

I scorned myself for judging
Her by her cover.

Melodie O'Dowd

My Tierra

The busy morning of the soft sonido of the calle.

Over alla en mi tierra I would hear the vacas mooing and the cantar of the roosters.

Wake me up.

I don't need to have an alarma I just need to hear the honks, motores and the frenos of the car out in the street.

Going out the door, feeling the brisa as it goes down my espina dorsal.

The gente that walk along the sidewalk, that smooth cemento that makes you stand perfectly.

At mi tierra their the pierdas go side by side or up and down a cierro.

Where the mocosos play freely,

While aqui vigilamos a los vatos and las pistolas.

The dangers at night that a bala could go into you.

Where en la ciudad we have lights hanging over us.

Alla en mi tierra the estrellas watch over us.

While we sleep.

Maybe this is not alla en mi tierra,

But this is the tierra en que naci.

Guadalupe Ortega

And this is just the beginning.

What a life, shall I say that now or
wait another hundred years and scream
out to my son's and grandson's ears.

Here I am about five years old, officially
now in the Catholic religion, after being
baptized. Welcome to the franchise.

Didn't take long to really get involved in
Catholic events. Instead as usual terrorizing
live events.

Flying in the air with no hair, the Mayor thought
it was just another tale from some guy called Dale
who just came out of jail.

Dressed in a suit but never really liked to eat soup.

Can I dance Tango, in more than one angle.

Traveled over a million miles, I better see everybody
smile when we reach the nile.

Yet, a picture with all my family will make this small
highlighted dream a reality.

What an event.

Time to twist this upside down. Once again we meet.
After The Psycho Realm rocked the House Of Blues
early in the year. Did their preaching, spread their words
of wisdom. Shame on the crowd. Still didn't get the message.

Amazed not me. Wasn't the first time or last time I talk

to Louis most notable known as B-Real, Joaquin, his older brother Gustavo, and Eric.

To think that these are some of my life highlights is wrong.

This is just the beginning of a very long 18 year old's journey.

Raul Rangel Abounce

The Snow

Cold shivers are sent up my back,
as the fast wind hits my skin.
The pure view of heavenly white,
blankets my surroundings.
The sky is clear but all I see is blue,
as feathers of iced heat hit my face.
My heart pounds as the sound of the wind
shakes the trees that tap my window as I sleep.
The heavens are disturbed,
not knowing whether to be angry
and present a cold shoulder
or cry out in sadness.

Jamesa Rhodes

Why do people call me a weirdo, psycho and a punk?
Is it because I don't brush my hair?
Or because I have a purple gem in the middle of my forehead?
Or is it because I have a nose ring?
Or is it because my teeth are yellow and black?
Maybe it's because I have bright flowers going around my face.
Or maybe because I have blue thunder bolts to show that I'm
strong.
Or maybe it's the colors on my cheeks.
Well what ever it is, people shouldn't judge a book by its cover.
You have to open it, to the pages. You'll see I'm the best friend
you'll ever have.

Loretta Trevino

My Neighborhood

There are children playing and riding their bikes along the side-
walk,
While parents sit on the stairs and talk.
There are big trucks driving down the street from the factories
across the street.
When the trucks reach the end of the block they are stuck in a
long line of traffic,
And just on the other side of the other side of the traffic there
are gun shots.
There are no children playing on the sidewalks and no parents
sitting on the stairs.
Instead you see parents rushing their children home from school
so they
Won't be caught in the cross fire.
There are people standing on all four corners selling drugs and
making other deals.
One person shows up with less money than he should have had
and a gun shot
Is heard all throughout the neighborhood and another body
falls to the ground.

Lisa Varney

Water

Water is another word for life
It is constantly moving, like feelings
So clear you can see your reflection
It stays the same, yet always changes
So fresh and clean it helps you
Clears your thoughts when you're confused
Or when you are in deep sorrow
It is the greatest part of nature
Running in a pure, holy river
It gives the trees and flowers beauty
Without water there is no life, no loves

Lucy Repta

Like wind around me
 I want you to stay
Don't make me rust
 Like metal
Don't make puddles of my tears
 Make culture grow
Fill me with laughter
 Let us express the wonders
Of emotions
 Make me warm when I'm cold
 Let me feel the tenderness
 of your skin
 Let us mix and become one
 Don't make a wall of frame
 shatter our tender feelings
 Let us stand firm on soil
 Proud like soldiers
 Fighting for their country
 Let our words braid with each other
 Let me always see your seed-shaped eyes
 Let us become one...

Miriam Medina

If

If I were to go back in time and correct all
My errors would I be a perfect person?
If I regretted everything wrong that I ever
Did would I be living?
If I took everything to heart would I be
A strong person?
If I were so self-conscious would I have to
Prove and justify myself to everyone?
But then I didn't do anything wrong,
I was just being me.
I don't need your "ok" or your approval to
Go on.
I will live my life to the fullest and only take
Into consideration the criticism of a true friend.
You have such a picture of what you think I am
But you don't even take the time to know me.
You say you are my friend, but what friend
Talks behind your back, saying a whole bunch of crap.
When you should look at yourself, I know your
Errors and your sorrows but I never judge you, I took you
As you are with your faults, but you never took me...
You left me there as an abandoned child!!!

Ana Luisa Garibay

LIFE

BARRIERS OF THE WORLD, TREMBLES OF

THE BEATING HUMAN HEART. MINDS

OF SACRED WORDS. SOULS THAT ARE

WAITING TO BE RESTED. TEARS CRYING,

FOR PEACE. ALL CRAMPED UP IN A CRAZY PLACE.

MAZES THAT NEED TO BE FOLLOWED THROUGH,

TO THE FINISH LINE. TRIVAS GETTING SOLVED

WITH PRECISION. IMAGINATIONS FILLED WITH

ILLUSIONS. WISHING TO BE IMMORTAL, BUT WHO

KNOWS WITH THE IMMORALITY OF THE WORLD.

DECEITFUL ISSUES THAT ONE BELIEVES, BUT

SOON ALL DYING IN A WORLD OF SIN THAT ALL

ALL OF US MORTALS CREATED.

Angela Zakrzewski

The Spirit

The spirit is mine.
By my birth right it is so.
Born with an unusual spirit.
Born at the time of need.

A special girl in an unwilling world.
A girl to grow up almost unknowingly what was
in store for her.
A girl special as the sun is to the earth, and the
moon to the sea.

In the flame of the fire you will see your spirit
burning brighter.
Soon you will see your brightened spirit, in the
shape of something new.
But be warned that spirit is you.

The spirit of you is the spirit of an animal.
The animal defines who and what you are.
The greater the animal the better the spirit.
The bear is the spirit of great strength.

The bear is mostly meant for men of high rank.
When a female is the bear it is a special event.
A celebration is to be made.

When the time comes you will know.
For all sorrow will grow.
The time of a new blessing is here and now for the
bear is me.

Georgene Ford

Ode II My V Senses

My fingers reach out for your face
And I bring it close to mine.
I can hear every breath you take.
I see you look into my eyes.
I taste the warmth on your lips.
What great blessing to know we are near each other.

You know, it's funny how we match each other perfectly.
My eyes lock with yours,
My ears hear only your voice,
My lips taste only your lips.
My nose smells only your scent.
And my hands feel only your body.

All of a sudden my nose grows,
 And Grows, And Grows!
My eyes explode, My hands and fingers
Are too big to wear rings.

My ears have huge drums,
My mouth opens wider, and wider,
And I see you standing there, contemplating me.
I notice you are going through the same thing.
I STOP.
I THINK.
And I come to the conclusion that some people
Just have MORE SENSE than others.

Adriana Diaz

All that I did was tell her of my plans
of marriage before college. She was off-
pulling her dress to scratch at her dark tan
and turning her ring with a laughing cough.

"When I was young I was the same as you,"
she said, which never had occurred to me.
Her dress through grainy sunlight shone deep blue
the glitter on her eyes a silent plea.

She rambled out her speech, pressed dresses flat
against the board, and I could see her young
and not my cousin, a girl with ratted
hair, dreams of castles and careers, high strung,

thought the last thing she would do was marry.
She began a queen, became a quarry.

Nova Benway

Sestina for those who Fly

He is the artist who paints the sky
on Sundays
smoothly stroking soft sheens of color onto the sunset
gracing every detail with starry fingertips
Sculptor the Sun
yet so distant by so many miles

His smile
glows in the sky
golden, gentle, like rays of sun
that tickle my eyelashes on Mondays
The suave tip
of his tongue inscribing love poems that linger, long after the
sun sets

Ever notice, the fiery vibrance that erupts when the standing
sun sits?
Did you ever feel its fuschia flame sizzle inside you for miles?
And miles?
Ever witness, the earth's turpentine temples being kissed by the
tips
of the sky's
lavender lips? He opened my heart to these things on Tuesday
And I absorbed them all, like sparkles that dwell in the sun

Together we have watched the Periwinkle sun
setting
only to rise again on Wednesday
Danced upon piles
of ruby red clouds that groove in the sky
and even God was snapping his fingertips

How heavy his hazelnut honey slips
Slick and silky past and mountains that shape my valley.

Ascending
like the sun
into an orange autumn sky
Desert for Two after Sunsetcreamy mocha cappuccinos
sweeten our smiles
under a Moonlit Paradise on Thursday

On Friday
he whispered, I love you, in sea green rain that dripped from
angel's lips
And I gazed into the two smiling
suns
called his eyes, as the silver sun set
outside our window sill. Sharing love in the lemon fresh sky

On Saturday he tantalized the sun
and with delicate fingertips illuminated my womb with
the sunset
and I gave birth to the topaz butterfly that smiles in the sky

Temeka Johnson

section three

"I didn't know what to say."

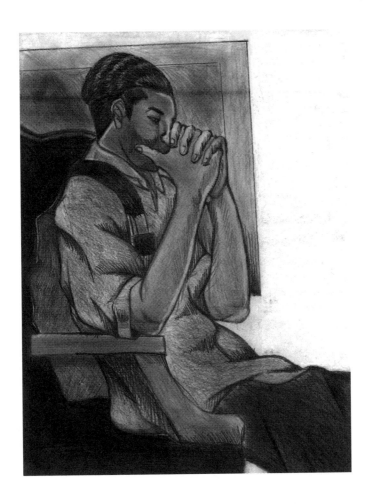

Strange Fruit

by Selly Thiam

She drove around our neighborhood in a big white Lincoln-Continental and bought exotic fruits my mother never bought from the local fruit market where everyone knew me by name and gave me free candy.

She had a friend I overheard her call Sonia, who wore her hair in long dreadlocks, even though she was white, and adorned her body with long soft skirts that fell to her feet.

Everyone whispered about them. I would sometimes catch them kissing each other like my father kissed my mother when they thought I wasn't looking, and when they went shopping together, they would smile at one another as if they both knew the secret to life and helped each other breathe it in and out everyday.

I would watch them together and smile to myself because watching them gave color to so many dull things and their happiness would paint walls as they passed them.

My mother, on the other hand, hated these women. She called them immoral and walked around the house stomping whenever she saw them in the market or driving around in the Lincoln-Continental. She talked to her friends on the phone preaching about God, and sin, and dykes, but I didn't understand.

I wanted to blame my mother for what happened the day I woke up knowing something was wrong. The lights beat against my walls like a child in pain screaming for its mother. I ran to the window and peered out. A crowd had formed and I could see my mother was at the front of it. The big woman was crying. Her tears could have irrigated crops, but her sorrow would have killed them. She reached out and held the hair of her lover as she was wheeled into the back of the ambulance. A puddle of blood stagnant on the street, and I stared at Sonia's beautiful soft dress, stained, and cried too. The big woman's crying was so contagious, her sorrow so

real, that I was sure my mother felt guilt as she stared at her with a look of indifference. I watched the big woman talk to the police and fell asleep again looking out that window.

I woke up later that morning and stared at the dry street that seemed to show no sign of the accident. The sirens were gone, the crowd had dwindled and everyone and everything seemed to be singing a song of normalcy.

I walked into our living room and looked at my mother who was sewing a shirt together.

"Mom what happened this morning?"
My mother didn't answer and continued to sew.

"Mom please tell me. I want to know."

She stopped sewing and stared at the wall. Her voice was small at first.

"Someone hit that girl. The one with the funny hair. She's dead now, and the big one is just sitting in her apartment crying like she's lost a husband. I don't understand why people sin against God and expect not to get punished."

I wanted to say to her, "You know this is your fault and people like you that this is happening." I wanted her to give Sonia back her blood that was now all over the street. I wanted to give her woman back all her salty tears. I wanted to go back in time and run up to them in the market and ask to taste the fruit they were sharing.

But instead I stared at my mother. Her lack of caring, of understanding, of recognizing true love scared me. I got dressed, went outside and walked to the market.
People smiled and waved and handed me candy. No one seemed to talk of the dead girl. I walked into the fruit market and bought a piece of fruit I had seen purchased before but had never tasted. I put it in a brown paper bag and walked towards their apartment building. I knocked on the door, and heard the footsteps move towards me.

She looked smaller without her lover, the happiness in her eyes was replaced by dullness and her skin was pale and in mourning. I reached out and handed her the brown paper bag. She took it.

"I'm sorry about your friend. I wish I could fix it."

She opened the bag and took out the Passion fruit. She stared at it and smiled. She looked at me and for a moment the life returned to her eyes. She touched the top of my head, bent down and kissed me on the cheek.

I turned to walk away and heard her voice as if for the first time.

"Thank-you."

I smiled at her as she walked back into her apartment and closed the door.

"You're welcome." I thought as I left her building and returned home.

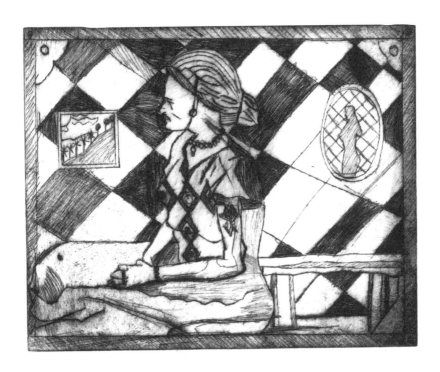

An excerpt from

Ruben

by Kareema Cruz

A burst of blue and purple sparks shattered the dark
night sky. The crowd roared with excitement. A young boy sat
on the curb across the street from the park where his best
friend's older brothers were shooting fireworks. He smiled as
they popped and then fizzled, drifting away on the warm July
breeze.

"They're so pretty," he whispered innocently.

A car horn abruptly interrupted the child's silent
adoration.

"Ruben, where the hell have you been? Get in the car!"

Ruben hated the sound of his father's voice when he
was upset. A red and orange firecracker went off as Ruben's
father whipped his rickety old truck into reverse. When the
truck came to a halt Ruben reluctantly climbed in. Fear swept
over the boy's body as his father pushed the gas pedal with all
his might and the truck sped away. Ruben knew he wasn't sup-
posed to leave home after ten let alone without letting anyone
know where he was.

"Boy you got yourself in deep this time. I've been look-
ing everywhere for you. You just wait till we get home, you're
gonna get it."

Ruben's dad never took his foot off the gas pedal as they
barreled down the highway. Ruben had a death grip on the
door pocket and with the other hand he clutched his seatbelt
and pulled it tighter as his father swerved around two huge semi
trucks. The truck drivers beeped and mouthed profanities as
Ruben's dad accelerated. Ruben swallowed hard and took a
chance at speaking.

"Dad, I–"

"Did I say you could talk boy?" his father interrupted.

"Sorry," Ruben murmured sorrowfully.

His father reached over and backhanded Ruben, hitting him square in the mouth, his glance never straying from the road. Rubens lips stung. He could taste blood between his teeth. Tears swelled up in Rubens big green eyes, but he didn't let them trickle down his face for he knew what his dad would do if he saw Ruben cry. The rest of the ride was silent. When they got home Ruben's father dragged him out of the truck. Holding him tightly by the collar of his shirt he pushed Ruben into the house.

"Juan, is that you? Did you find Ruben?" Said Ruben's mother Anisette who was in the kitchen washing dishes. She glanced up just as Ruben and his father passed by the doorway. Ruben looked up at her for a moment and she could see the fear in his eyes. They seemed to plead for help and resist it at the same time. Anisette saw the blood on Ruben's lips and dropped the plate she was washing in the sink, splashing water all over the counter and floor. She rushed over to her son and grabbed his face with her wet, soapy hands.

"What did you do to him?" She demanded.

"He needed a good beating and I'm still gonna give it to him. He needs to realize that I am the boss and he can't be goin' out so late," Juan replied.

"Juan, he's only ten!" Anisette said, her voice rising.

"Oh shut up and mind your own damn business," shouted Ruben's father angrily.

"Hijo de puta don't you dare touch him," Anisette warned.

Ruben's father wheeled around and punched his mother full force in the face. She fell to the floor and cupped her hands over her cheek. Ruben stood in the living room frozen, eyes wide open in shock. "No you didn't." Anisette said, picking herself up. She grabbed Juan's shoulders and planted her foot firmly between his legs. Juan bent over, moaning in pain. "Maricon don't you ever touch me or my kids again. EVER! Ruben go to your room. Go baby, now!"

Ruben ran to his room and slammed the door behind

him. He could still hear the sound of his parents arguing. Their shouts outdid the blaring television. He heard a door slam and then silence. Listening closer Ruben could hear his mother's muffled sobs. Since there was no other sound he assumed that his mother had kicked his father out.

It was late before Ruben finally fell asleep. His stomach ached because he had missed dinner the last time it was his turn to eat.

As Ruben drifted off into the subconscious world of sleep he saw visions of open fields with running horses. The atmosphere was free. He longed so much to be there. He wanted to flee from the cramped houses and littered streets of downtown Brooklyn, to get away from the pushers and users and backstabbing, so-called friends. Ruben had just fallen asleep when he heard his wake up call.

The bedroom door slowly opened and the hallway light brightened up the room. The silhouette of a thin, small woman stood in the doorway. Ruben thought for a moment he could pluck the door and the silhouette from the room and place them on a page as a perfect picture.

"Boys, are you up yet?" came a voice from the silhouette. The small woman moved effortlessly to the side of the bed and kissed Julian's dangling head. The six-year-old sat upright and gave his mother a toothless grin.

"Mom, can't we sleep for ten more minutes?" Ruben pleaded sleepily.

"No mi amor, lla son las ocho de la manana," said Ruben's mother as she sat down on her son's bed and kissed him on the cheek.

Julian jumped off the bed and ran down the hall to the bathroom. Anisette got up and walked to the kitchen to make breakfast and left Ruben to ponder the thought of waking up.

Father to Son

by James Vickery

My very strict father, who is a college professor, is taking my hand and leading me into a dark place. When I first enter all I can hear is a jukebox belting out a country song and all I can see is smoke. Then I hear men's voices, loud laughter and the sound of billiard balls being knocked into each other. As we walk further into the room, still clutching my father, I realize that we are in a bar.

"Dad, what are we doing here?" I asked in a rather surprised tone.

"I think it's about time you learned how to relax," he replied as he lifted me onto a wobbly barstool.

My father, in his gray suit, wearing steel rim glasses, beckoned the bartender over in our direction. Now the only alcohol I had ever seen my dad consume was once when he had a cold and took a tablespoon of Nyquil. Even after that he said, "Never again."

"Charlie, two shots of whiskey. No, make that doubles," he told the gray-haired man across the bar. How did my dad know the bartender's name, I thought to myself, but decided not to ask. The man took a bottle from the wall and poured what seemed like a gallon of whiskey into two glasses.

"Drink up son," my father told me as he raised the glass to his lips. I watched him empty the glass in two quick gulps. My mind drifted back to the day before when he told my older brother that all he needed to be concerned with was school and church. "There's no room for partying in this household," he scolded.

"Whatcha doing...babysitting that thing...drink it up!" he said as he slammed the empty glass down. I stared at him for a few seconds, then back at my drink. I lifted it up to my nose. My eyes watered as the stench nearly made me gag, so I decided it would be easier if I held my nose. Then with my other hand, I poured the alcohol down my throat. To my

amazement it didn't taste like anything.

"Now was that so bad," my dad said in a chuckle and patted me on the back. "How 'bout another one?"

"Sure thing pops," I said returning his pat on the back. I emptied the next glass that was placed in front of me...and the next...and the next. Before I even realized it was happening, my dad and I had our arms around each other, while we loudly and awkwardly sang various parts of the song "Louie, Louie." After the song was over my dad helped me down from the barstool. When I touched the ground and began moving, I realized how incredibly strange I actually felt. I could not feel my legs beneath me and my left eye would not stop blinking.

I followed my dad and as I walked everything appeared blurry and everyone, including myself, seemed to be moving extremely slow.

"Hey there kiddo," I heard someone say. I turned around just in time to see my normally buck-toothed and grossly unattractive neighbor, Sue, passing by. But to my surprise, she looked really, really good this time. We kept walking until we stopped in an especially dark corner of the bar where no one was around. My father knelt down next to me.

"Have you ever heard of pot?" he asked as he reached into his back pocket, pulling out a small plastic bag. I saw someone do it on television once, but I had to shake my head in disbelief as I stood and watched my father roll a joint. When he was finished, he took out a lighter from the inside of his suit coat and in the next motion, lit the end of the rolled up paper. He took a big, long drag and looked at me. With his voice choking he said, "Here... take this."

I took it from him, put it to my lips and inhaled, exactly as he had done a moment before. We passed it back and forth again and again. When there was no more left to smoke I began laughing uncontrollably and my dad was doing the same. The next thing I knew I was staring down at the floor. I felt as though I was floating in mid-air.

"Dad, why is the...floor so...far down?" I managed to

stammer out.

"Because you're high son!" my dad said, still laughing hysterically.

"Wow, this is great! I'm high! I'm high!" I exclaimed.

"And don't forget drunk too!" my father yelled at me. "Don't tell your mother!" he added.

Suddenly, I was sitting in a chair. I couldn't see my dad any longer and the music had stopped. I couldn't hear the men laughing or playing pool and I watched as the smoke cleared the room. Everything became brightly lit. My head was becoming clear again. I felt someone standing in front of me...it was my father. He bent down, looked me straight in the eye and said in a quiet voice, "Now how do you expect to go to Harvard when you're getting a C in Spelling."

I didn't know what to say, I just stared at him blankly.

"Well, what do you have to say for yourself?"

With my head sinking to the floor I said quietly, "Sorry dad. I won't let it happen again."

"From now on, you're doing your homework immediately after school and I'm going to look over all of it," he said flatly, folding up the report card and putting it into the inside of his gray suit coat. "Now go outside and finish cutting the grass. And don't rush it. Take pride in your work. You have to learn that you can't just goof off and expect to succeed in life. We'll discuss this some more later." With that, he walked out of the room.

Dream

by Yelena Shtern

I walked out of that damned store sure of my direc-
tion. I walked, leaving behind a hard day of work, worry, and
wait. I was so tired and determined to get home as soon as
possible. It was Saturday; our busiest day and Cathy spent
the whole day yelling at us dumb employees. She's the owner
so there's not much we can do. If she decides that she doesn't
like you, you're a goner. So I walked, leaving a headache
behind me. I was at the end of the block when I stopped in
my tracks. I had to go back. I ran. There was a very strange
feeling in my stomach, like I forgot something very, very
important.

The entrance to the store was gone. There was no
trace of it ever being there. I walked back and forth, con-
fused, feeling a bit high. When I turned the corner I saw
Mike and Summer standing there, making out. What the hell
were they doing here? I ran, ran. Everything was spinning
in front of my eyes. Wow! There it is! There's that damned
door! I stopped in front of it. Why was I here? Why did I
waste all that time looking for it? Stupid. Stupid. I felt so
stupid.

I walked with Summer and Mike to the train station
to take the red line home. I was getting on the train, then the
next thing I knew— I was driving on Lake Shore Drive, in a
hurry to get home. As I passed a curve, I realized that I was
going way over the speed limit. The car was very hard to
control. I eased off the accelerator, but the car did not slow
down. I tried pressing the break pedal, only to find out there
wasn't one. Instead, there was another accelerator. I kept
pressing it, I don't know why. I was going so fast, it seemed
that any second I would fly. It was totally dark now; I was
the only one on the road.

From somewhere above I was watching myself. My
face had a strange expression. I didn't look scared, although I

was. I was smiling one of those evil looking smiles. Suddenly, I wasn't a sixteen-year-old girl any more. I was old with white hair and wrinkled face. I kept driving, driving. Then the car started to slow down, finally coming to a full stop. It was out of gas. I pressed my wrinkled face against the wheel. I was dying. There was hurt somewhere deep, deep inside of me. So I ran to the car. Are you all right? Are you all right? I screamed to the old woman with white hair. She looked up at me with her brown eyes– eyes just like mine. Then, she smiled.

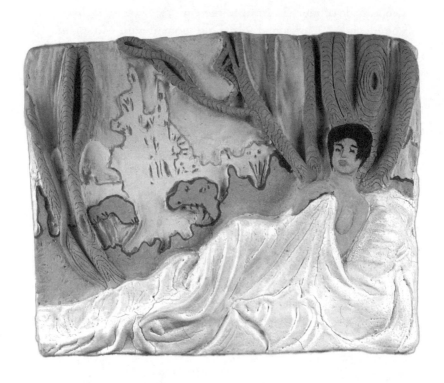

Scared

by Andrea Thomann

I get scared when something touches me, touches the deep part inside. Because I know someday when I had just learned to love it, it will be torn from my soul. Maybe my flu-like symptoms are effects of the girl who was pushed out of my heart– by circumstance. Perhaps, I'm walking through the world in a buzzed haze because I want to avoid: avoid the deep part inside, avoid the painful love inside.

Avoidance can only lead to madness. If you don't mind pushing away the inevitable until it hits you like a ton of bricks, I suppose it's fine. Personally I like to deal with it right here and now. But what do you do while you're waiting for a love to die? I want to deal with it now, while I'm strong. I don't want to be waiting forever.

How does love die? Does it just sit in your heart until it disintegrates of old age, of inactivity? I wouldn't be so curious if it weren't for my aching heart, of a love that's unrequited and unheard. Tell of your love, is that what you say? Sing it from the mountain tops? Sorry, it's simply not done in situations that contain a lesbo in love with a straight girl, who just happens to be her "good" friend. It's unheard of in my parts. It's not the type of thing that's written up every day in *Seventeen*. I can't ask my mom or dad. That would mean coming out first. Besides, knowing my parents really would not understand, more or less want to talk about such things with their daughter, the freak. I guess I'll just have to wait for it to end.

Esperanza
by Rocio Vallejo

Esperanza was her name, that little Hispanic girl that moved up and down the rocky cement ground, jumping from square to square singing, "uno, doce, trez." She lived there, there in that red brick house on the corner where a black painted fence chipped away. The fence that stood there enclosed conflicts that lingered throughout the tamale reeked home.

Huey's yell interrupts sweet innocent Esperanza's singing, "Tengo una muneca vestida de azul." "Cabrona I's talking to you, get your ass over here." Esperanza's heart pounded faster, she continued jumping and singing, "Con zapatos blancos y medias de tul." "Girl don't you hear me?" Esperanza whispered to herself, "Five more minutes, just five more minutes." "Don't make me get off this stoop, or you'll really feel the belt this time." Huey holds his cigarette between his thumb and index finger, bringing it up to his cracked lips. He takes a couple of puffs. In his left hand he holds a half-empty bottle of corona, his third one in the hour. He gulps heavily, so heavily, that beer streams over the sides of his mouth down to his chin. He uses the back of that same hand to wipe his mouth. Esperanza can hear him calling still from behind, she drowns him out, still singing, "La llebe a el paseyo." "F— all this! Girl you just wait, your ass is getting a beating." Esperanza felt her drunken step-father come closer as he staggered down the concrete steps of her sweet red-bricked home. The sun's heat hit this body-odored man, causing sweat to bead down his face. He worked his way to Esperanza, "I thought I told you to sweep la calle." "Why don't you listen to me, I's your daddy or ya think I'm not good enough for your pretty little ass?" "La puse en la cama." She sang louder and louder as Huey got closer.

She could almost smell his sticky body and almost

feel his drunken breath seep down her back. Huey stood behind her now, stopping her jump rope from twirling. Esperanza turned cold, her mind thought run, her body stood still. Huey lifted his hand in the air and let it go, slapping Esperanza's skinniness. He thrusted her arm, shaking her, "Get your ass in—" There she was, finally she turned onto the block.

Beautiful, yes, she was beautiful, curvy, big breasted. She walked like she was dancing, her hips jumped from side to side. Her long black hair moved in the wind, her eyes full of pain, she wore a smile. Huey stopped shaking Esperanza, his hand still tightly locked around her arm. "Mommy," called the child. "Maria Ohena, please baby, tell this thing, this daughter of yours to do her chores." "She sits out here all day singing and jumping, jumping and singing." Huey swayed his hand that held his sweet Corona, back and forth. "Arturo, please honey, leave Esperanza alone, she's only a child, only nine, she's my baby." "I's your baby woman, you treat her better than you treat me", Huey interrupted her. "Ok Arturo, I'm sorry. Mija, please run inside and get me my silver clip so that I can put my hair up, and bring me the broom and the pala." Esperanza ran inside, and into her mother's room. She rummaged through her mother's jewelry box. She felt something round, something smooth, she brought it up to her sight. A ring, a silver ring, plain, solid. Engraved in the inside read, mi amor siempre, my love always, Salvador. Esperanza's eyes lit up, a ring from her father. Her eyes drifted to the picture surrounded by dry rose petals that hung in the corner of her beloved mama's jewelry box. Esperanza took the ring and stuck it in the pocket of her sky blue dress. She quickly picked the silver clip her mama asked for and ran into the kitchen.

She passed the garbage can, corona and vodka bottles surfaced the top, surrounded by cigarette butts. She grabbed the broom and the pala. "Esperanza", called her mama from the doorway, "Mija que haces, hurry up." Esperanza

scrambled out the front door, passing Huey, who lay on an orange couch in the living room. One arm tightly covered his eyes, the other arm lingered over the end of the couch, and still he held his sweet corona. "Esperanza," he called roughly behind her, "Mija wait, pinche girl, just wait."
"Esperanza, mija what was Arturo doing outside here with you when I got home from work?" asked Maria, now outside, sweeping the sidewalk. Esperanza sat with her elbows resting on her knees, her hands cradling her head, "Nada mama." "Mija!" "The same old thing mama, he was telling me to sweep." "Listen to me ok, Esperanza, you only listen to him if what he is saying sounds right to you, you hear me child."
"Maria ohena," interrupted Huey, "Your hermana just called she said for you to get your ass to your mother's house, esta enferma la bieha," he laughed. Maria's face went cold, she dropped the broom and ran inside, and quickly she ran back out, bus money in her hand. Walking to the bus stop she turned around and called behind her, "Hija I love you, I'll be home soon," she blew her daughter a kiss and continued to walk away. Esperanza finished her mothers sweeping outside and carried herself up the concrete steps of her home. Esperanza entered the kitchen and began to sweep. Dragging footsteps interrupted the thoughts of her ill grandmother. The smell of cigarette smoke and alcohol became strong to her nostrils. Esperanza took a deep breath.

section four

SCENES FROM ANY YESTERDAY

An excerpt from

Chris and Mary
by Jesus Trzek

INT. LIVING ROOM

CHRIS takes a deep breath and examines himself in thought.
He looks over to the phone and smiles. He gets up by the
phone and grabs the phone book, sits back down on the
couch putting the phone book on his lap. He picks up the
phone and starts dialing.

As it rings:

 CHRIS
 Uh, what the hell.

A party on the other line answers. It is the voice of a girl,
Mary.

 MARY
 Hello.

 CHRIS
 Hi Mary it's me Chris.

 MARY
 (whispers) How did you get this number?

 CHRIS
 From the phone book.

From off screen we hear a man's thick, scratchy voice.

 MAN (O.S.)
 Who the hell is it? I thought I told you not
 to answer the phone.

 MARY
 It was a wrong number.

She hangs up.

Chris removes the receiver from his ear and looks at it.
He hangs up with his free hand and hits the redial button.

The phone rings once again. A man answers.

 MAN
 What do you want?

 CHRIS
 May I speak to speak to Mary?

 MAN
 No.

He hangs up hard.

 CHRIS
 Oh, man.

FADE:

INT. SCHOOL CAFETERIA - DAY

Mary does not see Chris enter the room and
stand behind her. He looks at her for a while,
then walks around to her and sits down.

 MARY
 (cries) I am so sorry. The way I treated
 you was wrong.

 CHRIS
 Is there somewhere we could go out?

 MARY
 My stepfather wouldn't let me.

 CHRIS
 Why not?

 MARY
 Because... He's mean.

 CHRIS
 Could we talk to him?

 MARY
 He wouldn't get it.

 CHRIS
 Why does he treat you the way he does?

 MARY
 Because my parents got a divorce.

 CHRIS
 Oh, that's why?

 MARY
 Yeah.

Chris holds her hand.

 CHRIS
 Are you telling me the truth?

Mary says nothing.

 CHRIS
 Come on, tell me.

 MARY
 He expects me to... oh Chris, it's terrible.

 CHRIS
 What Mary?

 MARY
 I have to go straight home from school.
 I'm not allowed to leave the house, ever,
 and I have to... do everything he says.

Chris hugs her.

 CHRIS
 Come stay with me.

 MARY
 Run away?

 CHRIS
 You could stay at my house.

 MARY
 What about my stepfather?

CHRIS
Who cares.

Mary stays quiet, thinking about it. She gets up and packs all her books. Mary and Chris walk out.

FADE:

INT. MARY'S HOUSE — DAY

LIVING ROOM

Mary and Chris enter the living room. Chris puts his arms around her. They lie on the couch. Just as they are about to kiss, OFF SCREEN: Someone coming home and opening the door. Mary and Chris look at each other scared. They sit up.

CHRIS
Who the hell's that?

MARY
Oh no, it's my stepfather.

CHRIS
Let's leave through the back.

The door opens. It's Mary's stepfather, he is incredibly angry and drunk out of his mind.

STEPFATHER
Mary. Oh Mary honey, I'm home. (notices
Chris) Who is this? You have ten seconds
to get out of here.

They stand up, Mary behind Chris. They stand still.

STEPFATHER
(to Chris) You're going to wish you were dead.

He punches Chris causing him to knock over a lamp. They begin to fight. Chris punches him a couple of times, but he is knocked to the floor. The stepfather kicks at Chris while he's on the floor. Chris gets up and subdues him. While the stepfather struggles to regain his composure, Chris grabs Mary by the hand and they run out of the house.

An excerpt from

This One Time

by Mary Mikel

INT. RESTAURANT — DAY

MONICA, 18, hard attitude, and MARIBEL, 18, mostly a
follower, are out celebrating with LUPE, 18.

With a big smile, Lupe has a cheeseburger in front of her
face. She takes a big bite.

> LUPE
> Mmmm! Man! I can't remember the last
> time I had food this good.

Sitting next to Lupe, Maribel glances around to make sure
no one is looking. She pulls a gun from her sweater pocket
and puts it on the table. Monica smiles, picks it up and looks
at it. Maribel turns to Lupe.

> MARIBEL
> Tomorrow night we're gonna hold up a
> store, you in?

Lupe sits back in her seat and takes a deep breath.

> LUPE
> I just spent three years in juvie, I'm
> not going back.

> MARIBEL
> You won't get caught.

> LUPE
> It's bad in there, they...

> MONICA
> Ok! I don't want to hear about your
> days in jail. Are you in or not?

Monica pushes the gun toward Lupe. Lupe watches Monica
as Monica touches her stomach. They meet eye to eye.

> LUPE
> It's this one time, right?

EXT. ALLEY — NIGHT

Maribel, Monica, and Lupe are peeking from behind a dumpster.

> MONICA
> You see that little convenience store up
> ahead? That's our target. Who's got the gun?

Maribel pulls it out. Monica takes it and hands it to Lupe.

> LUPE
> I don't want it. It wasn't my idea.

She turns to Maribel.

> MARIBEL
> Don't look at me, I don't want it.

She pushes it away.

> MONICA
> Lupe.

> LUPE
> Why can't you do it, or Maribel.

> MARIBEL
> I have a bad arm. I can't hold the gun.

> LUPE
> Why can't you do it?

> MONICA
> Let's just say you owe me.

Lupe strips it from her hands.

> LUPE
> Let's just get this over with. Ready?

The girls put on their masks and follow behind her.

INT. STORE — NIGHT

Lupe points the gun at the clerk, an elderly man.

> LUPE
> Freeze! Put your hands up.

 CLERK
 Please! Don't kill me.

 LUPE
 If you don't shut up, I will.

Monica and Maribel go behind the counter, open the
register and take the money.

 CLERK
 I just started this job...

 LUPE
 Shut up. Do you want to live?

The man's hands shake as he nods his head.

 LUPE
 Then stop talking. And we'll be gone.

 MARIBEL
 There's not a lot of money here.

Lupe looks in the register and up at the clerk, pleading.

 LUPE
 You have to have more money.

 CLERK
 No, I don't. Whatever's in here is all I have.

Monica takes the gun from Lupe and shoves the gun to the
clerk's neck.

 MONICA
 I know you have more money. If you
 want to live you'll tell me.

 CLERK
 Ok, ok. There's a safe in the back.
 The number's 12 - 36 - 5.

Monica takes Maribel with her. Lupe holds the gun to the
clerk.

 LUPE
 Don't move.

Lupe turns, looking at the door. She turns back and finds the clerk holding a gun at her.

CLERK
How does it feel being on the other end?

The clerk shoots but misses her. She runs behind a shelf and shoots back. Things are quiet. Lupe spots the clerk in a security mirror sneaking behind her and shoots him. Monica and Maribel come out.

MARIBEL
Lupe, are you...

They find her staring at the body with her mask off, they both take off their masks.

MONICA
Is he dead?

Lupe nods her head. Police sirens are heard. Maribel taps Lupe.

MARIBEL
Come on the cops are coming.

She's doesn't move. She grabs Lupe's arm.

MARIBEL
Come on.

They run out the door.

EXT. STORE — NIGHT

In a split second, Lupe turns her head and meets eye to eye with a man. A couple blocks from the store, Lupe stops and vomits, Maribel goes to comfort her. Monica lifts her shirt and touches a small scar on her stomach.

MARIBEL
Lupe, are you ok?

LUPE
Yeah. Let's go before we get caught.

INT. ABANDONED WAREHOUSE — NIGHT

Lupe has her back facing them. She rubs the back of her neck. Monica and Maribel take their money and put Lupe's share on the crate. Monica eyes Lupe suspiciously.

 MARIBEL
 Why do you have to mess with her?

 MONICA
 Am I messing with her?

Monica walks up to Lupe.

 MARIBEL
 Monica.

Maribel hangs over the back of the sofa watching. Monica rudely pushes Lupe with one hand.

 LUPE
 What the hell's your problem?

 MONICA
 My problem. I was going to ask you the
 same thing. You never cared about anyone
 before.

 LUPE
 That's because we just robbed them and
 fled. An innocent man died back there,
 and we killed him.

 MONICA
 We! No, you killed an innocent man back
 there. We had nothing to do with the killing.

 LUPE
 Now you're gonna pin all this on me?
 No way.

 MONICA
 So what now, are you going to run to the
 cops and snitch, you little b--.

Lupe punches Monica in the mouth.

 LUPE
 I told you, never call me that.

Monica wipes the blood from her lips.

 MONICA
 B---!

Monica punches Lupe and they fight. Maribel jumps over
the sofa and breaks them up.

 MARIBEL
 Hey! Stop it. We're supposed to be friends.
 You two use to be so close, what happened?

 MONICA
 She happened. Ever since she got out,
 she softened up.

 LUPE
 I learned a lot while I was locked up.
 Now we have to worry about the cops.
 This time I'll get locked up for good, if I
 don't get the chair first.

They're all quiet for a while. Monica walks up to Lupe and
puts her arm around her.

 MONICA
 Nothing's going to happen. Listen, I'm
 sorry about what I said. I'm glad you're
 finally out. I just wish I could have shown
 you in a better way.

 MARIBEL
 Every things alright now? We'll get through
 this together.

Lupe looks up at Monica and smiles.

 LUPE
 Yeah!

 MARIBEL
 Good, let's get out of here, I'm hungry.

Just Look Deep in Your Heart
by Aracely Sandoval

Francis walks to the dresser. A man he doesn't recognize stares back at him in the mirror. Slowly he places a Roman collar around his neck.

> FATHER FRANCIS
> Oh, God. What have I done?

INT. VICTORIA'S APARTMENT DAY

Father Francis sits on the couch swirling coffee in a cup. Victoria sits on the edge of an easy chair.

> FATHER FRANCIS
> I, I have to tell you something.

He covers his face with his hands and shakes his head slowly. Finally, he takes a deep breath.

> FATHER FRANCIS
> I want you to forget about everything.

Victoria shoots up from her chair.

> VICTORIA
> What!? Tell me why!

Father Francis stands up. He looks out the window at the dark grey clouds.

> FATHER FRANCIS
> I get so frustrated with this situation.

> VICTORIA
> But last night.....

> FATHER FRANCIS
> Don't you understand?! This is over!
> It shouldn't even have started!

Victoria nervously collects the dishes.

> VICTORIA
> It's too late now! You have disgraced your

family and your friends! Even if they don't
know what you and I have done.

Father Francis spins her around to look at him. Victoria's
eyes tear.

> FATHER FRANCIS
> Damn it! You think I don't know what I
> did is wrong?!

He yanks the door open.

> FATHER FRANCIS
> Just forget it.

> VICTORIA
> Wait, don't leave.

He walks out and slams the door.

EXT. STREET NIGHT

Father Francis walks in the heavy rain. As he pulls off his
collar, he accidentally bumps into a man.

> MAN
> You idiot! Don't you know where you're going?

Father Francis ignores the man and crosses the street. A
car swerves to miss him.

> DRIVER
> You son of a b—! Are you blind or
> something?

Father Francis walks in a daze. He sees Victoria across the
street and cowers behind the person next to him. He finds
himself in a park.

EXT. PARK NIGHT

Father Francis sits down on the bench. An old man sits
next to him with a plastic bag over his head.

> OLD MAN
> It's kind of rainy, don't you think?

Father Francis pays no attention to him. The old man waves

his hand in front of the priest. Father Francis turns to him.

 OLD MAN
 You know? It's much more beautiful when
 the sky is clear. I love looking at the stars.
 I guess I would say it just makes me happy.
 How about you?

Father Francis scrunches himself further down into his
jacket.

 OLD MAN
 Women are like stars. Well, to me of course.
 They're beautiful like the stars. They're bright.

The old man laughs.

 OLD MAN
 But damn it, they could just sometimes be
 a pain in the ass.

Father Francis turns to the old man.

 FATHER FRANCIS
 What?

 OLD MAN
 Yeah, they can be as gorgeous, splendid
 and sometimes nice. But they could also
 be a big pain in the ass. Except you don't
 think that when you're in love. 'Cause damn
 it, it hits you really hard.

 FATHER FRANCIS
 What do you mean?

 OLD MAN
 Son, don't tell me you have never been
 in love.

 FATHER FRANCIS
 Well, I don't know. I think I am.

 OLD MAN
 Is it her family? Is it yours?

Father Francis nods.

OLD MAN
Let me tell you. Women are special. They
are here...well... to make us happy. We as men
are to love them in as many ways as we can.

FATHER FRANCIS
I don't know anything anymore.

The old man gives Father Francis a serious look.

OLD MAN
Just look deep in your heart. Try and find
your answer there. As hard as I know it will
be, the harder it will be if you don't.

He turns to the old man.

FATHER FRANCIS
How do...

The old man is gone. He looks around the park to see
where he went, but it's too dark to really see anything.

INT. PRIEST'S BEDROOM NIGHT

The priest takes off his wet clothes. The door starts to
open slowly. He goes to see what it is. He opens the door
and sees Victoria. She closes the door and hugs him tightly.

VICTORIA
Oh, I'm so sorry. I didn't mean to be so
cruel. Its just that I don't ever want to lose you.

He closes his eyes, grabs her hair and smells it.

FATHER FRANCIS
You shouldn't have come.

He starts to kiss her neck gently. He pulls himself away
from her.

FATHER FRANCIS
I'm tired, please, just leave.

She nods her head slowly with a sad look.

FATHER FRANCIS
Please, just go.

She gives him a hug. They walk towards the bed and sit.

> FATHER FRANCIS
> Look, this isn't going to work. I've tried
> hard to figure out what I'm going to do,
> and God knows I have.

> VICTORIA
> I know if we try really hard we can make
> it work. I know we can. All those things I
> said in my apartment, well, I didn't say
> them to hurt you. You've made me the
> happiest woman in the world ever since I
> met you. All I want us to do is be together.
> That is all I ask for.

She puts her head down with tears on her cheeks. He lifts
her head back up and gently kisses her on the lips. He sadly
looks at her.

> FATHER FRANCIS
> I'm confused. I wish I had an answer. It is
> very hard for me, and you know this.

> VICTORIA
> But...

> FATHER FRANCIS
> But what? I'm sorry but I can't take
> this anymore. Just go. Go now.

He gets up and pulls her up. He walks her to the door.

> FATHER FRANCIS
> I'm so sorry. I didn't mean for it to be
> this way. Now please go.

She wipes her tears and walks toward the door.

> VICTORIA
> Alright, I guess there is nothing I can do
> anymore. But remember this, I love you
> now, and I always will.

Father Francis gives Victoria an agonizing look. He watches
her walk out of the door.

An excerpt from

Making Choices
by Jose A. Toledo

EXT. DAY, STREET CORNER.

DAVID meets JUAN and the gang.

> JUAN
> I thought you weren't coming.

> DAVID
> Well you thought wrong.

> JUAN
> So what's up, are you going to join
> in or what?

> DAVID
> I guess I have no other choice.

> JUAN
> I talked to the leaders a minute ago,
> and they told me that you get to be part
> of the gang the moment you accept my
> invitation.

> DAVID
> So I guess I'm officially in the gang and
> you're now one of the leaders.

> JUAN
> That's right, I'm one of the leaders, and
> you're one of us now. Don't worry,
> we'll protect you, and your mother. You're
> part of the family now.

> DAVID
> So now what?

> JUAN
> Don't worry man, we'll give you your
> welcome party later. Right now we
> need you to represent your gang.

DAVID

How?

JUAN

We need you to throw our gang sign
up in the air to every car that passes by.

Suddenly a car of the rival gang passes, David throws his
gang sign up, the other gang members see it, they pull out a
gun. Shots are fired. David falls to the ground.

INT. NIGHT, HOSPITAL.

David lays on the bed and his mother sits close to him
crying for her son.

DAVID'S MOTHER

(crying) Why? Why, did you have to get
in a gang, was there something I did or said
that made you change your life? I always
thought you were a good kid and suddenly
I find out that you were shot because of a
stupid gang.

David starts to wake up.

DAVID'S MOTHER

(crying) What did I do wrong?

David wakes up and looks at his mother crying.

DAVID

It wasn't your fault mom, it was mine.
I did it because they threatened me, they
said that if I didn't get in the gang they
were going to hurt you, and I didn't want
that. So I decided to join the gang.

DAVID'S MOTHER

Why didn't you tell me. I could have helped
you and none of this would have happened.

DAVID

I didn't want to worry you with my
problems. I thought that everything
was going to be the way I wanted.

DAVID'S MOTHER
But your problems are also my problems
and you should've told me about it.

DAVID
I know and I'm sorry for not doing that
and I'm sorry for hiding things from you.

DAVID'S MOTHER
Don't worry I already talked to the
doctor and he said that everything
is going to be okay and that in a
few days you'll be able to go home.

DAVID
That's what I would like to do, go
home, pack things up and leave.

DAVID'S MOTHER
Leave? And where are we going to go?

DAVID
I don't know, but what I do know is that
I'm not staying there. I'm going to find
you a better place to live where it's safer
and we can all live in peace.

DAVID'S MOTHER
Let's just wait until you get better so we
can move out of that place, and start a
new life.

EXT. DAY, DAVID'S HOUSE

David is packing up putting his things in the car. He's ready
to leave with his mother, when suddenly Juan comes by.

JUAN
Hey, man I thought you died?

David puts his bag in his car.

DAVID
Well I didn't, I'm still alive.

Juan sees David packing up his bags.

JUAN

Hey what do you think your doing?

DAVID

What does it look like, I'm leaving.

JUAN

(surprised) You're leaving?

DAVID

Yeah, you heard me, I'm leaving.

JUAN

You can't leave man, you're one of us man,
you're family. If you leave they won't make
me one of the leaders. You can't leave.

DAVID

Oh, I'm part of the family.

JUAN

That's right.

DAVID

And where was my family when I got shot?

Juan looks down.

DAVID

What now, you don't remember? I got
shot and everybody ran, not even
looking back. Is that what you call family?

JUAN

We had to run man, if we just stood
there we all could'a got killed.

DAVID

Well I don't care no more, I'm leaving,
and you can stay in your gang all the
time you want to, but I'm not.

JUAN

So, you think you could just leave
the gang like that man?

103

DAVID
Well that's what I'm going to do, if you
don't like it, it's your problem not mine.

JUAN
You don't understand man, you can't
leave, once your in, there's no way out.

DAVID
Look man, I'm tired of your threats, and
this time I'm not going to fall for it.

JUAN
You don't really know me, David,
when I mean something I mean it, and
that's the way it has to be.

DAVID
I'm sorry man, but there's no other
choice for me, I'm leaving and I'm
taking my mom with me to a better
place where–

Juan interrupts David

JUAN
(sarcastically) There is no better place!

DAVID
That's what you think, and maybe
that's why you're here, you think this
is where you belong.

JUAN
And I'm right, this is where I belong.

DAVID
Well I don't, and that's why I'm
leaving, because I don't belong here.

JUAN
So that's it, you think you could
just drive out and leave.

David turns around and walks towards his car.

DAVID
Watch me.

As David turns Juan pulls out a gun and points it at David's head.

JUAN
If you leave you die. If you stay you live.
Make your choice.

DAVID
Why don't you make that one for me.
I'm tired of making choices.

As David says that he starts walking towards the car. Juan looks down to the ground holding up the gun, then he looks up and shoots. David falls to the ground for the last time.

Secret Embrosia
by Crystal Carlson

FADE IN:

EXT. ANGEL CLIFF NIGHT

EMBROSIA, divine, beautiful, funny, sits in her car seven feet away from the edge of the cliff, crying. The night is cold and it's raining.

> EMBROSIA
> Why must it be me? "It is your allegiance." They say. Well not anymore.

She slams her fist on the steering wheel.

> EMBROSIA
> I can end it all now. Just the edge of the cliff between me and death down below.

She rests her head on the steering wheel.

> EMBROSIA
> Now is the time to get it done. It must be done. It's simple and quick. It's right.

She stares at the edge. She presses gently on the gas pedal, forces it to the floor.

> EMBROSIA
> This is it!

DEREK, 43, tall and skinny, advanced investigative skills and a sharp insight in the paranormal, driving by, sees the car drive off the cliff. He grabs his phone.

INT. HOSPITAL DAY

Embrosia awakens. The blinding light blurs her sight. The blur clears. A DOCTOR enters the room.

 DOCTOR
Hello. How are you feeling today?
You've been unconscious nearly a week.

 EMBROSIA
Where am I?

 DOCTOR
You're in the hospital, honey. I heard
you were in a nasty accident. Your name,
please?

Embrosia rubs her forehead.

 EMBROSIA
My name is Embrosia. Embrosia...
that's all I know. I don't know my
last name. Tell me my last name.

 DOCTOR
When you came in you didn't have any
I.D. We took tests, and found that
you have amnesia.

 EMBROSIA
Amnesia!

The Doctor writes on his clipboard. Derek walks in.

 DEREK
Hello Doctor. My name is Derek Rayne,
we spoke earlier over the phone.

 DOCTOR
Oh yes, the one who reported the accident.

 DEREK
That would be me. I was wondering,
how is she?

 DOCTOR
She's fine. You can take her with you now.

Derek and the Doctor walk out.

EMBROSIA
Wait a minute...

INT. LUNA FOUNDATION DAY

RACHEL, 39, short, intelligent psychologist, giving and
outgoing.

Derek and Embrosia walk in. Rachel meets them
at the door.

RACHEL
So, you're the one Derek spoke of.
Hello, my name is Rachel.

EMBROSIA
Yes, of course. Derek told me all
about you on the way over here.

Embrosia shakes her hand.

DEREK
Well, let me take you to your room.

Embrosia nods.

EMBROSIA
Bye.

Rachel smiles and watches them leave.

SUPER: THE NEXT DAY

INT. BEDROOM MORNING

The ENTITY is a mysterious, ghostly essence that appears to
Embrosia. Embrosia brushes her hair. The mirror reflects
a black shadow in the beam of light, mid-air in the middle of
the room. The shadow takes the shape of a translucent
human. She turns around.

EMBROSIA
What the hell are you?

The Entity moves toward her and holds its hand out to her.
It groans. She is frightened.

 EMBROSIA
 Get away from me!

She faints. The figure disappears.

EXT. COURTYARD MORNING

Rachel and Embrosia walk together.

 RACHEL
 It's beautiful out today. Do you
 think so Embrosia?

 EMBROSIA
 Yes. If only I knew who I was, I'd
 be with my family, if I have one.
 Or maybe at the beach with my dog or
 something. I wish I could remember.

 RACHEL
 What about hypnosis? Would you like
 to try that?

Embrosia stops under a tree. Rachel leans on the tree.

 EMBROSIA
 Hypnosis, what's that?

 RACHEL
 Well, a person goes to sleep and we make
 them remember things. Sometimes it works
 and sometimes it doesn't. Most times it does.

 EMBROSIA
 I don't think so. I don't think I
 want someone playing with my brain.

 RACHEL
 Ok. I'm not gonna pressure you. If you
 feel that you do, come to me anytime.

 EMBROSIA
 Ok, I'll remember that.

Rachel and Embrosia walk toward the house. They go inside.

INT. SECRET ROOM DAY

Embrosia stares at the primitive map of the world hanging on the wall. A thin, red beam of light shines into her right eye.

 EMBROSIA
 What the hell?

She jerks her body away, loses balance, falls through the wall onto the floor in the room behind it. She looks around. Computers are everywhere.

 EMBROSIA
 What the hell happened?

She is startled by the sudden voice of a computer.

 COMPUTER
 You entered our secret room. You
 just passed through the hologram.
 What is your purpose?

 EMBROSIA
 Wow, a talking computer.

She moves closer to the computer screen.

 EMBROSIA
 Um... how about showing me things
 about the people that work here.

The computer brings up a number of files.

 COMPUTER
 Choose a file.

 EMBROSIA
 What is the Legacy?

The computer shows her the contents of the file. She gasps in surprise.

 EMBROSIA
 So, the Legacy fights the supernatural.

She looks around at all the other computers.

 EMBROSIA
 Hey, maybe I can do the stuff this
 thing talks about too! Let's see!

She concentrates on a vase, it doesn't budge. She squints
her eyes concentrating harder. The vase shakes calmly.
She squints harder. The vase shakes wildly. It falls over,
hits the floor, breaks.

 EMBROSIA
 Wow! That was so cool! But did I
 really do that?

Derek walks in.

 DEREK
 Who's in here? Embrosia? How did
 you get in here?

 EMBROSIA
 I fell in when I was looking at the map.
 Why did you bring me to the Legacy?

 DEREK
 What are you talking about?

 EMBROSIA
 It's ok, you don't have to play dumb
 with me. I know about the Legacy.
 The computer showed me.

 DEREK
 Ok, I brought you here because I
 wanted to find out what happened
 that night you drove over the cliff.
 I heard a noise; what was it?

She takes him over to the vase. Derek picks up a piece.

 EMBROSIA
 I did it with my mind...

INT. TESTING ROOM DAY

Embrosia sits at a table. Rachel and Derek hold up two
separate cards, front facing her.

EMBROSIA
Squiggly lines?

DEREK
That's good. So far you're doing
well. How about this one?

Derek holds up another card.

EMBROSIA
Um... a positive sign?

RACHEL
Ok, enough of these. They're too easy
for you. Let's move on to something
complicated.

DEREK
Do you think you could move a vase
again? We'll start with a light one. If you
get it, we'll move to a heavier one, ok?

EMBROSIA
Sure! Why not? It's gonna be easy!

Embrosia concentrates on the vase, it doesn't move. The
Entity appears. Wind picks up in the room, Embrosia is
distracted. The vase flies off the table, smashes against
the wall. Derek, Rachel, and Embrosia stand back.

EMBROSIA
Oh my God! What the hell are you?
Why are you bothering me?

DEREK
You've seen it before?

EMBROSIA
Yes, in my room, yesterday.

RACHEL
Why didn't you tell us? We would
have believed you.

EMBROSIA
It's not that. I was really scared
and I fainted. I didn't believe it
until now.

The Entity moves toward them. Embrosia glances at the heavier vase. It flies in the air, hits the Entity, the Entity disappears. The wind dies down.

 EMBROSIA
 Wow! What a rush!

 RACHEL
 Would you like to try my suggestion now?

Embrosia stares at her despairingly.

 EMBROSIA
 Yes.

back to the quietness

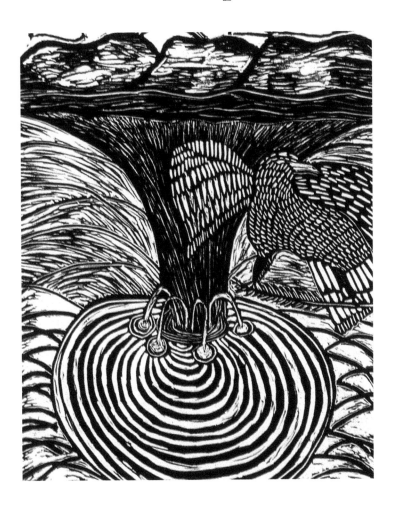

Alone

By yourself, one.
Play a one-person game.
Fun, boring, privacy, just you.
Alone.

Myself

Great, conceited.
Intelligent, sincere.
Playful, athletic, excited.
All-star.

Kenneth Collier

Enveloped

The events of today bind
Anger malice hate
these feelings are the wounds in my chest
though
I am strong
my restraint is true
the provocations of my own wounds are received
without falter

Yes, my strength is true– my God is true
my God is temperate– so very temperate
my succumbings to sin are coated– by Him
yet I do falter

not in my own temperance,
in my long lost innocence
my loss of appreciation
my loss of child-like forgiveness
child-like reverence
child-like unconditional love
child-like remission
child-like submission,

I falter in the fact that in some ways, I do not grieve
the absence of these child-like virtues, these restraints.

Virtues that when seen by themselves are allies
but when cast alone ill effect
that which they strive to achieve...

 ...is lost.

Richard N. Roberts III

1. MONEY
sounds like a penny dropping from the silver tower.
tastes like Red lobster and new Eddie Bauer.
smells like an old sour wildflower.
feels like I got more will power.
looks like we got a new car, to beat rush hour.

2. ABORTION
sounds like a murderer hollering a wimpy cry.
tastes like drugs that gets you high.
smells like a rotten pie.
looks like a baby going to die.
feels like why you make your baby go by-by.

3. TRIPS
sounds like kids having fun.
tastes like hot dog buns.
smells like new Air Force Ones.
looks like fun in the sun.
feels like a hole in one.

Erica Early

Picnic in the Ghetto

Bring the chicken and corn, the fruit, and Kool-Aid.
Bring the macaroni and cheese mama made.
Tell sis' to bring two blankets and the stereo too.
Bro' don't try to bring your crew.
Put on the "Off", 'cause y'all know the bugs are on.
Sis' don't put on that skirt, you ain't grown.
Bring the water jug
And the candles for the bugs.
Grab the hot sauce, chips and greens.
Don't forget the pig feet and peas.
Grab my belt 'cause y'all know y'all some fools.
We're going to have a picnic...

Falyn Harper

1. OLD PEOPLE
tastes like cake.
smells like moth balls.
looks like crickets.
sounds like crickets.
feels like sandpaper.

2. FLOWERS
tastes like sugar.
smells like perfume.
looks like new clothes.
sounds like birds.
feels like satin.

3. FAVORITE MOVIE
tastes like candy.
smells like show popcorn.
looks like fireworks.
sounds like music.
feels like sticky floors.

4. XICA
tastes like Haagen-Daz.
smells mellow.
feels like grief.
looks like a beggar.
sounds like a con man.

Xica Henley

A Trio of Triplets

I've always prayed for a true love.
Not just some little puppy love.
Still I have none of the above.

Why do you want to give me nothing but pain?
Do you have a reason or is this all in vain?
Tell me it is something you've got to gain?

Must I go on in this cruel life?
I feel like I'm being cut with the sharpest knife.
Must I stay here until my Lord arrives?

Marilyn Piggee

Remember Me

My dear child
I want you to know that I love you even on this day
When I'm gone. Your friends
are holding you, but let my love
hold you.
And remember me

for now I'm only a memory.
Child,
love me as I have tried to love you.
Weep for me today.
My love
isn't gone. In my heart I am still your friend

You were my dearest friend.
My favorite memory
of your love
is when you were trying to be the perfect child.
It was a Tuesday
and you told me that you

loved me. People say we weren't family, they say you
and I were just two crooked people
who needed friends.
Someday
they will recognize everything I taught you.
Don't you remember me
telling you that love is what makes a child
a child and I know you loved

me. And love
is what makes you
mine. I was your teacher so you were my child.

I was your friend so you were mine
because we both needed friends.
My memories
of the days

when you weren't there, are days
without love.
Twisted memories
of only the mirror saying I love you.
Because I had no friends
because I had a twisted face. And you were but a child

but love led your childish
innocence to me. And you became my friend
and let me see the days through your strong hazel eyes.
Always remember me.

Janet Feder

1. HAIR
tastes like nothing.
smells like oil.
feels like cotton.
looks like yarn.
sounds like popping popcorn when combing it.

2. WHIPPINGS
tastes like nothing.
smells like nothing.
feels like pain.
looks like whips.
sounds like whacking a horse.

3. POLICE
tastes like a pig.
smells like a dog.
feels like a human.
looks like people in black.
sounds like alarm.

Martin Pumphrey

Quietness

Finally, I have quietness after three years.
Finally, I don't have any kids shouting,
Or anybody that is annoying to my ears.
I can lay in my room and like Bernie Mac said in the
movie, *The Players' Club*,
"Buck naked," if I want to.
With the door closed and the fan on high and
Wouldn't have to worry about anybody coming
through.
But when I'm in quietness, some things are still loud.
Like the couple upstairs who are having sex
And he's doing all of the hollering.
Yet, I wonder why is this man so proud.
The kids next door are getting yelled at for leaving
their dishes on the table.
Homies in the basement bumping "Make 'em say
Uhh"
Because No Limit is the number one rap label.

But, back to the quietness.
It eases my mind and relaxes my tiredness.
Every poetic thought doesn't really need requirement.
But, I bet every poet's mind would love quietness,
quietness, quietness.

William Watson

The last time I can remember.
It was a cold party night in December.
It was the 5th, I think.
When I went to hear Ella sing herself pink.
Tonight I'm sporting my brand new mink, a sequined dress that's all that
And my big suede feather hat.
Clubbing to the same tavern on 35th street.
Pull up to the club, cats outside dancing to the beat.
Entered the tavern as the biggest big shot
Got a drink of Courvosier right on the spot.
Women staring, whispering behind their cigarettes.
"What's wrong sistas, never seen a fine bachelorette?"
Duke blowing, women scream and shout.
Count Basie banging the drums about.
And Billie shoop dooping without a doubt.
Big daddies come in with their lil' mommas dressed to impress.
And the woman with the short dress, getting free drinks is her success.
Now look at her, laid all over that bar trying to get some rest.
Here comes the pimps and players strutting their stuff.
Didn't bring their hoes so they wouldn't have to put up no fuss.
But tonight, it's all about who's best.
And if you ask me I think I passed the test.
Every five minutes that drunk man picks his fro'.
Saying, "time to go, time to go, time to go."

Antoinette Wiley

Chicago

Chicago, one of the best known cities. The blanket of almost all the races in the world. The biggest and most lively city. Home of Al Capone, the notorious gangster. The Sears Tower, the tallest building. Home of the six-time world champion Chicago Bulls. Home of Wrigley Field and its hot dogs.

So much tradition, home of culture. Chicago, the best known city. Chicago my hometown. Home of the Blues, because we know how to get down. The home of the movies and our Hollywood. I love Chicago with its background. This is my state of mind, my own sense of place.

Chicago, my town, my own place. To do things I want to do. It might be violent at times but still it's my town. The only place where I feel safe. The only city with my ethnicity. Chicago, my very own town.

Yinka Giwa

Standing on the rough
Yellow sand.
Feeling dark inside.
It rained but I couldn't
Go anywhere.
I felt many staring eyes
But there was nobody there.
I wanted to be in the rain
To get my anger out.
As it got more blurry, the
water looked like turquoise.
It was scary but I
Also felt free being where I
Wanted to be.

Saveth Som

A Dream

I am walking down a desolate stretch of pavement in some foreign country. All of a sudden I appear in the middle of a public bath house surrounded by beautiful women. First I feel lust and then fear. Why? I don't know. I touch one of the women and she turns into a He-Man action figure. I go around and touch all of them and they all turn into He-Man figures. I look up and there's a giant mushroom with a rosary around its "neck." The mushroom asks me what religion and sexual preferences are. I reply, "I don't know." The mushroom says, "You are a heterosexual Jew," and I say "O.k.," and turn around. I realize that I am no longer in the public bath but instead I am in a bingo hall with a room full of Orientals singing "Ten Little Indians." I go to the front of the room, say "Einsterzinde" and set the place on fire.

Seth Sher

Cat

Cat
Beautiful, lazy
Running, eating, jumping
I like the cat.
Lucy.

Mom Dy

That Raining Morning

That raining morning
I had anger in my heart
And it felt like sand
Dry and soft.
Those dark blue eyes
were just above that sky
Looking right
at me.

Luz Maria Navares

Mother

Mother
Smart, fear
Cooking, yelling, working
She makes us food
Intelligence.

Shoes

Shoes
Cool, dirty
Wearing, jumping, running
They protect our feet
Nike.

Keo Sok

Why are so many people
against rap music, it's
Just people reading
Poetry. Just because they swear and talk about
The honies they meet. People
Say that they can't
Understand what they are
Saying but I feel
The same way about your
Music and I don't say
A thing, so why are you?

Victor Duprey

Too Cold in the winter
Too Hot in the summer
Incredible
Cool
Adorable
Gangs
Outgoing

Semha Ogorinac

The Hood Never Sleeps

Exotic houses.
Neighborly love and a warm feeling in which we give.
Gangbangers fight and decorate the block.
Loitering and laundering, drug traffic never stops.
Exciting action goes on every day.
Wild parties jumping off while babies are at play.
Old folks sitting on the porch whispering "Look at so
and so."
Odds and ends matching up, trying to make ends meet.
Dead silence during the night; Oh no! The hood never
sleeps.

Shateila Slater

Homeless Woman Sestina

I stop because I am not very busy
She sits on the bridge, as always, alone
She squats in the filth-ridden streets of the city
"I'd like to eat. Can you spare any change?"
merchants and lawyers and businessmen pass
this is her job; how she lives, day to day.

But I break the pattern and greet her today
As she counts her earnings and tries to look busy
Maybe she's seen me here in the past
On my way to the station- I'm always alone
Her patter is clockwork, the lines never change
People like her make their life in the city

Begging the world, the country, the city
To help them, to keep them alive one more day
Once there was dignity- now things have changed
No one has family, we're all too busy
You either have children or you live alone
And do it yourself, thinking "This too will pass!"

Your siblings, your cousins, they won't get you past
All the trauma and misery spawned in a city
You're always in crowds yet you're always alone
And losing a piece of your soul every day
It's too much to handle, can't keep yourself busy
Your mind falls apart, it can't deal with these changes

When they let you out, the conditions have changed
You've lost your apartment, belongings and past
You cry out for help, but EVERYONE'S BUSY!
From city to suburb, from suburb to city
You wander the streets, unbalanced and dazed
The cops think you're crazy and leave you alone.

"Honest!" she says, then she asks for a loan
to get on her feet she'll need more than spare change
I wonder, does she tell this story all day?
Pleading her case to whoever might pass?
Does she seek out the few friendly smiles in the city
Asking for more than coins if they're not busy?

She's all alone in the world. Can I pass
On the chance that I'll change one life smashed by the
city?
I dazedly give her my wallet. Goodbye. I am busy.

Donni Saphire-Bernstein

The Phone is Ringing

An excerpt from

Certain Needs
By Moses Harris

(CHRIS sits on his bed and picks up his cordless phone, dials a number and waits. You hear SHANICE's voice from offstage.)
SHANICE: Hello.
CHRIS: Whas' up?
SHANICE: I'm sorry. I'm not home right now, but if you leave your name, number, and a brief message, I'll get back to you.
(CHRIS pushes a button on the phone and puts it on the floor.)
CHRIS: Damn, where is she? She said she'd be home.
MIKE: Who?
CHRIS: Don't worry about it.
MIKE: Fine then, don't tell me.
CHRIS: I'll tell you if I want to. Don't act like you're the boss o' me.
MIKE: Shut up man. I know who it is anyway.
CHRIS: Who? You don't know.
MIKE: It was Shanice, wasn't it?
CHRIS: No it wasn't.
MIKE: Don't lie. All those times you think I'm asleep and you get on the phone I'm listening. I hear things. I hear a lot of things—
CHRIS: You know what you remind me of? That one guy in all those movies who tries to sell information to someone but ends up getting killed.
MIKE: Shut up.
(CHRIS picks up the phone and dials again. Scene at left is illuminated. SHANICE is in the chair next to the table.)
SHANICE: Hello.
CHRIS: Hey.
SHANICE: 'ey Chris.
CHRIS: I just called you. Where've you been?
SHANICE: I just went to the store for a minute.
CHRIS: So whatcha been doin'?
SHANICE: Nothin' much, just thinkin' about you.
CHRIS: I been thinkin' about you more.
SHANICE: Prove it.
CHRIS: How?

SHANICE: Tell me you love me.
CHRIS: I love you.
SHANICE: Okay.
CHRIS: Wait a minute, how are you gonna listen to me say I love you and not even say it back?
SHANICE: I just didn't.
CHRIS: Fine then, bye.
SHANICE: Wait, Chris, don't hang up. I love you too.
CHRIS: I thought so.
(SHANICE looks offstage left. You hear a click as the phone connection disconnects.)
SHANICE: Dad!
(Scene at stage left is in darkness. CHRIS stares at the phone in disbelief. He pushes a button on the phone and dials another number. Scene at stage right is illuminated. NICOLE is seated in the chair next to the table.)
NICOLE: Hello?
CHRIS: Hey baby.
NICOLE: I was just about to call you.
CHRIS: Well, I called you first.
NICOLE: Well, we're both here.
CHRIS: I miss you.
NICOLE: Whatever happened to me coming to Chicago to be with you for the summer?
CHRIS: We never talked about it much.
NICOLE: What, you don't want me to come?
CHRIS: It's not like that, it's just that first of all I gotta talk to my parents. Second of all I gotta figure out where you'll stay. And lastly we gotta save up to get you here. I'd rather just see you at school than go through all that. Cause by the time you get here, we won't have any time to spend together.
NICOLE: Oh.
CHRIS: Besides, If you stay at the house with us, where's Mike gonna go?
NICOLE: Mike?
CHRIS: Yeah, you know Mike, my brother.
NICOLE: Ohhhh, Miiiike...I gotta help my sisters with the dishes.
CHRIS: Call me back? My parents are getting tired of all the calls to California.
NICOLE: Ok. I love you.

146

CHRIS: I love you too. (Both hang up. Scene at stage right is in darkness. CHRIS' phone rings. Scene at stage left is illuminated.) Hello?

SHANICE: I didn't hang up on you, my dad accidentally kicked the phone cord.

CHRIS: Anyway, remember that party we went to the day before yesterday?

SHANICE: Yeah?

CHRIS: Well, after I dropped you off at home, my friends and I went to another party, right. Well you know how those late night parties are.

SHANICE: No, I don't. How are they?

CHRIS: Let's just say on the way home I was a little tipsy and lightly toasted. Coming back from the party we were drivin' along Lake Shore Drive when I changed lanes in front of a police car, right. Well he turns on his siren and comes squealin' after us, you know what I'm sayin'. Anyway I pulled over and waited for the cop to pull up behind us. He came up on my side and Jay was trippin' out. I'm like, hey man shut up, I'll take care of it. So the cop strolls up on my side and asks for license, registration and stuff, right. I calmly hand it over and while he's checkin' it he's askin' why we were goin' eight miles over the limit. I told him we were going to a study group and if we were late we would get three demerits. Larry and Tony in the back seat were crackin' up. The officer, not amused, shines the light back there and they pull straight faces real quick. Anyway the cop gives me my stuff back and says, get this, "All right, you can go, just remember to signal when changin' lanes." We pull off and we're bustin' up laughin' for like the next mile and a half. All that because I didn't signal.

MIKE: Wait, wait, waaaaiiit a minute.

(CHRIS takes the phone slightly away from his ear.)

CHRIS: What?

SHANICE: I didn't say anything.

CHRIS: Hold on a second, I was talking to my brother. (CHRIS moves the phone further away from his ear.)

MIKE: You were out, right, at a party. You left the party high and drunk, right? You then proceeded to get behind the wheel of Mom and Dad's car with three passengers. Stop me when I start to get my point across–

CHRIS: I get what you're sayin', but I'm home safe aren't I?

MIKE: Yeah, but you not only put your life in danger, but the lives of three other people.

CHRIS: How 'bout you shut up? I don't have to hear this.

MIKE: No, you never listen to me when I'm -

CHRIS: How 'bout I make you shut up? How 'bout that? (CHRIS puts the phone back up to his ear.) Hello?

SHANICE: Why are you so mean to your little brother?

CHRIS: I'm not, he's just in my business, and I don't like when he does that.

SHANICE: I heard you yelling at him, you know he's right. Next time you're like that call me and I'll come get you.

CHRIS: It wasn't that bad.

SHANICE: No, seriously. You can get your car the next day. Just don't drive when you're like that. What if something happened?

CHRIS: You sound like my Mom. And that's the last thing I need to hear this late at night. I'll call you some other time. Bye.

(Scene at stage left is in darkness. CHRIS pushes a button on the phone and puts it on the floor. CHRIS leans back and lies perpendicular to his bed. MIKE gets out of his bed and thoughtfully walks to the table then back and jumps back into his bed.)

MIKE: Let me get this straight.

CHRIS: Get what straight?

MIKE: Just listen. Okay. You go to school with Nicole right?

CHRIS: (hesitantly) Right.

MIKE: And you all had a relationship at school right?

CHRIS: (hesitantly) Right.

MIKE: And you two never broke up right?

CHRIS: Right. Where exactly is this going?

MIKE: Just stick with me for a couple more questions. You and Shanice are close right?

CHRIS: Yeah.

MIKE: Real close?

CHRIS: Yeah.

MIKE: Really, really close?

CHRIS: All right, we're close.

MIKE: Okay then. So basically, you're going out with two girls.

CHRIS: So?

MIKE: You don't see anything wrong with that?

CHRIS: No, not really.

MIKE: You know if they find out your ass is grass and they're the lawn mower.

CHRIS: But they're not gonna find out are they?

MIKE: Not from me if that's what you're saying.

CHRIS: I didn't say that though. Are you feeling pangs of guilt about any plans you might have?

MIKE: No.

CHRIS: Okay then. (CHRIS gets up and walks around the room getting dressed.)

MIKE: Where are you going?

CHRIS: I'm goin' downtown with Shanice, why?

MIKE: You aren't even a little bit worried about them leaving you?

CHRIS: Nope, they wouldn't do that.

MIKE: How can you be so sure?

CHRIS: Because if they been with me all this time, they must see somethin' in me worth stayin' for.

MIKE: But they don't know what kind of game you're playin'.

CHRIS: And they won't know.

MIKE: How can you be so sure?

CHRIS: Because, the only people who know are you and me, and I'm not going to mess up my own game and you aren't gonna tell. Are you?

MIKE: What if one of 'em found out?

CHRIS: (frustrated) I don't know. What's with all these questions? Listen, Arabs do it, Mormons do it so why can't I?

MIKE: You're neither of those.

CHRIS: You get my point. Bye. (CHRIS exits stage left. MIKE gets out of bed and paces back and forth in the room.)

MIKE: Oh man. This is bad. This is definitely bad. On the one hand Chris trusts me and expects me to keep quiet, but on the other hand he's doing something terribly, terribly wrong. If I don't tell he won't be pissed but the girls in the situation will be – but what if I do tell and he doesn't change? Then what? Not only will he be pissed, but he'll never trust me again. And he'll just find someone else and start all over again. What if I tell and not only does it ruin his game but he gets angry and takes it out on me? Then not only does he keep doing it but I'll have gotten beat up too. That's a backfire if I ever saw one. What if he's right and they don't care and not only that they tell me off for getting in their business and trying to break up their relationship with him. And that

would break up his relationship with me, but blood is thicker than water, I mean he is family and all. But maybe I could tell them without him finding out. Then again he might. Oh crap. (The phone rings, MIKE picks it up.) Hello?

NICOLE: Hey Chris, I heard -

MIKE: I'm not Chris.

NICOLE: I'm sorry, what's up Mike? You sound so much like your brother.

MIKE: Don't worry about it, I get it all the time. Chris isn't here.

NICOLE: Where'd he go?

MIKE: Downtown... (NICOLE freezes, spotlight on MIKE.) If, I'm going to tell this is the perfect opportunity. All I have to do is tell her that he went downtown with Shanice and then just answer her questions.

(Unfreeze NICOLE. Regular stage lighting.)

NICOLE: Well I'll call back later, bye. (NICOLE hangs up.)

MIKE: Wait! Nicole! (The phone rings again MIKE picks it up.) Hello?

CHRIS: Hey, I need you to do me a favor.

MIKE: What?

CHRIS: Call Mom and Dad and find out when they're gonna be home.

MIKE: About nine o'clock on Monday.

CHRIS: What, you talked to 'em?

MIKE: Before they left this morning.

CHRIS: All right, I'll be home in about thirty minutes.

(Both hang up, MIKE walks downstage center.)

MIKE: Personally, I think Chris thinks I'm some sort of idiot. Think about it, you're an eighteen year old male, your hormones pretty much rule your one track quest for "gettin' some," your parents are out of town for a couple days, and no one stands in your way but your little brother who can easily be threatened but preferably bribed to be quiet about the whole affair. Now what would you do? Would you a.) Sit at home like a good little boy and follow rules or b.) Go out, get drunk, smoke a couple joints, and bring your perfectly willing girlfriend home for a little extra-curricular activity. If any of you said a.) then you're a damn lie. I know because I'd do it too.

(end of scene)

An excerpt from

Use a Loveless Eye
By Brandi Jackson

Characters
APRIL - A 17 year-old female in her last year of high school who
happens to become obsessed with her boyfriend TRAVIS.
ANGIE - APRIL's good friend, the two go to school together. Lived
in New York for twelve years. She is 18 years old and tends to
become the leader or advisor of the group of friends.
STEPHANIE - APRIL and ANGIE's good friend. She is 16 years old
and attends the same school. She is a little naive at times.
TRAVIS - APRIL's boyfriend. He is 19 years old and is working.

(APRIL's bedroom. A closet, bed, dresser, door, small table, floor
rug and a phone are seen in her room. During phone call a voice is
heard only offstage. ANGIE and STEPHANIE are sitting on the
floor rug in relaxed positions. APRIL looks toward a calendar on
her wall. Filled with red x's but one's not on today's date.)
STEPH: So tell us about your anniversary. I'm interested.
APRIL: I wanna hear about the party first... (A bit sad) since I
missed it to be with Travis.
ANGIE: Yeah April, you shoulda been there. You would of cracked
jokes all night.
STEPH: Like I did. You should of saw the clothes that some people
wore like–
ANGIE: Mike...He pissed me off last night.
APRIL: Why?
ANGIE: First off, I was dressed to the teeth. I wore that blue dress
because you had my skirt that I wanted to wear.
ANGIE: But anyway, I had my hair all nice and what did he wear...
APRIL: Oh Lord, he wasn't dressed to impress?
ANGIE: (Shaking head 'no') Tell me why, w-h-y did Mike wear
some booty tight pants to the party? Could I have been more
embarrassed?
APRIL: (mellow) It could have been worse.
ANGIE: Worse?!? His darnn pants were so tight Aladdin couldn't
get out of them.
APRIL: (Laughing) That's tight.
ANGIE: (Serious) It's the truth. I was scared that if I rubbed against
his butt 'I love Genie' would appear.

STEPH: More like Wishmaster.

APRIL: Eee!! That thing was ugly.

STEPH: And you should of saw the butt that he didn't have!

ANGIE: Ha! Our dancing on the wall made the walls jealous.

APRIL: Mannn! So harsh. (laughing)

ANGIE: But, he's still my guy. He's cool other than his clothes at times.

APRIL: Rule #5, if he don't dress to impress he don't pass the test.

ANGIE: Well, he has his bad days.

STEPH: Oh yes, his bad days.

APRIL: (mumbling) Not many good days.

ANGIE: (Jokingly) Shut up. Just because you have a guy with a Brad Pitt mentality and he's soooo fine does not make you 'all that.' (APRIL just looks at ANGIE)

ANGIE: Don't laugh you guys.

APRIL: Oh God, what happened?

ANGIE: OK, after the party Mike and I were walking down Carpenter. We were getting ready to kiss so I tried to tease him and pulled my head back. I wasn't paying attention and next thing I knew I walked into a bus stop sign.

STEPHANIE: (Trying to refrain from laughing) I was going to ask where that red mark on your forehead came from.

APRIL: (Trying to refrain from laughing) Oh, I thought Mike was just sucking your head now.

ANGIE: (Laughing) Shut up. (There's a moment of silence between them. Change of subject and a little concerned) I'm just curious, why did you want us to come over today? We never come over on Sunday. We always sleep late cause of the parties unless we have a sleepover.

APRIL: (Embarrassed and ashamed) Well I guess I took long enough to hide it...I have a problem.

APRIL: That day we had a good conversation. Angie you said it all, but with my own dreamy eyes I never saw it all...I put my heart on the highest line and I trusted the line.

ANGIE: What do you mean?...I'm lost.

(APRIL glances at her calender)

APRIL: You know how I count all the days Travis and I stay together?...There's not an X on today...

(While STEPHANIE and ANGIE glance at the calender APRIL flops on her bed as if there is so much more in her heart.)

ANGIE: (Looking concerned and unbelieving) Noooo...

STEPH: (Unbelieving) No way in hell, he's too good -
ANGIE: What happened?!!?
APRIL: Our BIG sixth month anniversary was unreal. I broke up with him.
STEPH: What! What happened?
APRIL: We decided to have the date at his house...on his porch...in a swinging chair, just like our very first date.
(Lights go out. Lights appear on a porch with windows in background. There is a swinging chair. TRAVIS and APRIL are approaching each other)
TRAVIS: Happy Anniversary! (They hug...happy to see each other)
APRIL: Happy Anniversary to you too. (Travis motions to sit down and APRIL sits down too and they hold hands.)
TRAVIS: So, we're back where we had our first date...
APRIL: (Dreamy eyed) Yea. When are your parents coming home?
TRAVIS: More like just my dad at 8:00.
APRIL: I know, we're in the same situation.
TRAVIS: Maybe that is why I feel such a strong need for love. Since my mom wasn't around for long. I was left with my cold-hearted father. The one who is totally different from me. He judges me nonstop like clockwork. I can't stand it. That's probably why I was in and out of relationships.
APRIL: (Afraid) Why is that?
TRAVIS: Because most girls don't put 110% into the relationship.
APRIL: What's the extra ten percent?
TRAVIS: The extra ten percent?...it's like a bonus in a relationship. See, if the bonus isn't good it stays at 100%.
APRIL: You're confusing me.
TRAVIS: You don't understand me do you? Don't worry about it.
APRIL: How can I not worry? It's on my mind now. I want to be the one that can give 110%.
TRAVIS: I really hope you are. So, far you've been close. (APRIL doesn't exactly get what TRAVIS is saying but instead she just listens.) I'm so tired of going to work when all I do is think of getting closer to you. I use to see you almost everyday. Now it's like twice a week.
APRIL: I know...me too.
TRAVIS: I think of you constantly. You're like a fly– you give me a buzz.
APRIL: A FLY? That is not attractive.
TRAVIS: (Laugh) You know what I'm getting at.
APRIL: (Sly smile) Nooo, I don't, explain yourself. (APRIL smiles

looking interested in what he has to say about it.)

TRAVIS: (Smiling) A-P-R-I-L...

APRIL: (Smiling) T-R-A-V-I-S...

TRAVIS: APRIL...

APRIL: TRAVIS...

TRAVIS: (In a sexier voice) A-P-R-I-LLLL...

APRIL: (In a sexier voice) T-R-AAA-V-I-SS.

TRAVIS: Man, you are so sexy. And you're mine...I'm lovin it. I still don't believe I'm here with a beautiful intellectual female. Most of all, you're a cheerleader.

APRIL: (Defensive) That's the only reason you like me so much?

TRAVIS: (Stutter) No, I just wanted to tease you...to brag about you. Don't leave me like the others. I think you're meant for me and that would be a double wammy. I love you..

APRIL: (Smiles) Sometimes I think about you leaving me at night, or before I eat breakfast in the mornings. Then, I get this nervous pain in my stomach. I guess it's healthy butterflies.

(Travis rubs her hand)

TRAVIS: (Looking serious) How far would you go to keep our relationship together?

APRIL: How ever far that is needed.

TRAVIS: (Pause) I remember the first day I met you, I had to have you. You had to be mine.

APRIL: That's funny I was thinking the same way.

TRAVIS: And here we are, together still. We've actually lasted six months. That's long for most people. Do you want a future with me? To have little April, May and June's runnin around...

APRIL: Yeah, you are so silly. I do hope we get married and have twins or sumthin.

TRAVIS: They'd be real pretty too with a mother like you.

APRIL: I bet you'd be the best father they would ever have.

TRAVIS: Yeah since my father was horrible to me I wouldn't want my kids to feel that same pain.

APRIL: Don't feel too bad, I never had one either.

(TRAVIS pauses for a moment of thought)

TRAVIS: You know how they say you should test out your girlfriend or boyfriend before marriage?

APRIL: (Pause and a little shocked) Uh, Y-e-a-h.

TRAVIS: Well, do you ever wonder how I'd be in bed?

(There is a moment of silence and uneasiness on APRIL's part)

APRIL: Um—maybe sometimes—did you want a 'now or later' candy?

TRAVIS: (Thinking of something else) Now.

APRIL: What?

TRAVIS: Oh, nothing...I've been thinking...

APRIL: What's that?

TRAVIS: We've been everywhere together and have done everything together...the times that your friends weren't around–

APRIL: What's wrong?

TRAVIS: I was wondering if you wanted to try something different.

APRIL: What, leaving them behind? No problem–

TRAVIS: Not that.

APRIL: Then what?

TRAVIS: I want us to try having sex together– it's about time.

(APRIL's hand slips away from his palm and her mouth drops)
It's been six months and you haven't thought of it? Come on, I know I'm not ugly. You love me, right?

APRIL: (Extremely shocked and hurt) That doesn't make it right! What is going on! What is this anniversary shock? Don't use my love against me. I thought we were fine the way we were.

TRAVIS: April–

APRIL: (Cutting him off) Here I am telling my friends how great you are. Oh how blind I was. How only college guys think of...and you're asking me for it, the one I thought I didn't have to worry about. I was the one you'd wait forever for!

TRAVIS: That is– was how I felt. I mean it changed once I was around you so much in the beginning. You're gorgeous and after I fell in love I've had so many dreams of you.

(APRIL stands up from swinging chair)

APRIL: (Angry) Dreams! Dreams—that's how you think of me...in lingerie doing your every desire? Oh what a jack–

TRAVIS: (Defensive) I haven't had sex in one whole year April! April, I tried to wait, but it's hard on me! I thought you may have wanted to within six months so I waited.

APRIL: How could you? Why are you doing this? I thought I was so different MR. PICKLE head. I hope you get herpes all over it–

TRAVIS: You are different– I thought–

APRIL: You thought wrong. You think you're slick! Why can't you wait? Why can't you hold it like your pee...your bladder never busted.

TRAVIS: (Laughing and frustrated) At the time I thought I could!

APRIL: You love me right? Then why is this a problem? (TRAVIS looks at APRIL blankly) There's someone else...I shoulda known you were doing it with someone else since I wasn't...uhhhhh!

TRAVIS: No that's not true at all. (APRIL paces across the porch.

She comes back around and swings the swinging chair on TRAVIS)
Why is having sex with me so bad? What can you lose?
APRIL: What can I gain? I want to wait...I don't wanna have to worry
about a–
TRAVIS: I really can't take it anymore. You're gonna have sex with
me or I'm just leaving you for real. So you think about it and meet
me back here tomorrow at 6:00 with your answer. APRIL EVERY-
ONE has sex. JUST think about it or I can't stay.
APRIL: OH MY G-O-D! (Lights go out and reappear back to the
bedroom with STEPHANIE, ANGIE on the floor rug. APRIL is
standing) Do you think I was too harsh. Should I take him back??
ANGIE: I am dumbfounded....I thought you guys were so perfect.
HE DIDN'T EVEN GIVE YOU A GIFT ON YOUR ANNIVERSARY!
(STEPH and ANGIE have an upset guilty look on their face)
APRIL: You two are experienced with sex with Chris and Mike...
how did you get to it? (STEPH AND ANGIE look at each other.)
STEPH: So what you tell him the next day at 6:00??
APRIL: I told him No.
STEPH AND ANGIE: Nooooo??
ANGIE: I didn't either. I have a confession. Mike and I never did
it...I chickened out.
STEPH: Add me in...Chris asked me to and then threatened to get
some from his ex.
ANGIE: Oh my God. (They all look at each other, laugh, and hug.)
APRIL: I thought you guys were so experienced.
STEPH: I was trying to match up to your big love affair by saying
Chris and I were real close.
APRIL: Well I'm glad we're still virgins...I was a bit embarrassed to
tell you the situation. I felt like a fool. (The lights dim and all char-
acters freeze except APRIL. She talks to audience) I've learned two
things...that is you'll always have your true friends...and not to be
ashamed of things because they may be, too. I never examined
Travis with a loveless eye. Meaning the eye that is not attracted to
your desires– The naked eye that's not full of smoke. And two never
take for granted that after leaving someone and not trying to work
things out that the next love is going to be a dream come true. All
our lives we wait. Just think about it. We waited for birth, to grow
old, to find our soulmates, and for college acceptance letters. But,
most of all we wait to hold sacred things we cherish the most...our
bodies, morals, and our values. Through my journey in life I learn a
lesson each day. My eyes are now open. You too can wait and be
patient to appreciate the appropriate ways of life. I love you guys.
(They all hug as the lights fade)

An excerpt from

Nopales On Augusta Boulevard
by Olga Chavez

Characters:
MIKE: 18 years old. Poet, painter, starting college. Tall, long haired Mexican.
MARIA: 17 years old. Starting her last year in high school, Mike's sister. 5'6" long brown hair and bronze skin.
PABLO: 22 years old. Crooked older brother to both of them. 5'11" short black hair and black eyes.

(Lights up on stage. MIKE starts talking to the audience.)
MIKE: In Mexico, he was a respected craftsman. He used to hitch rides on weekends to the capital city to sell his art: portraits, paintings, sketches of surreal landscapes he told my mother he'd seen in his dreams, carved figurines of La Virgen De Guadalupe and El Dia De Los Muertos. He brought home enough money for my mom, grandma and him to live comfortably in their poor village.
When my mother got pregnant with Pablo, they decided the United States was a better place to raise their children. There were jobs and opportunities for those who had ambition and the right attitude. It was a place where the officials with blonde, Spanish ancestry didn't run over the indigenous because the amount of Indian blood that ran through your veins and the color of your skin didn't matter. They left everything behind only to find that the best they could do was a roach infested one-bedroom apartment and a factory job that left my father no time for dreams. The wheels and gears of the working world trampled him, leaving an inverted shell that over the years filled with a mixture of resentment, hate, bitterness and discontent. That and the struggle to survive became all he could see. (Lights down on MIKE.)
(PABLO smiles and runs off stage)
MARIA: Do you think he'll be all right?
MIKE: Isn't he always?
MARIA: But don't you ever wonder? What if he doesn't come home. What if he becomes another statistic in the Metro section? What would I– we do?
MIKE: If you worry about things you can't change–
MARIA: You see, that's it. Maybe we can do something.
MIKE: Maria, we've talked about this before. He thinks he's happy

with money and girls and all the weed his lungs can smoke. He has been forced down a tunnel and if he looks the other way, he'll get hurt.

(A plate smashing against the wall and a cry of surprise is heard. The music suddenly stops. There are still shuffles heard from inside the house)

MARIA: Things didn't used to be so bad, Mike. Remember the Nopal, Mike? Remember Pablo used to slip a big plate of food with tortillas on top through the wide crack under the pantry door when they fought so bad we didn't want to come out? It was always nopalitos, what mom made when there wasn't time to make any-thing else. Sliced cactus and egg with the hard Mexican cheese from the back of the refrigerator some cousin brought in a greasy box tied with twine.

MIKE: You told some good stories, Maria. I wonder where our father thought we were all that time. He would never have thought to look in the pantry.

MARIA: Remember the story about Pancho Villa and the cactus?

MIKE: That's why we had to call the sanctuary "El Nopal," the cac-tus from the promised land. Like the name of the liquor store that opened down the block late that summer.

MARIA: I hated that short ugly owner. He looked at you like... like... I can't explain it, Mike. But little girls never went in there–

MIKE: Unless they wanted some liquor. He would sell a bottle of Jack Daniels to a two-year-old–

MARIA: If I didn't get it there, I would have gotten it from Pablo.

MIKE: (To himself) Some sanctuary.

MARIA: What?

MIKE: Oh, I said a lot of kids had it worse than us. People in the apartment buildings we lived in–

MARIA: They used to sit on the concrete steps of those buildings and be happy. I think it was the music and the kids that made peo-ple forget their bills. I used to say I hated that Spanish crap, but you know something? I miss Luis Miguel, Vicente Fernandez, Pedro Infante, even Juan Gabriel. Mom doesn't sing or listen to the radio anymore. We used to sing in the kitchen, listening to the dishes rattle when we danced. (MARIA looks down at the tips of her fingers) I can flip tortillas off the burners now, too, Mike. The fire doesn't burn me any more. (She laughs bitterly) But I still can't roll my "r's" like a real Mejicana.

MIKE: (sadly) Maria–

MARIA: And isn't that just the way it goes? Like with Jorge? We

used to be best friends and he promised me if I gave him that X-men comic, he would never join a gang. They spray painted his flower arrangements in his colors last October. He lay there with the picture he took in sixth grade on the casket. The face in the box was old, Mike. It was cold and hard, like it was made out of concrete, or set in a cast like it was broken. Then the before picture, with clear, livid eyes, crooked teeth, and his mushroom haircut. His big brother was there too, the brother who swore he would always take care of Jorge, but he was standing only because he had a cop on each arm.

(Another loud crash and a thud like a person falling is heard in the house, then a door slam. MIKE and MARIA disappear inside. Lights down on stage, spot light up on MIKE talking to the audience.)

MIKE: Is it the echo of church bells, tolling for the funeral procession of forced Migration that makes them avert their eyes? Does it make them shiver as the sound fills Sunday morning silence and the church's wide steps are empty? The santos are lonely and their altars are dark. The flame drowned in its wax so long ago. Everyone hated the yuppies and we all felt we had the right to hate them even though most people couldn't tell you, exactly, what one was, but everyone knew one when they saw one, damnit. They were attracted to my neighborhood because of its proximity to downtown and the property value was a steal. Some people claimed that they were in love with the architecture, yet they built horrid buildings in weeks, with less than a hair between them, squeezing the last ounce of blood from the land. They called these Town Houses or Deluxe Condos On Wolcott. "Raping of Wicker Park" someone spray painted on the cinder block after breaking all the windows. They plundered; building lofts from abandoned churches, buying buildings, gutting them out, displacing their inhabitants. The polish woman with the crooked neck was kicked out last week. She'd been living there for over twenty years. The children who crowded the grammar school, who rubbed the paint off the monkey bars in the park, who went through 152 park district baseballs in one season, are gone. When does doing the right thing become a question of character? Of class? The resistance was shoved into the back of a store whose entrance was located at the mouth of an alley littered with bottles. Everything looks manufactured. Like the grey plastic on an airplane. It felt dirty. It needed the leaky hose, Ariel soap from the corner store and the tired, worn, bristles of a grandmother's broom. The people have always been moving; driven

out, slaughtered, mixed and classified. From field to field, shack to shack with a pot of frijoles following the seasons. Sun weathered skin, calloused hands and shirts stained, faded and torn from being pulled in so many directions by tiny, hungry hands. Corridos sung after a case of Coronas tell the journey; we're still trying to find Aztlan and it's easier to profit from broken dreams than to help make new ones.

(Lights fade on MIKE and Pink Floyd can be heard under the racket of glass breaking and things hitting walls. There are screams and shouts, cursing in Spanish. A door slams. Lights up on Porch, There is a plastic bag containing two 40s hastily placed by the door. Enter MARIA and PABLO from the kitchen. MARIA sits on the step.)

PABLO: I don't believe what that sonofabitch did to her. I'm gonna kill him. I'm going to kill him. I'm going down to my car and–

MARIA: Pablo, sit down. He'll be asleep soon, mom's in her room–

PABLO: To hell with that! She has to get out.

MARIA: We can't do anything.

PABLO: The hell we can't. (To the people across the alley) What are you looking at? I'll go down there, goddamn Yuppies.

(PABLO opens the 40 ounce of Miller Lite, spills the top on the floor and takes a big gulp. MARIA begins to fidget with the plastic loops that keep a 6-pack together. She sits down, takes a 40 and starts to drink too.)

PABLO: I wish we could just drop the Y-bomb. As in Y are all these goddamn Yuppies out here?

MARIA: I'm getting tired.

PABLO: Do you remember that store on Chicago Avenue? Goldblatt's?

MARIA: Uh-yea.

PABLO: All condos, all torn up and made into condos. That was the only place a lot of people could afford to shop at.

(Enter MIKE unnoticed from kitchen with a baseball bat in his hand. He drops the bat, sits down and takes a swig of PABLO's 40 and lights a cigarette.)

MARIA: What do you do when you're inside and open a 40? Do you spill the top on the carpet?

PABLO: No, see, you always gotta give it up. It's for the homies, even if you were in the hottest desert, you gotta respect. We were–

(MIKE stands up and throws his cigarette on the ground.)

MIKE: Don't you ever get tired of reminiscing? Everything is dead and dying and you're not going any where. (Mockingly) Do you

remember? Do you remember? Well, do you, Pablito? That last
night on Augusta? Mom thought she could leave him, but it didn't
change, did it? Do you remember swinging? Joking about being so
good you could get to second base with a 2x4 while Maria was
screaming? Do you remember the eight stitches you put on his
head? He fought back, but you couldn't feel it, could you? You
always thought you were el hombre de la Casa, el big Patron,
well..."

PABLO: WHO DO YOU THINK YOU ARE?! Your family is all you
have. You think a poem will pay the light bill? You need to wipe
the snot from your nose and realize that there is nothing in this
world except what you can take and hold on to. Do you think the
professors at your school care about you? They're thinking about
how much money they can milk from the state for having a minori-
ty. Having a little Chicano brown looks good on their college pam-
phlets. Tu Familia, pendejo. And don't you forget it.

(MIKE stand up to meet PABLO. They stare into each other's eyes,
neither of them backing down.)

MIKE: Go to hell.

PABLO: You don't know where you'd be if it wasn't for me. Did you
forget who put food on the table when your pathetic excuse for a
father spent his paycheck at the Cantina? Who took you to the
hospital when he cut you? I was the one with the guts to fight back
and take care of you.

MIKE: No, Pablo. I took care of it.

(MARIA cringing, sees the bat for the first time, lets out a small cry
and runs into the house. PABLO looks at MIKE with a shocked
look on his face.)

PABLO: You didn't?

MARIA: (hardly audible) Oh my God, Pablo, Mike, help me.

(Offstage The Mother can be heard crying and saying "Dios mio,"
"y, Dios mio." PABLO reaches into his pocket and takes two keys
out of his key ring looking at MIKE the whole time.)

PABLO: Classes start in two weeks, little bro.

(PABLO hands the keys over to MIKE. MIKE starts to run off stage,
crying. EXIT PABLO into the kitchen. Lights down on stage, cur-
tain.)

An excerpt from

The Phone Is Ringing
By Najah Charlton

(There is a dresser center stage left, with a phone and a glass of water on top of it. Next to the dresser is a bed. The stage is dark so you can't see anything, but there are various rustling sounds. The lights are still off as we hear voices)

MADELINE: Brian, let me in. I want to use the phone.

BRIAN: (in a muffled voice) Wait outside for a second, and get away from my door.

MADELINE: Come on Brian, let me in. What's wrong with you. I want to call Jen.

BRIAN: So what, I'm busy. I told you to get away from my door, now go away.

MADELINE: What ever you're doing can–

(Lights go on and a sound of door opening)

(MADELINE waits. Lights come on as MADELINE enters stage. Brian is handing CRYSTAL her coat.)

MADELINE: It's about time! (Pause) Oh, hey Crystal.

CRYSTAL: Hi, Mad.

(CRYSTAL gives MADELINE a hug).

MADELINE: You're leaving...already?

CRYSTAL: Yeah I've got to get home.

MADELINE: (pseudosweetly) Oh, really. That's too bad. I imagine your Mom gets sick of seeing you over here every day.

CRYSTAL: Yeah she says you guys aren't gonna be able to stand me pretty soon.

MADELINE: Imagine her saying something like that. I couldn't fathom such a thing.

(MADELINE gives CRYSTAL a syrupy sweet smile, but CRYSTAL doesn't notice its fakeness).

CRYSTAL: You're such a sweet sister, I don't know what Brian complains about half the time. (CRYSTAL gives BRIAN a kiss and exits as MADELINE casts a suspicious glance after her).

MADELINE: Oh, so you complain about me, huh? To your sweet little Crystal?

BRIAN: I have to complain to someone.

MADELINE: You could complain to me, (pause) we used to be close.

162

BRIAN: Are you even listening to your argument? Your a duffus.

MADELINE: See, that's more like it, telling me your emotions. So, (pause) now that we're on a roll, what were you—

BRIAN: Shut up.

MADELINE: But—

(BRIAN gets a pack of cigarettes out of a pair of pants pockets and exits. MADELINE pauses and looks after him, then picks up the phone. At the other end of the stage there is a phone with JEN sitting next to it. MADELINE dials and JEN picks up.)

JEN: Hello?

MADELINE: (whispering) I can smell your fear.

JEN: (sarcastically) I don't think it's my fear you're smelling.

MADELINE: (still whispering) I can see your every move.

JEN: (sarcastically) What did I tell you about installing video cameras in my room Madeline, you're beginning to develop a habit of it.

MADELINE: You make it very difficult for someone to stalk you.

JEN: I would think that's a good thing. Besides, you're the weirdo trying to scare me.

MADELINE: What are best friends for?

JEN: Hopefully not for stalking.

MADELINE: That...and a cure for boredom.

JEN: We're really pitiful. All we do is sit around on the phone all day. Gossip will kill us.

(BRIAN comes in to ask to use the phone. MADELINE and JEN continue talking. He leaves his room. MADELINE and CRYSTAL's conversation starts to focus on BRIAN and his girlfriend.)

MADELINE: What a skank!

JEN: Crystal?

MADELINE: Yes Crystal, what a horrible, putrid, loathful, disgusting, skank.

JEN: I thought you liked her.

MADELINE: I do.

JEN: I can tell, really.

MADELINE: Well I did till she started bumpin' my brother as you so tastefully put it. She's come between us.

JEN: I'm not even gonna say it, "you set yourself up." It's too easy. (pause MADELINE is silent) She's still the same person.

MADELINE: Yeah, but now she has a piece of my brother attached to her.

JEN: Do you kiss your mother with that mouth?!?

MADELINE: (defensively) I don't kiss my mother!

JEN: (dumbfounded) Oh-kay.

MADELINE: And speaking of my mother, sicko, I hope she finds out about Brian's extra-curricular activities. She's going to kill him. (MOM comes in saying her lines as she enters, BRIAN is with her and they both sit on the bed)

MOM: I'm not going to kill you, it's just that, I've been noticing that you have been hanging out with a lot of girl's lately, at least three that I can think of including Crystal. I know you're probably messing around in that fun, but unfamiliar territory—

BRIAN: Oh Mom, come on—

MOM: I hope that in the future you'll talk to me before you make such a drastic move.

BRIAN: What move? What—

MOM: I think, in fact I'm sure you've um, well have um, you see you're, well... you know what you did! SEX!

BRIAN: Huh?

MOM: You had sex like most naive boys your age.

BRIAN: Mom I—

MOM: Now that we've established that, there are more issues—

BRIAN: But Mom I—

MADELINE: (to friend on the phone) He's gonna get it now

MOM: Hear me out, what with HIV and Aids, and syphilis, and gonorrhea, and—

MADELINE: (to friend on the phone) Here it comes.

MOM: —and herpes, and genital warts, and pubic lice and crabs and chlamydia, and—

BRIAN: I get the idea, you're making my stomach turn.

MOM: Good this is the harsh reality of it. I have a point, though I think I just lost it.

BRIAN: Darn.

MOM: I guess what I'm saying is, with all these things, Aids, gonorrhea, HIV...well anyway, with all those things you have to worry about I...I sincerely hope you're not having sex with all three of them. (MADELINE drops the phone)

BRIAN: All three girls? No, only Crystal.

MOM: Oh, good. I mean not good, but, good.

BRIAN: And I love her.

MOM: I know you do.

BRIAN: And I'm using protection.

MOM: Wise move.

BRIAN: And you should be happy I'm being honest with you.

MOM: I am. You had me worried, I—

MADELINE: What's wrong with you people? Are you nuts, I mean, have you completely lost your minds? I'm serious, I'll get the padded room all ready for you. I could probably even arrange for a complimentary straightjacket.

MOM: Honey, this really doesn't concern you.

MADELINE: Doesn't concern me. Dork boy just told you he's groping his girlfriend and you said ok.

MOM: I didn't say ok, I said alright.

MADELINE: Same difference.

MOM: (to Madeline) You know I don't condone this,

MOM: (to Brian) I don't condone this.

MADELINE: You sure seem like you do.

MOM: Well, what do you want me to do– chain him to his room?

MADELINE: A good beating would do just fine. Maybe you could use the chain.

MOM: Oh, come on, Madeline, He's seventeen years old. He's going to do it anyway. Why not have this honesty?

MADELINE: Who ever said honesty was the best policy?

MOM: (sarcastically) Einstein.

MADELINE: Really?

MOM: No, It's just sort of known. And anyway he's a lot older than you, you don't understand.

MADELINE: A lot older than me? Don't understand? I understand it's only two years.

MOM: But he's seventeen.

MADELINE: And I'm fifteen. Let's see seventeen minus fifteen equals two. Simple arithmetic.

MOM: I know it's only two years, but there's a big jump in maturity from fifteen to seventeen.

MADELINE: Big jump in maturity?

BRIAN: That's right.

MADELINE: (to Brian) Shut up dip stick! Big jump in maturity? He has the maturity of a rubbed dog!

BRIAN: What is that supposed to mean?

MADELINE: You know I don't make sense when I get upset.

BRIAN: Yeah, all too well.

MADELINE: Bite me.

BRIAN: Bite yourself.

MADELINE: You're probably better at it, you get more practice.

BRIAN: You hit below the belt.

MADELINE: Apparently so have a lot of people.

BRIAN: No, only one.

MOM: What?!?

BRIAN: Nothing. I don't know why you're getting so upset over this anyway. It really doesn't concern you.

MADELINE: Doesn't concern me?

BRIAN: Here we go again.

MADELINE: Shut up and let me finish!

BRIAN: You haven't even started.

MADELINE: Brian!

MOM: Brian.

MADELINE: You told Mommy you're having sex routinely and indiscreetly with Crystal.

BRIAN: I don't recall saying all that.

MADELINE: I know what you meant.

BRIAN: So, I still don't see why you give two craps

MADELINE: I would give five craps, ten craps even. You know why? Because if I were in the same position, it wouldn't be this easy.

BRIAN: It wasn't easy, it was a long, grueling experience getting her warmed up to the idea.

MOM: Brian!!

BRIAN: I was talking about our (he points back and fourth between his mom and himself) conversation. Jesus, Mom!

MADELINE: See, it's a double-standard.

MOM: There are some double standards that need apply.

MADELINE: (sarcastically) I can just see the feminism swelling up in the room, I better watch out I might just choke on some of those ERA vibes.

MOM: It has nothing to do with being a feminist, or not being a feminist. It has to do with logic.

MADELINE: Oh yeah, it's real logical to say double standards are fine.

MOM: Not all double standards, just this one. For instance, Brian can walk down a dark alley and be fine and you could walk down the same dark alley and get raped.

MADELINE: On the other hand, Brian could walk down a dark alley, get beaten, robbed, harassed, kicked, brutalized, and maimed, and I could walk down the same alley and bat my eyelashes and be fine. See where double standards will get you.

MOM: I don't think I quite said that right.

BRIAN: She has a point.

MOM: Look, apparently, this isn't about me and Brian, it's about you and Brian. I'm not going to sit here and mediate. Work it out.

(Mom exits)

BRIAN: So what's your deal?

MADELINE: My deal is that I don't think you should be doing what you're doing.

BRIAN: And I don't think you should be in my business.

MADELINE: You don't know what you can contract.

BRIAN: Well, I've already contracted a nosy little sister, two if you count Jen. What could be worse?

MADELINE: Oh, I don't know, mono, having your leg fall off.

BRIAN: You always want me to talk to you!

MADELINE: We used to be close.

BRIAN: We still are in a way.

MADELINE: In the way that you don't talk, that's always fun.

BRIAN: I don't need this.

MADELINE: I'm afraid what you need I can't supply.

BRIAN: You're disgusting.

MADELINE: Shut up, you get on my nerves.

BRIAN: And you wonder why we don't talk.

MADELINE: Cuz your mother said never to talk with your mouth full.

BRIAN: I need a smoke.

MADELINE: It must be that pesky closeness again. (BRIAN picks up a pillow and hits her in the face with it. She falls on the bed and screams before realizing Jen is still on the phone.) I'm so sorry!

JEN: Yeah, yeah, what the–

MADELINE: Welcome to my world.

JEN: What happened? What the hell was–

MADELINE: All that about? Let me see if I can sum it up for you. So far my brother has come home smoking, obtained more popularity than I have ever had in my life, has condoms in his dresser, only one I may remind you. I found out he's having sex, my mother found out he's having sex, and everything is fine, peachy keen even. And now we can't talk anymore! Am I the only one having a problem with this? I mean, am I completely out of the water for feeling a little hostility?

JEN: So how was the date with Eric yesterday?

MADELINE: I pour my heart out to you and you ask me about my date!

JEN: It's like giving ice cream to a whining child, I know what will make you feel good.

MADELINE: Thanks.

(Lights down. Curtain)

An excerpt from

The Moon-Priestess of Printier
By Jessica M. Johnson

Characters
LAINE MARIE: Sixteen year old writer. Female.
DAD (Steve): Her father.
MOM (Sandy): Her mother
JEROME: Seventeen years old. Laine's boyfriend.
IRIS: Twelve years old. Laine's younger sister.

LAINE'S VOICE: *Mariah of Vakay stared into the mirror and realized she was looking at a stranger. Oh, same dark hair, same brilliant green eyes. A familiar reflection...and yet, not so familiar. There was something wrong with it, something wrong with her life. "Like what," her mind laughed. She was the daughter of one of the powerful Lords in Printie–* No, No, NO!
(Lights up on bedroom. LAINE is sitting at a desk with a computer and telephone. Bed, stereo and dresser present. She's riffling through several papers and suddenly tosses them all onto the desk.)
LAINE: No! It's not right. I hate this.
(IRIS enters the room carrying a duffle bag)
IRIS: Hate what, Laine? Are you complaining again?
LAINE: It's this stupid story. It keeps messing up! I'm trying to make it mysterious and descriptive, but it just ends up soundin kinda rambly.
IRIS: Lemme see.
LAINE: No.
IRIS: Why not?
LAINE: (evasively) It's not your thing. You don't even like fantasy.
IRIS: Hey, I read *A Wrinkle In Time*. That was fantasy.
LAINE: Not like my fantasy. Besides, you're just a kid. You wouldn't understand.
IRIS: I would!
LAINE: It has sex.
IRIS: (quietly) I know about sex.
LAINE: But this isn't just any sex. This is sweaty, raunchy, leather straps kinda sex.
IRIS: Ew! LAINE! (Laine laughs and turns to computer) Okay, so I

don't want to know it all, but at least tell me what it's about. I can help.

LAINE: (exasperated) A girl, in a land, who has a spell put on her so that she remembers nothing of her past. (slowly warming up) She thinks she's the daughter of this Lord Refuge-guy, but she's not. She's the daughter of a high priestess and was kidnapped to help spur on a war between the sorcerers and the Lords. The story's all about her findin' this stuff out.

IRIS: Confusing...but good. So what's the problem?

LAINE: I dunno how to start it.

IRIS: Start where the action is.

LAINE: (rolls eyes) You can't do that in a fantasy story. You need to give the reader some background like where you are and what's going on, so that they aren't floating around in fanta-space. You know like cyberspace? Fanta-space. Fantasy space.

IRIS: (laughing) You think up the craziest words, Laine.

MOM: (offstage) Laine!!!

(Lights up on the whole bedroom. LAINE sighs and looks up, still typing)

LAINE: What?!?

MOM: (offstage) Jerome's here!

(JEROME enters)

JEROME: What? You answer your Ma, what? (drops onto bed)

LAINE: When I'm writing I do. (stops typing and smiles) Hello Jerome.

JEROME: (dramatically) Hello love of my life, apple of my eye. So you finally got started on that story. Is that Yanni?

LAINE: Inspiration, boo. I'm at the part where–

JEROME: Don't tell. I wanna read it.

LAINE: You just don't wanna hear me yak about it.

JEROME: Maybe. I called your dad's house. He said you stayed home...and he didn't sound too happy about it.

LAINE: (furious) Oh well! I had things to do and I can't be expected to drop everything because he needs some quality time. I'm gettin' too old to be catering to him.

JEROME: Whoa! Hey! I was just passing on what I thought to be necessary 411. Phew! You two have some serious issues to work out.

LAINE: (annoyed) Why are you here anyway?

JEROME: I just wanted to see you. Kill me for caring.

LAINE: Silly boy. (Kisses him on the lips)

MOM: (offstage) Laine! Pick up the phone!

LAINE: (sighs and picks it up.) Hello?
(Lights up on DAD, wearing business clothes at a business desk, phone in hand)
DAD: Laine?
LAINE: Dad?
(JEROME politely steps away and spotlight centers on her. LAINE starts typing again)
LAINE: Hi.
DAD: Hi. (Pause) Whatcha doin?
LAINE: Stuff.
DAD: Stuff? Sounds like a story.
LAINE: Hm.
(Long pause. Dad looks into the distance)
DAD: Your Mom told me you weren't coming this weekend. We'll miss you.
LAINE: Iris sees me everyday, Dad
DAD: Me and Lara I mean.
LAINE: Lara's there? (Stops typing and perks up) Tell her I got started on my story and it's going great. Better yet, tell her to call me. She's got my number. (starts typing again) I like this one Dad. She has sense...and she's a writer.
DAD: (annoyed) So is that the big requirement?
LAINE: It helps.
DAD: Is that what it takes to get you talking because, I don't know, your mother isn't a writer but you're all happy and chatty with her.
LAINE: Huh? Are we on the same level here?
DAD: I don't think so. (Another long pause) You know, I had tickets to the waterpark. You're gonna miss it.
LAINE: I had things to do.
DAD: Really? I wanted to spend time with you.
LAINE: (annoyed) I said I had things to do.
DAD: More important than your father?
LAINE: (The clicking of computer keys gets louder and more hurried.) Whatever.
DAD: Don't 'whatever' me, Laine. (hears the computer) And could you please stop that? I'm trying to talk to you.
(LAINE stops typing and bangs away from the desk)
LAINE: Fine. Talk. But Jerome's here—
DAD: (yells) I don't care! He can wait!
(LAINE jumps, stunned. DAD visibly calms)
DAD: Okay, Laine, I give. Is this some kind of punishment? Did I do something wrong? Cause I feel like everyone gets this smiley,

happy Laine while I get the morose, sullen version. So now I give up. What'd I do? (LAINE doesn't answer. DAD sighs) You make it very hard being a father. I'm trying to be honest with you–
LAINE: Oh, did they teach you that in one of your self help books, Dad? How to be a father? Or better yet, how to win your daughter back? You know, sometimes you are all crap. It blows my mind how you're so full of it and don't even know it.
(Pause. DAD is shocked. LAINE continues to look smug)
DAD: Maybe you should go.
LAINE: Maybe I should.
DAD: I'll see you when I pick Iris up. (both start to hang up, then DAD gets back on) Oh and Laine?
LAINE: What?
DAD: We still have to talk about your grades. They were pretty bad last year. But we'll talk about it.
(LAINE's mouth drops. She pulls back to stare at the phone, listens, then stares again. Suddenly begins to laugh)
LAINE: Whatever Dad.
DAD: Bye Laine.
(LAINE's still laughing as she hangs up. Lights down on DAD. LAINE talks with JEROME. She continues to be unsympathetic toward her father. IRIS comes in the room to finish her packing. JEROME leaves just as LAINE's dad comes to pick up IRIS. LAINE and her dad are now in the middle of a heated discussion. Lights up on the whole room)
MOM: What? What happened? What-
LAINE: He's taking away my writer's club!
MOM: (stunned) What?
IRIS: Whoa!
MOM: I think you should go, Iris. (IRIS makes no move to leave)
DAD: Now Sandy, it's for her own good. Her grades weren't even close to expectations this last year-
LAINE: He can't do that!
MOM: Maybe we should talk about this outside, Steve.
DAD: (surprised) What's to talk about?
LAINE: I worked too hard to get into that. (runs to MOM) Mommy, he can't do that, can he? He can't!
MOM: Steve, come on. It's her writer's club. Take away something else.
LAINE: Yes! Anything!
DAD: No, I think this will get the point across nicely.
LAINE: (close to tears) Mom!

MOM: Steve, you can't do this. We can't take that away from her. It's too much.

DAD: It'll teach her not to do it again.

LAINE: You can't! (to MOM) He even said I had to quit my job.

MOM: Now that's just ridiculous. (to DAD) You have stepped way over the line.

IRIS: Her job! But she takes me to the movies with that money.

LAINE: Get out of here, Iris!

IRIS: No!

LAINE: This is none of your business!

DAD: Line? What line? I don't have a line! I'm her father and it's about time some authority was instilled around here! No wonder she's whining right now, bringing in these kind of grades! She's just a spoiled brat.

MOM: Excuse me–

LAINE: What?!?

IRIS: Wow!

LAINE: Iris, get out!

MOM: I have raised my daughter to be a mature, sensible girl who knows what she wants. She got her job on her own, she got into one of the most exclusive writers programs in the city on her own. I raised her with almost no help from you, that's for sure!

DAD: You've brought her up to hate me! Because we didn't work out–

MOM: Oh please–

DAD: You're bitter and you've brought her up to hate all men–

MOM: What?!?

IRIS: Stop it! Stop fighting!

DAD: (calm and triumphant) But I digress. (turns to his daughter) I'm sorry Laine, but the writer's club and the job have to go...and if you don't talk to your managers, your teachers, whomever, then I will.

MOM: (losing temper) Steve you cannot do that!

DAD: I can do anything I want! She's my daughter too.

LAINE: (yells) I am not your daughter! (Everyone shuts up and stares at her. LAINE is back in control) I am not your daughter. I am her daughter. Don't you dare come in here like you have some authority in my life. Leave me alone! (LAINE whirls away, towards the desk. Pause. DAD is stunned)

IRIS: Oh Christ!

MOM: Iris, get out right now or I will burn your butt so bad. (IRIS hurriedly exits. MOM stalks over to DAD)

MOM: (to DAD) I want to talk to you...outside...NOW.
(DAD and MOM leave. You hear yelling outside. LAINE stands alone in the room, breathing hard. Slowly goes over to stereo and puts in new CD, music comes out, drowning yells. Sits in front of computer and begins to type.)
LAINE: *"Get in there," Refuge snapped, pushing Mariah into her room. "Refuge please," Enea gasped, clutching her brother.*
"What did I do?," Mariah cried, furious and humiliated.
"What did you do? You were talking with one of them! The enemy! You were talking to a sorcerer!"
"He was a prisoner of war! You dragged me away from the victory parade, in full view of everyone, because I was talking to a prisoner! Offering my sympathy—"
"You don't give them sympathy!" he growled. "They're sorcerers! They sacrifice their children! They carve up their bodies in the name of their Moon Goddess! They murdered their own high priestess and blamed it on the Lords to turn the masses against of us!"
Mariah lifted her chin. "Oh yeah? Well I heard different."
Something dark and ugly crossed Refuge's face. "What did he tell you?"
"How do you know it was Mikosh? I could have heard it anywhere—"
"Oh. You know his name?" Refuge cried.
"Yes!" she screamed at him. "He told me! He also told me that I was the missing daughter of the high-priestess!" A surge like lightning filled the air, a rush of heat and sound, a crackling just below the threshold of hearing. "Is it true? How come I never knew about the missing daughter and the rest of Printier does? What else don't I know?" Refuge's eyes had gone wide and wild—and fearful. "Lies!" he screamed. "All lies—"
(LAINE breaks off as MOM enters again. The two women stare at each other. MOM goes to sit on the bed. LAINE immediately shuts off the monitor and turns to face her. Pause and you hear only music.)
LAINE: Is he still here?
MOM: Yes. (sighs) I'm sorry you had to hear all that.
LAINE: It's okay.
MOM: I can't believe he said all that in front of you. God, I wonder how I could have been married to him for so long.
LAINE: It's okay Mom. Really.
MOM: (smiles) I know darling. (stands and strokes her hair) You're such a wonderful daughter. Don't believe anything he said. He just doesn't understand. I am so proud of you, of the young lady you've become.

(Calm pause. LAINE finally sighs)

LAINE: Mommy?

MOM: Hm. (absently braiding her hair)

LAINE: Am I losing my writer's club?

(MOM stills, then pats her head and smiles wearily)

MOM: No. You're not. Or your job.

(LAINE sighs again)

LAINE: Call him in here, will ya? I wanna talk to him.

MOM: (smiles sadly) He wants to talk to you too.

(MOM exits. LAINE goes to the stereo and turns if off, then stands and waits. DAD wearily enters. Silence)

DAD: You wanted to see me?

LAINE: Yeah. I did.

DAD: Looks like you're calling all the shots now.

(LAINE doesn't answer. DAD goes to sit on the bed. Pulls out a pack of cigarettes and lights one)

DAD: Well, go ahead. I'm listening

LAINE: I thought you'd quit.

DAD: I did too. (takes a puff) I didn't know you knew I ever started.

LAINE: I knew.

DAD: (looks at cigarette, takes another puff) I remember when I used to be your favorite. I was your hero. We thought alike...we still think alike. (looks up) Do you remember? You used to call me "Popi" then. Not "Dad."

LAINE: Yeah, I remember. I also remember how Mommy did all the work, how stressed Mommy would get, and when you came home, you could cut the tension in the room with a knife. I remember that, too.

DAD: But you didn't care about that then, did you? For a while, Laine, it was just you and me, you and me against the world.

(DAD falls silent. Laine comes forward)

LAINE: I don't drink. I don't do drugs. I don't run around the streets at night. (picks up pack of cigarettes and takes cigarette from Dad's lips) I don't smoke. (puts cigarette out under her shoe and tosses pack away) I go to– I got into– a good school, I get good grades. I have good friends and a great boyfriend who doesn't drink, smoke or do drugs either. Hell Dad, we don't even have sex, and I'm still a virgin. Sixteen years old and a virgin. That's a miracle in itself. I guess what I'm tryin' to say is, I'm all right. I'm a healthy, teenage girl...and I did it without you.

DAD: (angry) You need me.

LAINE: No. I don't.

DAD: I'm your father!

LAINE: You gave me up for your work! You wanna know the moment I knew that it was over? It was your weekend, and I went into your room. You weren't home, as usual, but your room was lined with posters and charts from the business, you know, the kind where you fill your goals? Well on one it said "Your Goal." You wrote, be a millionaire by the year 2000. Then it said "What Are You Willing to Give Up" You wrote "Time with the Girls." The girls, dad. Us. That's when I knew you'd sold us out so you could make big money someday. That's when I realized work had become the most important thing in your life.

DAD: It was for us, Laine! Our future. Your future–

LAINE: It was for you! Your future. Your dreams. You just don't trade in your daughters for money, dad. You just don't.

DAD: Did you think it was easy? But "the road to riches is paved with sharp stones"—

LAINE: Stop talking like that! It's not true! Not with your children, your daughters. You were supposed to love us above everything, anything!

DAD: That's selfish, Laine–

LAINE: Of course it's selfish! We're your children! We're supposed to be selfish! We're supposed to come first–

DAD: You don't know what it's like. It's so hard to be poor, to be in debt. I lived in the projects most of my childhood. When Joel came to me with the business, the chance to finally have the world at my fingertips, I had to. I finally had a chance at true happiness-

LAINE: Well you'll have it, woncha? In your big old mansion and with your ugly sportscars. Without us...or at least me. You can salvage Iris, but not me-

DAD: I thought you'd understand-

LAINE: You thought we'd understand? I was eleven years old Dad. All I knew was that you didn't want me anymore. And now, you want me? You can't have me! (DAD drops hands in defeat. LAINE sighs) I didn't want to get into this with you. I know all the reasons...and I know I can't change the past...but you can't either. What's done is done. (angry) And as of right now, I want you to stop the "I'm your father and in control" bit. You don't know the first thing about me. You don't understand me. And I don't know you.

DAD: You're my daughter–

LAINE: We are complete strangers...but maybe we can be friends.

DAD: (shaking head) I'm not going to stand for this–

LAINE: (angry) You don't have to! You made it like this! Now live

175

with it! (DAD and LAINE stare at each other for a moment. DAD finally sighs)

DAD: I've gotta go. But we'll discuss this later.

(LAINE says nothing. DAD hesitates, wanting to hug her. LAINE smiles sadly, goes to the door and opens it, giving him the conclusion he was seeking. DAD pauses again, then walks to door. LAINE shakes her head)

LAINE: No we won't. Bye Daddy.

(DAD stops then exits. LAINE shuts door and goes to stereo. Hears doors slam, IRIS shouting goodbyes. Music drowns it out. Goes to computer. Spotlight centers on her)

LAINE: *It was over. Enea stepped into the bedroom Mariah had torn apart with the force of her magic and smiled. Even Refuge's warrior skills had been no match against the furious power the girl had wielded. No match. The woman sighed sadly. Oh she'd miss her. Desperately. But if there was any girl who had a Destiny, it was that one. And it made Enea smile. That girl was bound for great things. Enea looked around and nodded once. Yes. It was here, in the grimy, stone walled chamber, owned by a war lord, that Sharra, the new Moon Priestess of Printier, had come into her own. Mariah had grown up.*

(LAINE sits back, smiles. Lights down)

CURTAIN

An excerpt from

Me, Myself and I
By Chasiah T. Haberman

Characters:
STAV: 15 years old, female
AVIVA: 16 years old, female
DINA: 14 years old, female
ILAN: 16 years old, male

(Me Myself and I is a presentational play, and the characters of
STAV, AVIVA and ILAN are written in poetry. DINA's parts should
be read as would ordinary speech. Those of STAV's parts which are
written in iambic pentameter are her thoughts and should not be
noticed by other characters)

(The bell rings, students move back and forth across the stage hur-
rying to their classes. STAV sits down on the bench. She puts her
books down next to her and keeps a novel on her lap, as if by hold-
ing it she is doing something. The hall clears and she sits alone,
hardly moving for five seconds before she begins to speak.)

STAV: Do flowers shudder if they cannot fear?
And do they miss the joy of summer days?
When winter takes them underneath the ground
Can these that never had a heart in them
Now wish they had one, hold some jealousy
For crying creatures, do they deep down know
That all their beauty touches every soul
Except their own, and then what use is it?
What use is anything if no one knows?
(DINA walks up to STAV and waves, STAV looks up abruptly)
DINA: You look so lonely. Is there something wrong?
STAV: I was only thinking, that was all. I'm not depressed or any-
thing– and you?
DINA: I'm fine, I'm doing great, Except I came pretty late to chem-
istry today.
STAV: Oh, is it okay?
(DINA pulls a piece of paper out of her notebook and shows it to
STAV)
DINA: He's mad. Look what he's making me do! He's making me

write "I will not come late to class again," over and over.

STAV: Dina! Forty three?

DINA: Stav, he wants a hundred– I can't write so much, my hand is tired. I spent last night on that research paper.

STAV: Yeah, I know,

I did too.

That really was not fun.

DINA: It was awful. My mother decided I'd take care of my sister the whole time! And all she wanted to do was play blocks and throw them on my notebook.

STAV: That's tough.

DINA: I know! Then I was trying to type it– and guess who thinks I really need company?

STAV: Who?

DINA: Little sister. She actually came in and gave me the full story of her entire day!

STAV: Oh, no–

DINA: (imitating a baby) And then we played tag, and then, and then...

STAV: Why didn't you just tell her to go away?

DINA: She's my sister! You can't do that! It's mean.

STAV: I guess so.

DINA: I'm serious Stav, I wasn't kidding. You can tell me whatever's bothering you, I'm not going to make fun of you or anything, I care– friends always do.

STAV: I know, and thanks.

But Dina, honestly

I'm fine.

Don't worry– really.

You know I'd tell you.

DINA: YOU were sitting all alone, I thought I'd come and make you feel better.

STAV: I kind of like

being alone, really.

DINA: Just sitting alone with a book? You're not even reading it, what are you doing– thinking?

STAV: Basically.

DINA: Stav, it's all gonna be perfectly fine.

STAV: I'm sure it will.

DINA: I have to leave you now, will you be okay?

STAV: Yes, don't worry

DINA: Don't worry Stav, things just take time.

STAV: Okay.
(DINA pats her on the shoulder, STAV smiles, DINA exits)
STAV: I would have sat in comfort had you not
Disturbed my thoughts and babbled in the air
Around my head– in circles. But all that,
The noise you make and all your friendly smiles
They aren't what annoys me, all these things
Will entertain me other times, but now
I just can't stand it. Something makes me wish
To stay within my thoughts– to find the door
To somewhere where disturbances don't come
And having found the door– to find the key
That keeps it so forever. Sitting there
I could respond to everything and still
See what goes on around me, hold the world
Within enchanted eyes.
(looks up)
Here comes Ilan
(Enter ILAN. ILAN wanders absently, he stops and stares at the
wall as he begins to speak and then gradually moves on)
ILAN: Yeah, yeah– they're so dumb, people are so dumb–
as long as they had
their nice organized
air conditioned
house and shut curtains,
they wouldn't notice
If the world was bombed.
Idiots.
Yeah... But they don't know it
do they?
No, they don't know anything.
(Exit ILAN)
STAV: The world turns so gently, I cannot
take notice of its speed– it seems quite still.
And I remain so rooted in the ground
That all beyond its clutches is beyond
The clutches of my mind. Let silence thicken
And I cannot be sure of things by sound,
And have no proof that other people wander
The world my eyes take in. I see it then
Only through myself and hold unbroken
A thought or many of the worlds ways–

179

Till interrupted by a soul who talks
And seeks in me an answer
(Opens and then shuts the book in her hands)
All things speak
The language of existence, only one
Will ask a quick response, as if thoughts were
A game of keeping balls within the air,
And letting words go by with no response
Will end this game of catch that people play.
And as the game goes by someone will ask
Why it had mattered that the ball remain
Always in the air.
(AVIVA enters and asks STAV why she is sitting alone. DINA joins
them and inquires about STAV's state of being. She exits and AVIVA
and STAV continue their conversation– a didactic exchange about
the sky and the origin of thoughts. AVIVA exits. STAV is left alone
again. ILAN returns to his locker. STAV's and ILAN's conversation
follows his aimless thought pattern. ILAN exits. STAV is alone for
a moment longer.)
STAV: I look for mirrors, yet they are so smooth
I cannot touch them - cannot even hold
Them long enough before they drop in bits
Upon the solid floor
(STAV pauses and stares out the window)
Enter AVIVA
AVIVA: Stav, you're still sitting?
STAV: Yes.
AVIVA: All by yourself?
STAV: Yes.
AVIVA: Don't you start to think
Sometimes
You should talk to some...one?
STAV: Yes, just not always.
AVIVA: Don't you think it's nice
to be around people
and talk to your friends–
Isn't that more fun
than sitting
All by yourself all day?
STAV: No.
AVIVA: No?
STAV: No.

(AVIVA sits down next to STAV)
AVIVA: What are you doing then
all by yourself?
STAV: just thinking.
AVIVA: And you're not doing anything.
just thinking.
What, may I ask
Is there in your head
So important
That you have to be alone
to ponder
it?
STAV: It's not
anything special really
just random things–
and weird ideas
AVIVA: Then why do you need to be
by yourself?
STAV: Then I don't have to talk
When I talk
I can't think of these things
it's as if–
AVIVA: As if what?
STAV: I can't say these things
AVIVA: What can't you say
to me?
STAV: Nothing–
nothing real– or happening
just weird stuff
moving around my head.
I'm trying to hold it
I can't
hold enough together
to tell you about
I can't–
AVIVA: Tell me important things
Share what matters
to you
with me?
STAV: It isn't you, no
something deeper
I can't find it

exactly
What stops me
is in myself
AVIVA: If it's you
can't you change it?
STAV: To become who?
Some perfect being
Whose mouth and mind and soul
just lead to each other
flawless
Some–
AVIVA: Friend.
STAV: I–
AVIVA: Friend.
STAV: Aviva,
I have nothing
against you
and I like talking to you
most of the time
I just–
AVIVA: Friend.
(There is a pause)
STAV: Aviva, I didn't intend
to hurt you, I only desired
to catch my thoughts
And maybe,
maybe they aren't important
maybe they are the stupidest
thoughts that a person has had
but they are my thoughts
AVIVA: And I am your friend
and our conversations
may be
the stupidest ones
that you could imagine,
Maybe they aren't important
but–
STAV: They are important.
Just sometimes–
AVIVA: They're less important
than what goes on
in your head

STAV: No, not less
I care about them
just as much as
my thoughts
it's just–
AVIVA: That you can't stand it
STAV: No, it's just different
sometimes I need...
(AVIVA gets up)
It's not...
I don't...
(AVIVA begins to walk away)
Aviva
(AVIVA continues walking, STAV looks after her as she begins to
speak)
And if I crush a flower– will it grow
And will it matter if I sprinkle rain
For all its hopeless roots– will leaves and stem
That now support no beauty notice when
The golden warmth of sun will touch their green
In hopes of bringing sun– will summertime
Have vanished for them now– before the frost
Of autumn dares to peek through veils of heat
That call themselves the summer– in the spring
Of years that come– will flowers bloom again
When hope is robbed, can flowers still survive?
(STAV stands up and takes a few steps in the direction in which
AVIVA left and then goes back to her seat)
And if it makes a difference then perhaps
There's something precious in the constant game
Of playing catch with words– the constant fear
Or silence overtaking running deer
When deer are conversations, only there
To signify a peace that only friends
can have between them– company
Has unity in thinking even if
The thoughts are silly and the speakers both
Will recognize its almost worthless way
of being worth the world between two friends
(STAV takes out a piece of paper and a pencil and begins to write)
Dear Aviva,
I'm sorry, I didn't mean to do what I did, or to say what I said. I'm

sorry, I know what I did was wrong, and I'll try really hard not to do it again. It does mean something to me.

(She looks at it and then looks up and then back at it, she then rips it into pieces, letting them flutter to the floor, and then bends down and picks them up. Not knowing what to do with them, she crumples them up and puts them into her notebook)

What monster haunts the woods when all the deer
have stopped their running, and the birds have sunk
Their voices in the silence, when the sound
Of leaves that whisper foolishness has gone
And been replaced entirely by snow
Which having come, has fallen down so thick
That all the warmth that summer left the earth
Has disappeared– until the river swells
With springtime and in rising gently strokes
The grass that hid its green beneath the white
That was the choking snow

(she pauses and turns the book over in her lap)

If snow would hear
The pleading of the summer, then perhaps
In falling it would leave another hope
Another moment for the single burst
Of orange in the flower, leave the stem
Its pride, and spare for leaves the utter joy
Of owning something orange in the world
In which the white of snow had painted twice
All the worlds' cold

(The bell rings. There is the movement of students walking from class to class. AVIVA passes and STAV gets up to talk to her, several pieces of the letter fall down to the ground, and they exit together.)

CURTAIN

section seven

"We come bearing gifts."

An excerpt from

Tightrope

By Sarah Koteles

(Curtain opens. Lights up. DEVON is trying to balance on a rope that is lying on the floor. After about a minute of balancing, she hops off the rope and looks at the audience.)

DEVON: Hi. I'm Devon. Let me tell you a little about myself. I'm a seventeen-year-old senior at St. Katherine's High School. I love listening to music and watching horror movies. I have one younger sister and an annoying, overprotective parental unit. Ever since high school started, my life's gone downhill. Okay, first there's the question "am I going to college?" and if yes, there's the other nagging question...

(*Flashback DEVON's MOM and DAD are in the living room sitting on a couch.*)

MOM: What college do you want to go to?

DAD: You know, UIC's a great school. I remember when I went there. It was the best decision of my life. And of course I met your mother there. (He looks over at his wife lovingly. She giggles back. Devon rolls her eyes.) They've got a wide-range of courses from anatomy to psychology.

DEVON: What about photography?

DAD: Umm...I'm sure they must have it.

DEVON: Fashion design?

DAD: Probably.

DEVON: (muttering under her breath) Probably not.

MOM: You know, I bet you'd make a great nurse or doctor. Ever think of getting into the medical field?

DEVON: (making a face) No.

DAD: (to MOM) Honey, don't try making decisions for her. She's old enough to choose for herself. (to DEVON) You really should consider UIC. You'll love it!

DEVON: (annoyed) Daaad.

DAD: Now, I know it's big and looks intimidating, but hey. If I can do it, you can do it.

DEVON: (under her breath) Whatever. (Back to the present. To

audience) So that's how it went with my parents. Although it wasn't half as bad as when I talked to my friend, Trish. To make matters worse, I already have an inferiority complex with her.

(*Flashback PATRICIA and DEVON are sitting down at a table at school.*)

PATRICIA: So I told Miss White that if the school doesn't put my class rank on my report card, I'm leaving. 'Cause, I mean, that's not fair! Just because all the average students can't accept the fact that there are people way better than them, it doesn't mean I should suffer. No offense or anything, Devon.

DEVON: (pause) What's your rank in class?

PATRICIA: Seven.

DEVON: Seven?!?

PATRICIA: Yeah. I went down. Last year I was six. Hopefully by the end of the year I'll regain my spot at six.

DEVON: (to the audience) And you wonder why I feel inferior! It's people like this (gesturing to PATRICIA) who make people like me go to psychologists and pay for self esteem.

PATRICIA: Then there's the problem of too many after school activities. There's the French club, stage crew, costume crew, creative writing, dance club, and UNITY. On college applications, there's not enough room for all these things. What am I gonna do?

(Enter APRIL. She comes and sits down next to them.)

APRIL: Hey guys. What's up?

DEVON: Nothin' much. You? (to the audience) This is my other friend April. She's quiet, but really cool. I've known her since pre-school.

APRIL: Hey Dev, I bought you this book of poems by Charlotte Sennet. I think you'll really like them. Wanna read it? (APRIL digs into her bookbag and takes out a book and hands it to DEVON)

DEVON: Sure. Thanks. (to the audience) I had just about gotten over the college application trauma talk, when Patricia had to bring up something I've been trying to avoid for as soon as possible. I was hoping that if I ignored it, it would just go away. Right? (singing) Wrong!

PATRICIA: Hey, you guys are going to the prom, right?

APRIL: (sarcastically) Oh. Darn it. I think I have a root canal that night. (DEVON laughs)

PATRICIA: Come on, April. You're such a bump on a log. All you

do is sit at home and read all day with an occasional outing to the bookstore for some more of those boring as hell poetry books.
(APRIL is silent for a moment)
APRIL: So.
PATRICIA: So, you need to get a life! Have some fun. Paint your nails. Buy a dress. Be a girl!
APRIL: (lightly) Nah. Maybe next year. (PATRICIA groans)
PATRICIA: (exasperated) What about you Dev?
DEVON: Uhh...
APRIL: (in a deep voice) She's gonna stay at home and watch football with me.
PATRICIA: You've got to go Devon. (to APRIL) You too.
APRIL: That's a funny one, Trish! Good one!
PATRICIA: (to APRIL) Shut up!
DEVON: I don't even know how to dance. I suck at it.
PATRICIA: Who goes to a dance and actually knows how to dance?! (PATRICIA laughs to herself)
APRIL: (sarcastically) Call me crazy, but that's what I thought.
PATRICIA: (to DEVON) Devon, Devon, Devon. (to APRIL) April, April, April.
APRIL: (to PATRICIA) Psycho. Psycho. Psycho.
PATRICIA: The purpose of going to the prom, or basically any dance, is to have an excuse to buy a really expensive dress, get your nails and hair done, and the best part of all...get a really cute date who will soon become your boyfriend because he'll fall in love with your feminine ways and then he'll buy you things and you can talk about him constantly with your friends and they'll all be jealous.
APRIL: Oh Dear Lord. The youth of America today....I'm ashamed to say I'm a teenage girl.
DEVON: Well, I don't have anyone to take.
PATRICIA: I'm sure I can find you someone. (PATRICIA searches her purse for a minute. She takes out a little black book.)
Alright. What kinda guy do you want?
DEVON: (gesturing towards the book) What's that?
PATRICIA: It's my famous Book of Guys. It's arranged by types. There's the jocks, the freaks, the alternateens, the geeks...you get the picture.
APRIL: So this is what you do with your free time.
PATRICIA: (flipping through the book) Let's see. Billy's kinda cute.

Oh yeah. He's taking Lisa. There's Dan. But he hates dances and that could be a problem.

APRIL: (sarcastically) Ya think?

PATRICIA: Then there's David. (pause) Nevermind. Too short for you. Tom? Too egotistical.

APRIL: You two would be perfect.

PATRICIA: Now here's one. I found a date for you, Dev! You'll love him! (Back to the present)

DEVON: (to the audience) So I was stuck with a blind date for the prom. Fun. It was kinda freaky. When I told my mom about it, she was acting more excited than I was.

(*Flashback In the dress department of a mall. The MOM is looking at a pink dress on the clothes rack. DEVON is next to her trying to get her attention. A saleslady is off to the side behind a cash register.*)

MOM: I wonder if they have this in your size. Let's see.

DEVON: Um...mom?

MOM: Oh, darn it. They don't.

DEVON: (singing) Mom?

MOM: I'll go ask the saleslady.

DEVON: Mother? (MOM walks over to the saleslady with the pink dress in her hand)

MOM: Do you have this in a medium? All there's left are smalls.

SALESLADY: Let me check. (The SALESLADY goes to the back of the store (offstage).

DEVON: Mom?

MOM: You know, dear, your Aunt Judy's sister-in-law has her own hair and nail salon. I can see if I can get an appointment—

DEVON: Thanks mom, but you really don't have to do all this for me. It's not that big of—

SALESLADY: (proudly) I found one!

MOM: Oh good! Honey, go try this on, okay?

DEVON: Mom?

MOM: Yeah?

DEVON: I hate pink.

MOM: Well, why didn't you tell me?! (DEVON looks at the audience helplessly. MOM walks over to another rack of dresses and picks out a purple one.) How about lavender? You'll look so pretty in it. Whatta ya say?

DEVON: I was thinking more along the lines of something...black.

MOM: Black?

DEVON: Black.

MOM: This is your prom, Devon. Not your funeral.

DEVON: (under her breath) That's what you think.

MOM: But if you really want a black dress, I suppose we can look for one. (DEVON and her MOM start looking around. DEVON spots a dress she likes)

DEVON: I like this one. (MOM looks at the black dress DEVON's holding)

MOM: It's a little too short. Try to find something longer, dear. (DEVON continues looking)

DEVON: How 'bout this? (DEVON holds up another black dress)

MOM: It looks too big. They probably don't have it in your size.

DEVON: We can just ask the saleslady if she has it in a smaller size.

MOM: Oh I'm sure she's busy. Why trouble her? Let's just look for another dress. (MOM starts looking again)

DEVON: Mom, what's wrong with the color black?

MOM: (acting surprised) I never said I had a problem with the color black.

DEVON: (raising her voice) Well you sure do act like it. Why won't you let me pick out my own dress. I think I should have a say in it seeing as it is my prom dress and all.

MOM: (softly) Honey, is it that time of the month?

DEVON: (annoyed) No, mom. I'm just sick of shopping. We've been in the same department for three hours. Can we go?

MOM: Sure. We'll come back another day.

(Back to the present)

DEVON: (to the audience) Boy was that a nightmare! That day felt like it would never end. I thought I was going to lose my mind if I looked at another pastel-colored dress. It was then that I decided I wanted April to come with me to the prom. I needed someone not so enthusiastic and hyper like my mom...or Patricia. My plan worked! April was going to go to the prom with her number one crush, Keith. After she thanked me about a million times for daring her to do that, we went out for ice cream as a pre-prom celebration. The next week flew by and soon the prom was here. The dreaded yet anticipated prom. The moment of truth for me I would finally get to meet Joe. The dreaded yet anticipated Joe. The day of the prom my mom was going berserk. (sarcastically) What a surprise.

For the last two weeks she'd been frolicking around the city making hair and nail appointments, looking for the "perfect" dress, renting a limo, and ordering matching corsages for Patricia and me. Pink carnations to go with our pink dresses. Might I add that I looked like a bottle of Pepto-Bismo! Patricia, April, and I decided to all meet at my house before the prom. Our dates would also meet us there. It was my mom's idea. She insisted on meeting Joe. My dad also said he'd like to have a talk with him. At that point, Joe had my deepest sympathies.

(*Flashback. In the living room, DAD is sitting on the couch reading the newspaper. DEVON is in her room getting ready. MOM is crazily running around the house looking for the video camera.*)

MOM: April! Come here honey! (APRIL walks offstage) Say cheese! (a click is heard and a bright flash is seen from offstage.) Perfect! (The doorbell rings. MOM rushes to the door and opens it) Patricia! You look so cute! I love the color of your dress!

PATRICIA: Oh! Thank you! Pink's my favorite color!

MOM: Me too! (DEVON comes out of her bedroom. APRIL joins them) (sentimentally) Oh! You girls look so pretty and mature. You're making me feel old. (pause) I've got to get a picture of you three. Soon you girls will be off to college and forget all about your old and senile parents. You'll go off and get married and have kids. Next thing you know, I'll be a grandma! (She grabs the camera and takes a picture of them) I remember when you were only three years old, Devon. It seems like only yesterday.

DEVON: Mom? Have you seen my earrings?

MOM: You used to get spaghetti all over your face and down your diaper.

DEVON: Um...Mom? Do you know where my silver earrings are? The butterfly ones? That Aunt Sue gave me?

MOM: Every time I changed your diaper I'd find -

DEVON: (a little louder) You know what? I think I'll just wear the gold hearts. (DEVON marches to her bedroom)

MOM: Are you looking for something, honey? (The doorbell rings. MOM answers the door to find JOE wearing a tacky bright blue tux and thick, black-framed glasses) You must be Joe! (hollering to DEVON) Dev! Your date's here! (DEVON comes out of her room quickly. She shuts her bedroom door, turns around and freezes once she sees JOE.)

JOE: Boy do you look pretty, Devon.

DEVON: (pause) (to MOM) I don't feel well.

MOM: What's wrong, dear? You were fine a minute ago.

DEVON: I think I'm going to throw up.

(DEVON goes back into her bedroom quickly)

PATRICIA: That was weird.

APRIL: I'm gonna go see what's wrong.

PATRICIA: Me too. (APRIL stops her)

APRIL: I don't think that's a good idea.

PATRICIA: Why not? I'm her friend too, ya know.

APRIL: (under her breath) Not anymore. (APRIL enters DEVON's room and closes the door. DEVON is lying face up on her bed.)

DEVON: Do you think I should kill Patricia with a knife, a gun, a rope, or all of the above?

APRIL: I'd light her hair on fire.

DEVON: He's a geek!

APRIL: He's a freak of nature, that's what he is.

DEVON: What am I going to do? My worst nightmare has come true. What did I do to deserve this? It's not fair. How could Patricia do this to me?

APRIL: Cheerleaders. Go figure.

DEVON: I thought I could trust her taste in men.

APRIL: You call that a man?!

DEVON: I can't believe this. If only I could get back at her. She's got a hot football star date who's the most popular guy at Cajetan.

APRIL: And the stupidest. The only class he can pass is gym. I'll be surprised if he can even find your house. He'll probably get lost and refuse to ask for directions.

DEVON: That's it!

APRIL: What's it?

DEVON: (frantically) What time is it? (DEVON glances at her clock in her room) Good. We still have time.

APRIL: What are you going to do?

DEVON: (smiling deviously) You'll see. (DEVON searches through one of her desks for her phone book) Now where did I put that address book? (she finds it) Ah-Hah! Found it!

(DEVON picks up her phone and punches in a phone number) (pause) Hello? Mike? Hi. This is Devon. You know, Patricia's friend? (pause) You're supposed to be coming to my house in a

little bit? (pause) Yeah. Well, there's a slight change of plans.
Instead of you coming here, we're gonna pick you up, o.k.? (pause)
Alright. Bye. (DEVON hangs up the phone)

APRIL: You're so devious. (smiling) I taught you well. (pause) But
what about Joe?

DEVON: Well,...Patricia needs a date now.

APRIL: But now who are you gonna take? (pause) Hey! You can
take my brother!

DEVON: Aren't you going to feel weird about having your brother
with you at prom?

APRIL: If you don't have a date, then you can't go and there's no
way I'm going without you, Dev. C'mon. He's still got his tux from
last year and he can get ready real fast.

DEVON: Alright. As long as his tux isn't bright blue like dork boy.

APRIL: I can assure you it's not.

DEVON: (getting of her bed) O.K. (smiling) Let's rock and roll.

APRIL: Ready to rock. (DEVON and APRIL exit bedroom)

(Back to present)

DEVON: (to the audience) Prom night was awesome! April's broth-
er was really nice, April was in heaven with Keith, and Patricia had
to put up with Joe the whole night. Serves her right. There's a say-
ing I was told when I used to work at a fast food restaurant once: If
YOU wouldn't eat it, don't serve it. Obviously Trish has never heard
this before. Well, all and all, despite the awkwardness, embarrass-
ment, and horror of senior year, I'm glad I survived it. Just think,
next year I'll be a freshman in college. More fun and surprises there
to deal with. Well, like April always says, "Life's a bitch and then
you die."

An excerpt from

Night Visitors

by Judith Disterhoft

The framing device is AJ's journal. The scenes between AJ and Connor, AJ and Julien and the three characters are all flashbacks. The present is AJ reading from her journal sitting in her room. All of her flashbacks also take place in AJ's room. The series of scenes are interrupted by AJ's journal transitions, then we return to another flashback.

AJ: I'm always scared that the world will end before I've done everything I wanna do. I was smoking a cigarette up on my roof the other night, and I swear I was real close to witnessing something crazy. I was just mindin' my own business and all of a sudden this thick, dark sheet of clouds rolls across the sky. It got so dark so quickly that it was almost as though the sky was roaring and opening its endless jaws to swallow me whole for all my sins. It was grey, and then there was this deep red... It's times like those when I relive everything wrong in my life in like 30 seconds. Why is it we always remember the bad things, and never the good? Someone once told me that in life you regret the things you don't do, not the things you do. I don't believe that.

(Lights come up on AJ sitting on her bed with her knees tucked close to her chest and her arms wrapped around her self protectively, and CONNOR, wearing dark blue jeans and a white T-shirt, his coat is draped over the bed, he is sitting at the other end of her bed, looking upset)
AJ: Connor, I don't understand.
CONNOR: Yeah, obviously not. (There is a silence and CONNOR turns his head away from AJ while AJ looks at CONNOR intensely.)
AJ: What's going on?
(CONNOR sighs and looks longingly over at AJ. She untangles her legs and opens her arms, reaching for a hug. CONNOR falls into them gratefully.)
AJ: Are you okay?

CONNOR: I don't know what the hell is going on with me, AJ. I feel like nothing makes sense anymore. I'm slipping I can feel it.
AJ: What do you mean?
CONNOR: I feel so out of control. I mean, I can't seem to put things in perspective anymore. Everyone in my house is so damn crazy. I'm so sick of taking care of Gabe all the time. I don't have any time for me, for what I want to do. What happened to making decisions that will make me happy? Not my parents or my brother. I feel so trapped in that house. I need to get away.
(CONNOR pauses and then sits up in bed and grabs AJ's hands.)
CONNOR: (eagerly) Come away with me, AJ. You're the only one who understands me.
AJ: Away where?
CONNOR: Anywhere you wanna be. I'll take you anywhere.
AJ: You're crazy. We can't just up and leave. Let's wait 'til the summer, then we'll take a road trip. (CONNOR doesn't respond but instead drops AJ's hands)
CONNOR: (monotone) Okay.
(There is a silence and AJ seems uncomfortable. CONNOR stands)
CONNOR: I should really get going.
AJ: Why? You just got here.
CONNOR: AJ, it's two o'clock in the morning.
AJ: (smiling) That's never stopped you before. (CONNOR sits on bed again)
CONNOR: Don't you ever worry that one of these days we'll get caught? (AJ raises her eyebrows)
AJ: Caught? Doing what?
CONNOR: You know what I mean.
AJ: When was the last time my parents came up here? We won't get caught.
CONNOR: You're so lucky. I wish my parents could learn to give me a little space.
AJ: Yeah, it's nice to have parents who sort of respect you, ya know? Not many of them do.
CONNOR: Did you tell your mom about you and Julien?
AJ: What? About us... (hesitates)
CONNOR: (uncomfortable) Yeah, abut you two... Ya know.
AJ: Yeah.
CONNOR: How'd she take it?

AJ: She wasn't surprised. I think she probably already knew. I mean, we've been together for like, seven months.

CONNOR: Yeah. But it's an entirely different thing when your sixteen-year-old daughter sits you down and wants to tell you where babies come from.

AJ: She wants me to go on the pill.

CONNOR: (surprised) Really?

AJ: Yeah.

CONNOR: You goin' to?

AJ: I don't know.

CONNOR: Do you really think that's such a good idea? I mean, how do you know you guys will stay together?

AJ: (frowning) Connor, don't be ridiculous, of course we'll stay together.

CONNOR: I guess.(Pause) But how do you know he's right for you?

AJ: How do I know? Cuz he's so good to me. We make each other happy.

CONNOR: Well, whatever. (Pause) But doesn't that stuff mess up your body?

AJ: What stuff?

CONNOR: The pill.

AJ: No, not really. I know a lot of girls who are on it.

CONNOR: Like who?

AJ: Like this is really none of your business, okay?

CONNOR: (defensively) You brought it up.

AJ: No, you did.(AJ pauses to calm down.) Whatever. It doesn't really matter.

CONNOR: I just wish I could talk to my parents bout stuff like that.

AJ: Why don't you?

CONNOR: I just can't. They don't have time. Or maybe they do, but they just don't care. They care too much about all the wrong things.

AJ: Like what?

CONNOR: School, Gabe. I can't remember the last time they asked me how I was doing.

AJ: Well, you should try and talk to them about it.

CONNOR: AJ, it's just not like that, okay?

AJ: (submissive) 'Kay. (AJ looks down at her lap and fidgets with her hands, then looks at CONNOR) Well, you should talk to someone.

CONNOR: I talk to you.

AJ: Yeah, but someone else.

CONNOR: Whaddya mean?

AJ: I mean I shouldn't be the only person in your life.

(CONNOR looks hurt and turns his head away. AJ realizes that she's offended him and immediately reaches for his hand.)

AJ: You really should talk to someone.

CONNOR: Why, so they can feel good for ten minutes about helping me? It doesn't work.

AJ: How do you know until you try it?

(CONNOR removes his hands from AJ's grasp)

CONNOR: (sarcastically) Why are you so eager to get rid of me? Am I taking up too much of your precious time?

AJ: You know that's not what I meant.

CONNOR: Don't do me any favors. I can deal with this on my own.

AJ: (exasperated) Connor, what the hell is your problem?

CONNOR: What's my problem? What's my problem? Where should I start?

AJ: (angry) You know what? Don't guilt trip me. I have always been here for you, whenever you needed me at your beck and call. I've been there too, Connor. I remember begging you not to do it and then grabbing the bottle of aspirin out of your hands. (Pause) Or did you forget?(CONNOR sighs and calms down. He pulls AJ to sit on the bed. They face each other.)

CONNOR: It's like this. What if you really want to go to New York, but everyone keeps saying "Go to L.A., go to L.A.. The weather's great, all the people are rich and beautiful." But you really just don't wanna go to L.A., cuz you're already in the car, only four hours away from New York, no change in your pocket and the map flew out the window a couple hundred miles ago. It's so much easier to go to New York. (CONNOR pauses and thinks for a moment) And I don't know how to get to L.A..

AJ: What if I offer you a place to stay in Chicago? (CONNOR smiles)

CONNOR: I'd like that. But it's so far to L.A....

AJ: But think how many people you know between New York and L.A.. There are so many people who care about you so much. You could stay with them.

CONNOR: Yeah, I guess. But New York's so nice this time of year.

(CONNOR pauses and then snaps out of his daze. He grabs his coat.) I should go.

AJ: You're not gonna crash here?

CONNOR: No, I snuck out again. (AJ nods. CONNOR begins to open the window and climb out onto the fire escape. CONNOR turns to AJ and talks to her with one leg outside the window, one inside, holding the window open with one hand and his coat with the other. AJ walks over to the window. AJ gives CONNOR a quick peck on the cheek.)

AJ: Call me when you wake up, we'll go out to breakfast.

(CONNOR looks relieved)

CONNOR: 'Kay. Sleep tight. (CONNOR climbs out of the window and vanishes down the fire escape.) (Lights go down. Lights up on present, where AJ is sitting on her bed reading from her journal.)

AJ: I remember when I was little and my family rented a cottage down on the Cape for the summer. It was so beautiful. There's something amazing about the air out there. And the woods are so thick and deep you could get lost in them. I found this hollow tree and it became my secret hideout. It was my haven when I wanted to pretend I was someone else. No one knew about it. Escape is so hard to find now. Someone always needs you. But that tree was my own, a place to escape reality, and maybe if you're lucky, there'll be something there to comfort you and make you feel whole again. (Lights down on the present. Lights up on AJ's flashback. AJ is in the same blue plaid pajama pants and blue tank top. She is lounging on her bed smoking a cigarette. The chorus of Joni Mitchell's "Big Yellow Taxi" is playing in the background.) (AJ hears a noise. She quickly puts out her cigarette in an ashtray. She slides the ashtray under the bed.)

AJ: Hello? (No answer) Who's there? (Still no answer)

(AJ shrugs and lies down again. All of a sudden, her window opens and JULIEN pops his head in. JULIEN is wearing loose, straight-leg khakis, a white T-shirt and a blue-grey button down shirt.)

JULIEN: Hey babe.

(AJ jumps up, clearly startled)

AJ: Jesus Christ, Julien. You scared me. (AJ walks over to the window and holds it open while JULIEN climbs into her room.)

JULIEN: Sorry. (JULIEN stands next to her and kisses her on the mouth. AJ wraps her arms around JULIEN's waist and smiles. She

looks at the watch on his wrist.)

AJ: What're you doing here? It's the middle of the night.

JULIEN: (joking) Oh, I have to have a reason? (AJ laughs) I just wanted to see my baby. (JULIEN gives AJ another kiss on the lips. AJ smiles. AJ unwraps her arms from his waist and sits on the bed. JULIEN sits next to her and pulls her so AJ is leaning on JULIEN.)

AJ: Hi.

JULIEN: Hey.

AJ: It's late, Jules.

JULIEN: I know. I should've called.

AJ: (reassuring him) No, no, it's okay. What's up?

JULIEN: Nuthin'. I just wanted to see you.

AJ: That's sweet. (pause, AJ looks up at JULIEN) Is everything alright?

JULIEN: Yeah, yeah, I'm fine.

AJ: Good. (AJ leans her head back on JULIEN and closes her eyes)

JULIEN: Hey, AJ?

AJ: Hm?

JULIEN: Did you talk to your mom?

AJ: Bout what?

JULIEN: About us.

AJ: Julien, she already knows about us.

JULIEN: No, I mean us sleeping together.

(AJ opens her eyes and sits up to face JULIEN)

AJ: Yeah, didn't I tell you?

JULIEN: No.

AJ: Oh, I thought I did.

JULIEN: No. (Brief pause. AJ glances down and JULIEN looks directly at AJ) But Connor mentioned it to me.

AJ: Connor? That's weird.

JULIEN: Yeah, I thought so. Especially considering we haven't talked about it, and we're the ones it involves.

AJ: (apologetic) I'm sorry.

JULIEN: You two are always together. Really, AJ, when was the last time we spent time together?

AJ: I'm here now.

JULIEN: Yeah, but only because I resorted to climbing up your fire escape and sneaking into your room to see you. I hate knowing

that when I hang up with you at night you're gonna talk to
Connor afterwards. Remember when we used to fall asleep on the
phone together cuz we couldn't bear to hang up? What's happening
to us, AJ? I miss you. You spend all your time with Connor. Don't
I have any priority anymore?

AJ: Of course you do, Julien. It's just that Connor's really sick. He
needs me.

JULIEN: I need you.

AJ: I know, I do too.

JULIEN: I just feel like he's replacing me. I mean, I know he's not
doin' so good, but it's hard to see you two together. I just don't
understand why Connor can't talk to someone else. His parents are
payin' for that shrink, aren't they? Why doesn't he just go to him?

AJ: Because he's just a doctor. Julien, when you're upset, aren't I
always here for you to vent to? When you're hurting, isn't it better
to talk to someone who knows you and who'll understand what's
going on in your head?

JULIEN: But the whole point of therapists is that they're objective.

AJ: And cold and distant. All they can really do is diagnose you
with some standard behavioral description. They don't know how
to comfort him. I know him, and I understand him. He needs a
friend, someone who cares about what's gonna happen to him. He
trusts me with all of that. That's why he's able to confide in me.

JULIEN: He trusts you? What's trust got to do with it?

AJ: Everything.

JULIEN: But there are so many other people in his life who he
could turn to.

AJ: He doesn't feel that way.

JULIEN: But how is it fair for him to expect this from you? When's
the last time you did something for yourself? He's so goddamn self-
ish.

AJ: It's human nature to be selfish.

JULIEN: Oh, so that just excuses everything he's doing? Because he
has natural tendencies?

AJ: No, that's not what I'm saying at all. He's lost. He feels lost.
And fair or not, I'm the one he's chosen to help him.

JULIEN: Chosen? The one he's chosen to help him? So you're sup-
posed to be the designated watchman? Babying him until he feels

good enough about himself to face another day? Making sure the aspirin's locked safely away and the knives are in some secret drawer? Where does it end, AJ?

AJ: What would you suggest? See a shrink five days a week and force Prozac down his throat?

JULIEN: Yeah, isn't that what rich families are supposed to do?

AJ: Yes, which is why he's depressed in the first place. (AJ sighs) He needs to know that people close to him really care and love him. He needs to feel loved. He needs to be the priority in someone's life.

JULIEN: I don't understand why it has to be you. When have you ever put me before everything else in your life? (AJ doesn't answer) You haven't. But that's what you're doing for him. (JULIEN looks down and then back up at AJ) I can't do this, AJ. It's just too hard. I can't stand that he gets to be closer to you than I am. When have you ever cried in front of me? (AJ looks down at her hands) What has he done to make you love him more?

AJ: It's not about the different ties of my love, Jules.

JULIEN: I think it is. What has Connor done to deserve you that I haven't? It's so hard to know that I'm second best, AJ. (AJ sits closer to JULIEN. She looks directly in his eyes as she speaks.)

AJ: Baby, it's not about that. You know I'm with you. Connor is just a friend. Yeah, he happens to be a very needy friend, but he's just a friend. I'm with you, Jules. I'm not interested in Connor like that. I'm sorry that this is hard for you. It's hard for me too. But Connor needs me. I don't know why it has to be me, but I haven't stopped to ask. I'm just there cuz he asked me to be there. You know I would do the same for you.

JULIEN: (testing her but unsure himself) Would you?

AJ: Of course I would. I love you so much. Have faith, Jules. We're strong. I just need you to be there for me now.

An excerpt from

Decided

By Jennifer Gorman

JAKE: Merry Christmas. We come bearing gifts. (handing the food out) Okay, now, there's chicken in the noodley stuff, so you can eat that or there's chicken in the egg rolls so you can share, and, yes, I have your rice.

GINA: And here's the soups and the tea...

NANCY: (looking at the noodley stuff) Wow, that looks good.

JAKE: Okay, everyone settled and happy with their food?

NANCY: Do you mind if I try some of that? Okay, (Shoving her chopsticks into it. BRADEN looks at her in disgust.) Thanks. (loud buzz of approval)

GINA: So what'd you guys talk about for the five seconds that we were gone?

NANCY: You two.

GINA: What about me?

NANCY: I asked them what the hell you did to your hair.

GINA: I bleached it.

NANCY: I know.

GINA: What else did you say?

NANCY: Nothing else...about you.

JAKE: What are you implying?

NANCY: I had said that you seemed nice and would make some girl very happy some day, and Braden said–

BRADEN: Woah...well. I just said that you were...gay and you were just...a closet case. I guess...

JAKE: What?

NANCY: He said–

JAKE: It was rhetorical! (To BRADEN) Dude!

BRADEN: I mean, I'm sorry if you didn't want to be outed this way, but–

JAKE: Dude. I'm not gay. I don't know where you get these crazy ideas; but I'm just not. Sorry to destroy your dreams or whatever.

BRADEN: You dress sensibly...

JAKE: Do not! Look at me!

BRADEN: Well, you get along with women and relate to them really well...

JAKE: I'm a sensitive guy.

BRADEN: You know the words to almost every musical ever made...

JAKE: You used to force me to watch them with you!

BRADEN: Oh, alright–

MARIE: (jumping in to change the subject) We also talked about the fight that me and Nancy got into two years ago that had kept us apart until now.

JAKE: For some strange reason I don't doubt it...

GINA: What fight would this be?

MARIE: The one that caused us not to speak to each other and her not to come to our wedding or gramma's funeral?

GINA: Explain?

NANCY: Well, I was told by my husband–

MARIE: Her husband.

NANCY: That he had slept with her or she had slept with him or whatever it was.

MARIE: I didn't.

NANCY: So I was angry at her for it, but I held it in, until something came up–

MARIE: On Christmas Eve.

NANCY: Be quiet! Can't you just for once let me tell a story without butting in? Anyway, and so it just kind of...

MARIE: Came out.

NANCY: Exactly. And so here we are now–

GINA: (nodding) Ohh...I get it...A little family scandal...

JAKE: (looking at GINA) Seems there are a lot of secrets being kept in families these days.

BRADEN: Yeah...Jake...so lets get those all out.

JAKE: What are you talking about?

MARIE: Braden?

JAKE: Dude?

GINA: Jake?

BRADEN: How many girlfriends have you had?

JAKE: It doesn't matter! (sigh) One.

BRADEN: Why only one?

JAKE: I'm shy, I don't know. That's not the–

BRADEN: Still a virgin?

JAKE: What?

NANCY: He said–

JAKE: (through clenched teeth) It was rhetorical! Yeah. I'm still a virgin...What does this have to do with anything?

BRADEN: Why are you still a virgin?

JAKE: Because me and Gina don't wanna do it, because she isn't ready and it's illegal besides that!

NANCY: Woah...

GINA: Oh no, Jake!

MARIE: What?

BRADEN: You what? You and Gina? Yeah, right. (glancing at GINA) Wait, you're serious? You bastard! (BRADEN lunges at JAKE. He grabs JAKE pulls him into the bathroom and slams the door. GINA loses her balance and slips off the counter and onto the floor. A train passes by outside.)

GINA: (grabbing her knee in pain) Ow...I think I really hurt it...Oh, my God. (laying down slowly) I hope this floor isn't too dirty... (GINA curls up into the fetal position and passes out. BRADEN can be heard screaming in the background.)

NANCY: (looking at GINA) Well. What the hell was that?

MARIE: Remember that time that she hit her knee on the ladder in your pool when she was eight?

NANCY: And she passed out?

MARIE: Yeah, well, she passes out whenever she hits one of her joints. I guess something pops and causes a large amount of pain or something. Last New Year's Eve, she bashed her elbow against the coffee table and passed out for five minutes and no one noticed because everyone was way too drunk.

NANCY: Shouldn't we worry?

MARIE: I've never seen this amount of stress put on her before.

NANCY: Aren't you angry, though, at her or Jake about this whole thing? (Conversations jump back and forth. JAKE climbs behind the bath tub shower curtain, but BRADEN just rips it down and pulls him out.)

JAKE: Hey, man....I didn't want to tell you....at least not today...

BRADEN: So when were you planning to tell me that you've been molesting my daughter?

MARIE: No, actually, I found out on Braden's last birthday.

NANCY: Aren't you upset that he's been molesting her?

JAKE: Okay...it's not molestation...

BRADEN: Oh, yeah, you're right. A fifteen year old girl and a

twenty-five-year-old guy in a relationship is perfectly normal?

MARIE: I don't think they actually do anything but spend a lot of time together. I'm pretty sure that if they would have, Gina would have let on to something before. I know my daughter.

JAKE: Besides, she's not your daughter...

BRADEN: Hey! She's been my daughter for three months now! And my responsibility as a father is to protect my daughter from perverts like you. And I swear to God if you ever go near her again, I'll kill you.

NANCY: Are you sure that they don't do anything?

JAKE: She knows what she's doing with me. We don't do all that much anyway. She's always scared...

BRADEN: Shut up! Get out there!

JAKE: Look, listen to me, I want to talk this thing out. All of us...except maybe Nancy...

NANCY: Do you think we should have a family discussion about this?

MARIE: Maybe.

BRADEN: Get out there! (BRADEN and JAKE walk out of the bathroom and look at GINA lying on the floor in the fetal position.) Did she hit her knee or something?

MARIE: Yep. But I don't think the stress you put on her by overreacting like that was really any help.

BRADEN: Overreacting? This isn't overreacting!

MARIE: Then I hate to see you when you get really riled up.

BRADEN: Marie! A family secret has just been revealed to us! And you're acting like you've heard it all before.

MARIE: I have.

BRADEN: What?

NANCY: She said–

BRADEN: (through clenched teeth) It was rhetorical! When? When did you hear about it?

MARIE: Your birthday.

BRADEN: What?! (GINA wakes up with a jump.)

GINA: (dizzy) Ohhh...I have lint on my pants. This floor is dirty! I knew it!

NANCY: You heard her. (JAKE walks over and tries to help GINA up. She lays back down on the ground.)

BRADEN: Why didn't you tell me?

MARIE: On your birthday?

BRADEN: I don't know, whenever. I think I should have known

about this earlier and maybe I wouldn't have reacted so harshly now.

MARIE: Of course, you would have had the chance to react harshly a while ago.

BRADEN: Well. Maybe so, but what are we going to do about it now? What are our options?

MARIE: What options?

BRADEN: What do you mean?

MARIE: We can't do anything to stop them, since he's not really doing anything illegal.

BRADEN: You're fine with this!? You're letting our daughter date some sick, perverted grown man?!

MARIE: Calm down and we can discuss this rationally. You know that's not true.

BRADEN: I'm calm!

MARIE: Sit down in the chair. Now. (JAKE and BRADEN both take seats at the table.) I would like to say that all I want is for Gina to be happy and–

BRADEN: She's fifteen! Teenagers aren't supposed to be happy! We all know that.

MARIE: And I know her very well; and I know what she wants she usually goes for and is rarely ever controlled by anyone–

BRADEN: Even her parents?

NANCY: Oh, yeah!

MARIE: So, I guess what I'm trying to say is that her and Jake's relationship was probably not instigated by him.

BRADEN: Was it?

JAKE: Well...Kind of...

BRADEN: (standing) Kind of?! What does that mean?!

MARIE: Braden! Sit down! (pause) Anyway. Although I don't necessarily approve in the sense of age and law and whatnot, I still honestly don't see any problem with the majority of it, because I know Jake. He's really a great kid–

NANCY: And they really are cute together...

BRADEN: So what do we do?

MARIE: (shrugging) What can we do? We continue living our lives just as we had lived them twenty five minutes ago.

JAKE: It's decided, then?

BRADEN: Unfortunately.

NANCY: Looks like it... (Everyone sighs and turns to GINA curled up on the kitchen floor. Lights out, curtain closes.)

An excerpt from

Party Favors

By Joanna DuFour

Characters

Rosie Garrison: A thin, pretty fourteen-year-old girl

Libby Akin: A mature fourteen-year-old girl, Rosie's best friend

Eve Redfern: An energetic fourteen-year-old, friend of Rosie

Matty McPeak: A slightly self conscious fourteen-year-old, friend of Rosie

Brett Redfern: The handsome and charming seventeen-year-old brother of Eve

(It is 8:00 on a Friday night in October. The lights go up on a teenage girl's bedroom. There is a bed, a dresser, stuffed animals, stacks of magazines and a bulletin board with photos on it. EVE and ROSIE are next to each other on the bed reading a magazine together, and MATTY and LIBBY are on the floor. There are four backpacks and three overnight bags thrown carelessly around the room.)

• • •

EVE: Okay, new subject. (The room is silent for a few seconds.) Ooh, I have an idea!

ROSIE: (unenthusiastically) Great.

EVE: Let's play truth or dare! (Pause) Oh, come on guys, it'll be fun!

LIBBY: I'll play. Remember, we used to do it all the time.

ROSIE: I'll play too. I just hope we're still as creative with this game as we used to be. We were crazy.

EVE: Yeah, but someone always ended up crying that night, or died of embarrassment on Monday when word got around about what deep, dark secrets were revealed.

MATTY: I swear, you guys, the last time we played truth or dare, we must have been in sixth grade.

EVE: (hardly containing her giggles as she recounts the story) Yeah, yeah, it was in sixth grade because remember, Corrinna

208

Ardantowsky had to write "I love Boris" on her forehead, and she used permanent marker by accident!

MATTY: Yeah, and it didn't come off by Monday at school. Poor Boris was so in love with her. He nearly died when he saw that on her forehead. Too bad it was a complete joke!

EVE: Did you ever notice how Mondays are, like, the most insanely embarrassing days ever? I mean, every humiliation that I've suffered in my life has probably been on a Monday.

LIBBY: I feel awful. We were so mean that year. It was like no one could come near us. I guess everyone was terrified of what we might say to them. We were such a little clique of brats.

EVE: We were pretty bratty, weren't we? Oh well. You have to admit though, it was really fun, you know, feeling so in control of everything. Of people, I mean. I know that sounds terrible, but it's true. It's always fun to feel completely in control.

ROSIE: Yeah. I know what you mean.

EVE: All right, well, anyway, who wants to start?

ROSIE: I will. Matty, truth or dare?

MATTY: Truth, I guess.

ROSIE: Who was the last guy you had a crush on?

MATTY: What!?!

ROSIE: I've been wondering about this one for a while now. I just couldn't pry it out of you.

MATTY: No, I don't want to answer that.

ROSIE: Why not?

MATTY: Cause it's dumb.

ROSIE: I don't think it's dumb. Libby, Eve, do you think it's dumb?

LIBBY: No, I don't think so.

EVE: Me neither.

ROSIE: Well then.

MATTY: I hate you Rosie. I really do.

EVE: Well, at least we got that one out of the way.

LIBBY: Matty, we're all going to do this.

MATTY: I hate this damn game. I really do. This is the last time I play it. Fine. Well, besides Brett of course... It was, well, it was ummm... Grant Hartrich

ROSIE: Excuse me? Grant Hartrich as in my Grant Hartrich?

MATTY: It was a long time ago.

ROSIE: It's okay. I don't blame you. He's adorable and a stud. Just remember, he is all mine.

MATTY: I wouldn't worry. I'm not much competition.

EVE: God, I love truth or dare! Next!

MATTY: Fine, Eve, truth or dare?

EVE: Dare.

LIBBY: Uh oh. She's going to kill you.

MATTY: I dare you to stuff your face into that pizza.

EVE: No way. I'm not done eating!

ROSIE: And besides, do you know where the phrase "pizza face" originated?

MATTY: Okay, fine. I dare you to moon the next car that goes by!

EVE: Hey, I'll do that without being dared! (EVE walks to the window, gets ready. The sound of a car roars by, and EVE's pants go down.)

LIBBY: I can't believe you just did that!

EVE: (laughing so hard she's spitting up Coke) I think it was Principal Doverstone! He probably sets up camp outside my window at night just waiting for someone's butt to pop out so he can take a picture or something. What a perv! (EVE, LIBBY, and MATTY all sit back down around the pizza. ROSIE walks over to the door.)

ROSIE: I'll be right back. I just gotta go to the bathroom. Don't do anything too exciting without me.

(LIBBY looks at ROSIE in a concerned way, and their eyes meet for a moment. ROSIE looks away and exits. EVE and MATTY take no notice of the exchange.)

EVE: Wait, Matty, how many pieces of pizza did you have?

MATTY: I don't know, this is my third or something.

EVE: How 'bout you? (While they are talking, LIBBY gets up and stands by the bathroom door with her ear to it.)

LIBBY: Two.

EVE: Rosie ate half the damn pizza!

MATTY: It's so unfair that she can eat anything she wants and still be a teensy little waif.

EVE: Life is unfair, my friend. Oh, hey, I was reading this thing today. It said "one out of every four people in this world is mentally imbalanced. Look at your three best friends, if they seem okay,

it's probably you." So, which one of us do you think it it? My personal vote would be–

LIBBY: Definitely you Eve. Definitely.

EVE: Moi? Why whatever in the world would make you think that I am the crazy one? (EVE stands up and does a little jig.)

MATTY: Yeah, I'd bet on Eve.

EVE: I'm not crazy, I'm just creative. There's a difference, you know.

MATTY: In your case, I'm not sure how big of one.

EVE: You know what? I think that maybe you might be right because the other day I was walking home from school and everyone I passed on the street kept giving me these funny looks! I thought I had something stuck in my teeth, or my fly was unzipped, but I was all clear! What if I am crazy, but you guys don't know it yet and–

LIBBY: If you really are, I'd say that we already had it pretty much figured out for a while now.

EVE: No, but you'll come back to some boring high school reunion in ten years and find out that I've been committed to a mental institution.

MATTY: Wouldn't surprise me.

EVE: Libby, if you don't mind me asking, what the hell are you doing listening at the door of the bathroom?

LIBBY: Oh, I, um, I have to go next.

EVE: Hey, what's taking Rosie so long? I swear, that girl spends more time in the bathroom than the three of us combined.

MATTY: Look at this quiz. "Are your eating habits making you fat?" I don't need a stupid quiz to tell me that I'm fat. All I need is a mirror.

LIBBY: Matty, would you stop it!?! You're not fat!

MATTY: Hand me that pen over there. I'm going to take this thing. (EVE throws MATTY the pen.)

LIBBY: You know, those quizzes only make you feel bad.

MATTY: Yeah, yeah. I know. All magazines do. It's weird, I know this sounds kinda dumb, but it's almost like they're addictive or something.

EVE: Uh oh. Looks like Matty may have a magazine disorder. Better call Vogue Anonymous. (ROSIE comes quietly out of the bathroom, but is startled when she sees LIBBY at the door.)

ROSIE: What are you doing?

LIBBY: Well, I just wanted to see if you were okay in there. Are you?

ROSIE: (defensively) Yeah, God, I'm fine. You know, you're acting really weird. What's wrong with you?

LIBBY: (Softly, almost to herself) I was going to ask the same question. (ROSIE looks down at the ground, and MATTY and EVE give each other weird, suspecting looks. ROSIE tries to ignore it and returns to the circle, but LIBBY is still standing by the door and looking suspicious at ROSIE.)

EVE: Okay, whose turn is it? Ooh, I think it's mine! Libby, you know the question.

LIBBY: (As she returns to the circle) Dare.

ROSIE: You'll regret that.

EVE: No she won't. Dares are my specialty. And I dare you to...ummmmm, yell your bra size as loud as you can out the window.

LIBBY: You know, I'm really starting to wonder about the whole boob thing, Eve. It's getting a little strange.

EVE: Yeah, yeah. But I'm crazy, remember? Hey, wait a minute, before you do it let's place bets.

MATTY: Bets?

EVE: Yeah. I say 32D.

LIBBY: Ha.

ROSIE: 34C.

LIBBY: Close.

MATTY: 36B?

EVE: Matty, look at her. Now tell me, does this really look like a B-cup woman!?! (LIBBY walks over to the window.)

EVE: Silence everyone.

LIBBY: 36C!!!!!

MATTY: Jesus, she's got lungs!

EVE: And boobs!

LIBBY: Okay, it'd be absolutely great if we could stop discussing my various body parts now.

EVE: Okay, go ahead.

LIBBY: Well, it looks like Rosie is the only one left.

EVE: What'll it be?

ROSIE: Well, truth I guess.

(The room is awkwardly silent for a moment. LIBBY'S head is down in thought. Then, suddenly she looks up and looks at ROSIE gently in the eyes.)

LIBBY: Rosie, when you're in the bathroom so much, what are you doing?

(ROSIE quickly breaks the eye contact and looks down nervously. She tries to down-play the question and acts as if nothing has happened.)

ROSIE: You want detailed accounts of how I go to the bathroom?

(ROSIE laughs nervously but everyone else is silent. LIBBY hasn't stopped looking at ROSIE.)

LIBBY: You know what I mean, Rosie. It's okay. You can tell us. What do you do in there?

ROSIE: (becoming defensive) Nothing, all right! God. Why are you suddenly acting all concerned?

LIBBY: Because I am.

(MATTY has stopped looking at the magazine and is staring naively at LIBBY, not understanding what is going on. EVE is completely still and silent.)

Listen Rosie, I know what's going on with you, so you don't have to deny anything. I'm not trying to accuse you of something.

ROSIE: Well it sure seems like it to me.

LIBBY: I'm not, but–

MATTY: Does someone want to tell me what's going on?

ROSIE: Nothing! Nothing is going on. God. Really, Libby, the last thing I need is another mother.

LIBBY: I think that maybe that's exactly what you need.

ROSIE: Listen, I don't know what you're talking about, and neither do you. So why don't you just leave me alone, alright?

MATTY: What's going on?

LIBBY: Rosie, do you want to tell them, or should–

ROSIE: Jesus, tell them what!?! There's nothing to tell, Damnit! I'm fine. Completely fine!

EVE: Rosie, I don't know what she's talking about, but obviously something is wrong. If you don't tell me I know that Libby will later on, so you might as well do it yourself. (ROSIE turns her back to the other girls and tries to hide her tears. LIBBY sees this and goes over to try to hug her, but ROSIE pulls away.)

LIBBY: Rosie, please, just say it, or I will.

ROSIE: I'm fine. Just leave me alone, because nothing you can say will make anything any better.

LIBBY: You're right, I can't do anything, but there are other people that can help you if you just tell them.

MATTY: Help her with what!?! (There is a long pause. LIBBY looks encouragingly at ROSIE, but ROSIE just turns away. The tears are streaming down her face.)

LIBBY: Fine, Rosie. I'll do it. I'll say it and you'll probably hate me for it. But I can't just sit here and watch you do this to yourself and then not say a word to you or anyone else. (LIBBY turns to EVE and MATTY and pauses for a moment. ROSIE looks up pleadingly at LIBBY, but LIBBY doesn't back down.) The reason that Rosie can eat half the pizza, and then a quart of ice cream and chocolate cake, and not gain an ounce is that—

ROSIE: Please Libby, please stop.

LIBBY: Is that she throws it up afterwards. She throws it up every-day, more than once a day. That's why she's—

ROSIE: I hate you! I hate you more than you'll ever know! You were my best friend in the entire world. I trusted you so much, and look where it got me! (LIBBY's face remains calm, as if she expect-ed this reaction, while ROSIE screams at her. EVE is almost expressionless. MATTY is completely shocked.)

LIBBY: The worst part is over now, Rosie. It's done with. You don't have to hide it anymore.

ROSIE: That's not the worst part. The worst part is that I was betrayed by my best friend. The worst part is knowing that I was wrong about you for all of this time!

MATTY: I think that we were all wrong about each other.

ROSIE: I guess so. (ROSIE calms down and collects herself.)

ROSIE: Well, I know how you all think of me now, so maybe I should just leave. Maybe we'd all be better off. (ROSIE gets up, gets her bag and walks to the door, but EVE gets up to stop her.)

EVE: No Rosie, don't go. No one wants you to leave. If anyone has to go it should be Libby.

LIBBY: What!?!

EVE: Well, Libby, it's obvious to me that you don't care at all about Rosie's feelings. If she doesn't want your help, or our help, then we

don't need to force it on her. You really aren't being very sensitive to her, and if she had a problem, I know that she would come to us if she wanted us to know about it. Just lay off.

LIBBY: I can't believe what I'm hearing! How are you even thinking of the crap that is coming out of your mouth? God, I thought I knew you Eve, but obviously you're a totally different person than the one that I thought I was friends with! Do you even know what you're saying?

EVE: I know that Rosie needs friends, and that's why–

LIBBY: What the hell does it look like I'm trying to be!?!

(LIBBY and EVE stare at each other menacingly for a moment without a word, only their eyes challenging each other to do something. ROSIE looks at them, scared to say a word. MATTY sees this and jumps in.)

MATTY: You both need to sit back down, and take a long, deep breath because you're making yourselves look like idiots. Ask yourselves if this is going to help anything. I'll tell you right now, the answer is no. You're both acting like selfish brats. This isn't about either of you, so get off of yourselves for a minute and look at Rosie. It's about her. (LIBBY and EVE sit back down. They looked surprised at MATTY'S sudden sense of control. ROSIE looks at all of them, drops her bag onto the ground and collapses in tears, her head buried in her hands.)

ROSIE: (sobbing) I'm so sorry. I'm so sorry.

(LIBBY walks over and hugs her.)

LIBBY: You didn't do anything wrong Rosie. Remember that. None of this is your fault. None of it..

section eight

The Things
We Don't Know

An excerpt from

The Things We Don't Know
Onzsalique Wright

Lights up on entrance to Marquette Park. Catherine is standing at the bus stop. She is staring at a tree across the street. The tree has a birds nest in it. Catherine looks at her watch and taps her foot impatiently. Ranil enters up stage left. She moves very slowly and walks up behind her mother.

RAY: [She grabs her mother from behind] Hi!

CAT: [Jumps and looks up startled] Ranil! God, don't scare me like that. [Catherine lets out a deep breath] Where did you come from anyway?

RAY: The bus wasn't coming so I walked. I hadn't meant to scare you, only surprise you. [RAY smiles at Cat] Sorry I'm late, I couldn't help it.

CAT: Did you get held up at work? I've been waiting here for an hour.

RAY: Yeah, Shane didn't drop the baby off until way past the time I agreed to stay. What did you call me for anyway? What was it you said you needed me to do?

CAT: I need you to help me shop. There are a lot of things left to get for the wedding.

RAY: Ah, yes, your big day is coming up soon. Wedding bells, a honeymoon. Your champagne wishes and caviar dreams. How cool. What's left to buy and what stores do we have to hit?

CAT: I still need the flowers for the bouquets, candy for the wedding favors, the balloons and helium tank, what else, oh and the streamers for the reception hall. We can get all of this at Filene's Basement–

RAY: You're trying to get party stuff at Filene's?

CAT: No I told you that I wanted to buy something for Steve. Weren't you listening when I called?

RAY: Not really I was half out of it when you called, and whatever you are buying for Steve I don't want to know what it is. How much are the flowers going to cost you?

CAT: I'm not sure yet, I need to call the florist when I get home.

Are you going home with me? [RAY nods her head] Good then don't let me forget to call.

RAY: Which one? There's tons of them on the South Side. [CAT shrugs her shoulders] Mental note tell Ma to call some flower shop.

CAT: The Party Store is first because its closer, though I don't know where that is. All I remember is that Karen said it was on 51st and Pulaski.

RAY: You talked to Aunt Karen, she still owes me five bucks. [RAY looks at CAT] Why are you going some place that you have no idea where it is? We could get lost, and then Steve will call the police, then some hunky cops are going to have to come find us. [PAUSE] You know, that's not as bad as I thought. If some babe does come find us, can we get lost again a week before prom? [RAY takes her mothers hand] Please?

CAT: [LAUGHING] Would you come on. I don't want to be late. Karen isn't going to wait for us all day.

RAY: Sure, sure. Ma, if we had to go to Pulaski, why didn't I just meet you over there?

CAT: Because I haven't been to the park in a while, and a walk will be good for me and you. [RAY makes a face] Besides it's only a couple of blocks.

RAY: Only a couple of blocks [She drops to the ground] I'll starve to death. I'll dehydrate. I can't walk that far. You should carry me.

CAT: Yeah right, I couldn't and wouldn't carry you, besides I know you've got to weigh at least thirty pounds more than me. [RAY gets up and brushes off her sweats]

RAY: I'm insulted. I don't weigh that much. [She puts on her best wounded puppy look] and since you insulted me I should get a car.

CAT: You're crazy, but if it will make you feel better we'll walk in the park and I'll buy you lunch so you don't starve.

RAY: Yay! [RAY bounces up and down] Damn, if I had known we were going to be in the park I would have brought my blades.

CAT: What did you say?

RAY: I said damn I should have...uh-oh sorry I forgot who's presence I was in.

CAT: The people and bad habits you pick up amaze me. [CAT shakes her head. CAT and RAY walk into the park] What did you and Shane do yesterday?

RAY: Oh, the usual. We gang-banged, snorted some coke, and

knocked over a couple of liquor stores. After that we went back to her house and played the game of life.

CAT: Only you could fit a life time of crime into two hours.

RAY: Three and a half, and you know me I like to live on the edge.

CAT: So when are you paying me back?

RAY: Back for what? I don't owe you any money.

CAT: Yes you do. You owe me for the dress, remember you said that as soon as you got paid I was going to get my money back.

RAY: I don't see why I have to pay for something I don't even want. I should be walking down the aisle in a three piece Armani, not some dumb dress. You know your wedding is starting to ruin my plans. I can't cut my hair. I have to wear a dress, and shell out a ton of cash for it. I also have to spend time with the family.

CAT: You forgot the pictures.

RAY: Yeah, those too. Can you imagine me in a picture smiling and laughing or just standing there with a cheesy grin on my face. I look awful in pictures. My friends will never let me forget this. Shane alone has promised to torture the hell out of me for agreeing to do this.

CAT: I don't understand you. Why do you want to cut off all your pretty hair. You hate dresses and dress clothes period; and you are not, I repeat myself are not, going to wear black or red anything with that dress. No lipstick or eye shadow or nail polish. You have such a pretty face, and you cover it up with all that crap. [RAY makes a face] Don't make that face at me. I hate when you do that. Now back to the dress. [CAT looks at RAY. RAY turns her head and stares at a dog and his owner. CAT continues talking only moving her lips no sound]

RAY: [Soliloquy] God, why did I get her started on the whole dress thing. I should have stayed on a neutral subject like the wedding– no, that leads back to dresses. Liquor. We should have talked about illegal substances. Mental note never ever go with Ma to the park and talk dresses. What was that other thing that I was sup- posed to remember. I don't remember. Was it call Shane and tell her we have to hang out this weekend, no that wasn't it. Oh yeah, call the flower place...maybe I should write that down. [RAY looks into her purse, and pulls out a pen. She starts to write on her hand. She looks at CAT who is still talking]

CAT: I can't believe what a tomboy I've raised. Well at least you

agreed to wear the dress and smile. [CAT continues talking, only moving her lips no sound]

RAY: [Soliloquy] I've gone out of my way to be good about this. On top of all this I have to wear that medieval torture device you call feminine support, and pay for the dumb dress, oh not to mention the shoes. Damn I wonder how I'm going to pull off walking in those things. I know my feet are going to start hurting after two minutes in them. My hair is going to have those god forsaken bobby pins in it. The little silver things will puncture my skull, and no one will notice the blood oozing down my face because they will all be staring at the lovely bride. Can't you see that my face hurts when I smile. Only you would want me to be in that much pain for a lousy wedding. What you are is a thorn in my side and a serious cramp in my style.

CAT: [Soliloquy] I should ask Ranil who she is bringing to the wedding. I need to make sure there will be enough food. That girl never tells me anything. [CAT has stopped talking, she looks at RAY, and looks forward again, she looks back at RAY staring very closely] Are you wearing a bra? Why aren't you wearing a bra?

RAY: What? Ma I am wearing a bra. You need to get your eyes fixed or get bigger glasses. No your glasses couldn't get any bigger [laughs] Why did you ask me that?

CAT: Thanks a lot, my glasses are just fine, and the reason I asked was because you look like you are bouncing a lot more than usual. [CAT looks closer at RAY]

RAY: I just said I was wearing one.

CAT: Well do you have it on right, it looks like your breasts aren't...what's the word I'm looking for?

RAY: God, Ma why do you always have to bring up my breasts?

CAT: What is that word?

RAY: [Loudly] Perky. My breasts don't look perky enough for you. [RAY laughs.]

CAT: Well perky wasn't exactly what I was looking for...erect maybe, but it works. [RAY and CAT laugh out loud. RAY and CAT walk. Lights up on park bench]

CAT: Ranil, let's stop here a minute. I need to rest.

RAY: Why? We just got here. I thought you said the walk would do us good, remember?

CAT: Yes child I remember, but since I've been standing there waiting for you I got tired.

RAY: Sure I think you're just lazy, and this here park bench will aid you in your couch potato phase. [RAY sits down] Why didn't you bring Adam or Edward with you to carry all of the stuff. They are supposedly the two strapping young lads you raised?

CAT: Because I hardly see you since you've moved out, and I figured this would give us a chance to talk, and I also couldn't find either one of your brothers.

RAY: Oh, so I was a last ditch effort, hunh. [RAY looks at her mother. CAT smiles back] What did you want to talk about? I hope it has nothing to do with dresses.

CAT: Well, I make you no promises because I still need you to pick out shoes to go with your dress, plus some other things I had wanted to mention.

RAY: Hunh...I thought we had decided on the cream stacks at Marshall's?

CAT: You would wear those?

RAY: Yeah, I liked them, well I would tolerate them.

CAT: Good, then we can go get them later if we have time, and what are you doing with your hair?

RAY: I had really wanted to cut it, but since you wont let me I'm just going to pin it up.

CAT: You can cut it as soon as this is all over. Chop it all off if you like.

RAY: Nah, the skin head look isn't for me. [RAY looks at CAT and pulls her hair into a tight ponytail, slicking it back] What do you think?

CAT: I think you look fine just the way you are. [RAY lets her hair go and shakes it out] So are you bringing anyone?

RAY: Anyone like who? You mean a man. Now why would I do that. So you and the rest of the family can sit around and talk about my non-existent underwear, or better yet talk him to death. [RAY smiles at her mother]

CAT: No, I wouldn't talk to some stranger about your underwear. I do that in public. Everyone just wants to know about the people–

RAY: Men–

CAT: Boys in your life.

RAY: I don't date boys, come to think of it, I don't date at all; but if I did it would be a man.

CAT: I can't believe you, my daughter who has boys...excuse me

men on her mind all day long doesn't have a boyfriend.

RAY: It's not that I don't have one. I just don't want one. I believe that I could live a very happy life with a dog, and some popcorn–

CAT: [looks at RAY with eyebrows raised] And your repressed sexual urges.

RAY: Yuck, you said sex, Ma, and yes those too, a perfectly happy life. Now all I have to do is get me a dog, and some popcorn.

[CAT laughs out loud. RAY and CAT are staring out at the audience. There are dogs and children noises in the background]

CAT: Ranil.

RAY: Yeah, hey why can't you call me Ray like everyone else?

CAT: Because I named you Ranil, and that's what I'm going to call you.

RAY: Only you can call me that. That name is reserved only for my Mommy. [RAY gives CAT a hug]

CAT: No, I'm not buying you a car.

RAY: Damn...oops sorry. [RAY covers her mouth] What were you asking?

CAT: Oh, I just wanted to know why you think that you will never date any one? I mean what would make you want to live your life like that?

RAY: Like what? You mean, alone?

CAT: Well not alone [Pause] yes, alone. Look at Steven and me, we've been married thirteen years, and are about to renew our wedding vows. We both couldn't be happier. Don't you want that?

RAY: [turns and looks at CAT] What you and Steve have is great, and no one can duplicate that, and I'm not going to try. You and I don't want the same things, and I don't think that love, marriage, plus a thousand kids are for me right now, later, or ever.

CAT: Why? I see now that at your age thinking about kids love and marriage are all really big issues right now, but that doesn't mean you can't have a boyfriend or something along those lines, because it seems to me from what you are saying you have chosen to cut yourself off from all human emotion.

RAY: I know...It's just...I don't want one.

CAT: I don't believe that. What's the matter with you?

RAY: I'm scared.

CAT: Of what?

RAY: I don't want to mess up.

CAT: How can you mess up? What could you do?

An excerpt from

Inside Looking Out

By Andrea Gargano

MATT: All you gotta do Simon, is say, "Hey babe, me and you, prom, seven o' clock."

SIMON: Matt you're an idiot!

MATT: I know, but it works for me.

CLARE: And why it does is completely beyond me.

SIMON: I don't know, you guys. All this talk about Tyler and the prom is making me nervous.

MATT: I've never seen you like this over a girl before. You never told me that you liked Tyler.

SIMON: I said I did. I don't really know her too well but I've read a lot of her poems and stuff–

MATT: When did she let you read her stuff?

SIMON: She didn't. She's in my English class and every Friday we share what we've written during the week. Usually she just passes around her poems instead of reading them out loud. They're really deep. I don't really like poetry because I can't understand most of it. But her poems are good. I can actually understand what she's saying.

CLARE: (sarcastically) Why don't you go over there and read her deep poetry and get lost?

SIMON: She's kinda pretty too. Isn't she?

CLARE: How can you tell? Her hair's hanging in her face all the time.

SIMON: No it's not.

MATT: He's blinded by love.

VICKY: I think it's sweet. If you ask her to the prom, she'd be the luckiest girl in school.

SIMON: Thanks Vic. But I can't ask her, I'm scared. I don't know why. I mean I've never had this problem before.

VICKY: You don't have to ask her to the prom right now. You can afford to wait a few weeks.

CLARE: I say you ask her now, I need a good laugh.

MATT: Yeah, do it now. Be a man!

SIMON: See, you guys are going to make fun of me now, and she might think that it was all a joke. Besides, I can't just come out and ask her to the prom now. I barely know her.

VICKY: Well, the only way you're going to get to know her is if you ask her out now. Ask her if she wants to hang out tonight.

SIMON: Where would we go, though?

MATT: Take her to the movies.

SIMON: No, if we go to the movies then we can't talk.

MATT: Who says you need to talk?

VICKY: Shut up Matt.

MATT: Alright, take her to your house.

SIMON: And do what?

MATT: Oh, you know.

SIMON: Unlike you, I don't have sex on the first date.

MATT: Neither do I. I wait 'till the second, the third if I really like her.

CLARE: You're such a pig.

MATT: Clare, I know you want me, but sometimes even little rich girls like you can't get what they want all the time.

CLARE: Oh save it!

VICKY: Why don't you just ask her if she wants to hang out tonight. If she's cool with it then let her decide what you guys are going to do. Maybe she'll come up with an idea. Just don't be scared. She's a normal person just like you.

CLARE: Is she, though?

VICKY: Yeah, she is. Now are you going to talk to her or what?

SIMON: Yeah, I'm goin'. (SIMON walks towards TYLER, and fixes his hair on the way.) Hi Tyler.

TYLER: (nervously) Oh. Hi Simon.

SIMON: Can I sit down?

TYLER: Uh, yeah, sure. (TYLER moves her bookbag from the desk onto the floor allowing SIMON room to sit down. She pulls a few pieces of hair over the right side of her face.)

SIMON: Thanks. Uh, so what's going on?

TYLER: Nothing.

SIMON: What're you writing?

(TYLER abruptly closes the notebook that she was writing in.)

TYLER: Oh, I was just writing in my journal.

SIMON: Do you write a lot?

TYLER: In my journal?

SIMON: Well, don't you write a lot of poems too?

TYLER: Oh, yeah. Yeah, I guess I write a lot of poems.

SIMON: They're really good. You know, because I've read them in English class all year. And I like them a lot. I mean I usually don't read poetry. I usually can't understand the poems we have to read for English. But I understand yours. They make sense to me.

TYLER: Thanks. I'm glad someone gets them.

SIMON: There was one poem that I wasn't sure of though. I don't really remember what it was called. It was about a "minor mishap". I don't know, I didn't understand the "minor mishap" thing.

TYLER: Oh, uh...

SIMON: Did it pertain to you?

TYLER: I'm sorry, I don't know what you're talking about. It must've been someone else's poem.

SIMON: Oh, sorry.

TYLER: It's all right.

SIMON: Uh...listen, I'll be right back. (SIMON crosses over to the group and sits down.)

VICKY: So what's going on over there? What'd she say?

SIMON: It's going so bad. I don't know what to talk about. How can I just come out and ask her out? I need to talk to her about something. I just don't know what to talk about. She probably hates me. She's just answering my questions. She's making no effort to talk to me. She probably thinks I'm such an idiot.

CLARE: She's a mute. That's why she doesn't say anything.

VICKY: Don't listen to her Simon.

MATT: Did you ask her out yet?

SIMON: No, I was too nervous. I had a hard time thinking of what to say.

MATT: I don't know why you're making such a big deal out of this, just ask her out man.

VICKY: (laughing) Not everyone has it as good as you, Matt.

MATT: (jokingly) Yeah, well.

CLARE: Matt wishes he had it easy.

(SIMON turns to VICKY)

SIMON: What do I do now?

VICKY: Go back over there and start from where you left off. What were you guys talking about anyway?

SIMON: I told her I liked her poems. I mean I didn't know what else to talk about.

VICKY: Well, uh tell her, or no...ask her more about her writing or something. This way you're showing her that you want to get to know her. So when you ask her out you'll feel like you know her well enough. Do you know what I mean?

SIMON: Yeah, I guess.

VICKY: Don't worry about it, go do your thing.

(SIMON crosses to stage left and sits back down next to TYLER. TYLER stops writing to acknowledge SIMON.)

TYLER: Oh, hey.

SIMON: Hey. You like to write a lot don't you?

TYLER: Yeah. I can't help it though.

SIMON: Oh no, it's not a bad thing. I think it's really cool.

TYLER: Thanks. Do you write at all?

SIMON: I try but I can never put what I'm feeling into words. I write songs on my guitar and—

TYLER: You play guitar? I didn't know that.

(TYLER pushes her hair out of her face and faces SIMON.)

SIMON: Yeah.

TYLER: So do I. How long have you been playing?

SIMON: Ever since I started listening to Jimmy Hendrix in seventh grade.

TYLER: I love Jimmy Hendrix. I practically grew up to his music. My parents have all his albums, so I've been listening to him my whole life.

SIMON: My older brother, Scott, was in a band when he was in high school. He played bass and his band did a lot of Hendrix's songs. So after I had been taking lessons for a few months, my instructor taught me some of his songs.

TYLER: That's cool.

SIMON: Yeah, so how long have you been playing?

TYLER: Only about three years. I mean I'm not very good or any- thing.

SIMON: Don't say that. I've been playing for five years, and I'm still

not as good as I want to be. But it takes time.

TYLER: Yeah, I guess.

SIMON: Well, I have no problem playing songs on my guitar. I just wish I could write lyrics to go along with it. Maybe you could help me.

TYLER: Yeah, sure.

SIMON: Listen, Tyler. Do you want to go out with me tonight? We could just hang out or something.

TYLER: Oh, I don't know.

SIMON: Oh, alright. I understand.

TYLER: No, it's not like that. I just...Remember when you thought I wrote that one poem, the one that had to do with the "minor mishap"?

SIMON: Yeah, why?

TYLER: Well, I did write it.

SIMON: How come you told me you didn't then? I don't get it.

TYLER: Because you asked me what it was about, and I was afraid to tell you.

SIMON: Tell me about what?

TYLER: The meaning behind the poem.

SIMON: Why can't you tell me? I don't understand why it's such a big deal.

TYLER: Um...forget about it. Never mind.

SIMON: No, now I want to know what the meaning is. Why is it a big deal.

TYLER: I don't know. It's stupid. Just forget it.

SIMON: C'mon, this isn't fair. I want to know why you won't go out with me. (TYLER responds in a softer tone of voice.)

TYLER: The poem...well it's uh...about my scar.

SIMON: What? What scar? (TYLER covers her face with her hair.)

TYLER: I just have a scar, okay?

SIMON: Where?

TYLER: On my nose.

SIMON: Really? I never noticed it. (TYLER squirms a little out of nervousness.) Wait, what does this have to do with me asking you out?

TYLER: You still want to go out with me?

SIMON: Why wouldn't I? I just asked you out a few seconds ago.

Why would I change my mind so fast?

TYLER: I just thought the scar and lying about the poem might discourage you.

SIMON: Not at all. So do you want to hang out tonight?

TYLER: Uh...yeah, I do.

SIMON: Well where do you want to go?

TYLER: We could go to that new coffee shop that just opened. It's open mic tonight. So I'm sure a lot of people will do readings.

SIMON: Yeah, that's cool.

TYLER: I'm going there about seven, so you could just meet me there if you want.

SIMON: Ok, I'll see you there. (SIMON smiles and returns to the group confidently.) We're going out tonight!

VICKY: That's awesome. Where are you guys going?

SIMON: To a coffee shop. She's reading a poem there tonight.

MATT: How are you going to get close to the girl if there's a table in between you guys? I don't think going to a coffee shop is a good idea. You'll just be sitting there across from each other the whole night. No touching, no kissing, nothing. Just talking.

VICKY: They could always get it on on the table.

SIMON: Yeah right!

VICKY: Just kidding!

CLARE: A coffee shop? How lame.

VICKY: Lame? What's so lame about it? Are you jealous? Did you want to see Simon tonight?

CLARE: Hell no!

VICKY: Then stop criticizing Tyler.

SIMON: Yeah, Clare. Lighten up a little. Don't be so shallow. (Lights go down.)

An excerpt from

Mia Baby

by Kyra Termini

(Curtains. A flower shop fills the entire stage. A counter is up stage right, and a door with an open sign is center stage left. MIA is sitting behind a counter, reading an issue of *Readers Digest*. In walks CHESTER. As he opens the door, the sound of a storm, rain and thunder can be heard, and as the door is closed, the noise stops. Every time the door is opened it has the same effect. MIA is dressed in jeans and a sleeveless shirt. The tattoo of an unbloomed rose on her left shoulder blade. Door with glass window, radiator up center stage)

CHESTER: Morning Mia! It's pouring out there. (MIA puts down her paper) How long do you think it will last?

MIA: Forever, I hope.

CHESTER: Oh, that's right, you love the rain.

MIA: Now that I work inside I do. What can I do for you today, Mr. O'Brien?

CHESTER: Call me Chester, and do you have any of those white roses that I love so much left?

MIA: Always do. (Stands up then turns around and picks out one of the mentioned flowers, CHESTER walks towards the counter)

MIA: How will this one do?

CHESTER: It's perfect. You always carry the best.

(MIA lays the flowers out on the counter, and gets it ready for travel by cutting off the tip on a slant and fitting a plastic cup full of water on the bottom, then wrapping it up in tissue paper)

MIA: Anything else?

(CHESTER watches her)

CHESTER: Well, yes, actually... (Places money on the counter)

MIA: Another one of those, or some baby's breath for decoration? (Turns around to scan the counter behind her)

CHESTER: No Mia, not a flower–

MIA: Then what? (She turns back around)

CHESTER: Well...I come in here everyday–

MIA: Yes–

231

CHESTER: Who do you suppose I buy them for?

MIA: Your wife, daughter, a secretary I guess? Or maybe your mother? I don't know, I just sell them to you. Why, is something wrong?

CHESTER: I'm not married, have no children, and my mother lives in Connecticut. This is Los Angeles!

MIA: So you buy them for your secretary. (She shrugs) Doesn't she like them?

CHESTER: Like them? Where I work I'm the secretary!

MIA: So you buy them for yourself?

CHESTER: No, I buy them for you.

MIA: For me?

CHESTER: Yeah, well...the first time I came in here was to escape the rain...and everyday after I've come in, rain or shine, to buy from you, and well...I can't help but notice how attractive you are–

MIA: Oh god– (She begins to turn away)

CHESTER: You're fun to talk to, and I just wanted to see if we could further our relationship–

MIA: Our relationship? What relationship!! You come in here and buy flowers!

CHESTER: I know! I was just wondering...if you'd like to go out sometime. For dinner. (During this exchange, a woman walks in, and is patiently waiting)

MIA: Chester– I mean Mr. O'Brien. You're holding up the customers–

CHESTER: Maybe coffee? Just come with me to a cafe sometime?

MIA: I'm sorry, I can't. Now, excuse me. Excuse me, please, I have work to do. (CHESTER reaches out as if to touch her, but stops himself)

CHESTER: May–

MIA: Stop it! (Turns from him, CHESTER slams a five dollar bill down on the counter)

CHESTER: Keep the change! (CHESTER slams his hand down on the counter and storms out, forgetting the flower)

MIA: What can I do for you?

EL: Not that, I hope.

MIA: He said the wrong thing, now, can I help you, or are you just waiting out the rain? If so, I'm afraid I'm going to have to ask you to leave. (MIA puts CHESTER's money in the register)

EL: If I buy something will you let me stay?

(Not looking up)

MIA: I suppose so. It's the store's policy, not mine.

EL: Don't worry, I understand. Will you make me a bouquet?

(MIA reaches beneath the counter and pulls out a pad of paper and a pencil)

MIA: Sure, go ahead.

EL: Those blue carnations over there - (MIA jots down the different flowers on the pad of paper) Some babies breath and a little of that green one over there - (She points to it.)

MIA: This one...? (MIA finally looks up, EL smiles and nods)

Liz...? Liz, what are you doing here?

EL: I came to find you!

MIA: Why? Did I ask you to come? Was there some higher calling which roused your curiosity and told you to come and visit the sister you abandoned years ago? What were you thinking?!

EL: It's nice to see you too!

MIA: I'll bet it is.

EL: Mia, it's been six years, don't be so cold!

MIA: Thank you for proving my point. Six years! How do you expect me to act? You know what? I don't care. Get out, go home to our dear parents. They didn't kick you out. And if they had, I would have stood up for you!

EL: Mia! You're my older sister!

MIA: I'm aware of that. Didn't you bring them with you?

EL: Who?

MIA: Your precious parents!

EL: They're yours too, if you don't mind!

MIA: I know, sadly enough, thank you. You should go back to them! I bet every night they complain. (In a high sing-song voice) "Oh that distasteful girl! How we ever called her daughter I'll never know!"

EL: Mia...you know better than that.

MIA: Do I? Not according to them. Do you still want that bouquet?

EL: Yeah, sure...

(MIA begins to put the flowers together and get them ready in the same way as she did the rose, but she ties them all together at the bottom.)

EL: Mia...do you want to come have coffee with me somewhere, or something? Get out of this dreary place?

MIA: I've spent two years in "this dreary place," and the four before it in an outdoor version. Excuse me, but I have work to do if you don't mind. (She lays the bouquet on the counter) Will there be anything else?

EL: No...

MIA: Good. Now go home and have a good life. You don't need to get involved with your older, distasteful sister. That'll be $6.50. (EL gingerly gets out her wallet and places the money on the counter)

EL: But–

MIA: But what? Go, go! While you're still safe!
(ushers her towards the door)

EL: No! What are you doing? Why are you trying to throw me out the door! (Pause) Is it because of Mom and Dad?

MIA: Why do you think? You didn't stop them from throwing me out. I didn't hear one word of protest escape your lips!

EL: Don't you remember the note!?

MIA: What?

EL: The note, the one that you gave me, telling me where you were going, and that you would be okay? How else do you think I found you? It's a small world, but it's not *THAT* small!

MIA: But, after six years...why now? After doing nothing?

EL: I just wanted to know...to know how you were, and if your child came out alright...

MIA: We're doing great.
(She stands taller)

EL: Where is he? Or she...God, I don't even know.

MIA: He...is fine.

EL: So it was a little boy.

MIA: Yes. He's at a neighbor's apartment. She keeps him for me during the day.

EL: Oh. Tell me...what did you name him?

MIA: His name is Ivan.

EL: Is he a good boy? He must be getting big. Is he...will you...tell me about him?

MIA: He's five years old, and the sweetest boy...he obeys me, loves me, and respects me. I couldn't have asked for more. Even as a

baby he was extremely quiet. I love him so much.

EL: I'm sure you do. And I don't doubt for a minute that I would agree with you the moment I saw him.

MIA: Yeah, well...

(EL crosses to stage left and looks through the window in the door)

EL: It's so beautiful out. Do you remember what we used to do at home when it poured like this?

MIA: Not really...

(EL turns back to face MIA)

EL: We used to go and sit up in the tree house...you used to tell me really freaky stories, and every time the thunder hit, you would nudge me. I almost fell out of that tree a dozen times. (MIA smiles slightly) Do you remember that time the yard flooded, and we were trapped out there for hours?

MIA: Yes, you kept telling me to build a boat and go for help.

EL: I still think you should've. (Pause as they both stand nervously, MIA crosses over to center stage left and joins EL at the window)

MIA: Did I mention how long I've been working in this store?

EL: Yea...you said something along the lines of two years, when you were yelling at me back there.

(MIA ignores the last comment and continues)

MIA: I sold flowers for the four years before I came here, but I sold them outside, from a cart out on the street. It used to rain like this all the time, and with the smog here it's hard to tell if your waking up to cloudy skies.

EL: Ah...Los Angeles...

MIA: Very funny. (EL smiles at her) It was crazy, being out there in the rain, people running, trying to stay dry, not wanting to sit in an office soaking wet for the rest of the day. One day, the morning started off with a light drizzle. I hadn't brought an umbrella, and soon it began to pour. I quickly covered the flowers with a plastic sheet, and held Ivan close as I wrapped another one around the two of us. Those first years I used to bring Ivan with me to work. Oddly enough, that day it was quiet. I don't like silence. I don't like thinking, and outdoors in the quiet, with the rain, what else is there to do? That's why I read so much. I used to just sit there and read.

EL: Mia? What happened? You seem upset.

MIA: It just reminded me, that's all...it made me think, about...about him. (Pause) The rain became little ponds, and each drop that fell into those ponds created a cascade of waves. The ripples mesmerized me. Just like when I used to go sailing. Remember?
Sometimes I went with you. And a couple times even with Mom and Dad. One time though, just once, I went with him. That day the waves were so calm...with arrow shaped ripples. We were alone, but together. We decided to head even further out to sea, and I think he was trying to show off when he jived and capsized the entire boat. It was a small boat, and turtled easily. He did a walkover, but I went straight in. He could've righted the boat himself, and let me alone, and he would've managed to stay reasonably dry. But instead, when he saw me in the water he dived right in! (By now they have both turned and are facing the audience. EL latches onto MIA's arm, and rests her head on her shoulder) That was a moment. Right there in the freezing water, the shoreline miles of...Together we righted the boat. I remember. For awhile after that he just held me. The boat was still, the sail loose, tiller askew...yeah...then...he looked at me like I meant something to him then...damn him.

An excerpt from

The Coat Check Girl

By Mandy Vainer

Cast of Characters
Alison (Ali) - 18-year-old female, friend to both Lou and John.
Louisa (Lou) - 18-year-old female.
John - 18-year-old male, Lou's boyfriend.

(Fade in the song "What I like About You" by the Romantics near the end. Lights up on ALI's living room. The only necessary furniture is a couch at center stage with an end table to the left of it, and a door off to the right. LOU and ALI are dancing and singing along with the song. As it ends, they collapse on the couch)

ALI: Louisa, my love, I think it's time to ditch the tomfoolery and actually study some physics.

LOU: We can't, John's not here yet. And, what's this tomfoolery business? You think just cause we're here to study physics, we have to talk like physics teachers?

ALI: I don't know, I've never seen Mr. J. stress over a kinematic equation before.

LOU: I hate those things. I don't even think studying is gonna help me there.

ALI: How do you know? You haven't studied for a single test this year.

LOU: I get by.

ALI: By cheating off of John

LOU: Hey, we have study sessions.

ALI: Yeah, like the last test, when I couldn't be at the study session? You sure learned a lot about friction that day.

LOU: See?

ALI: The test was on projectiles.

LOU: Oh. But, so what? It's ancient history.

ALI: Everything with you is ancient history. If it wasn't for me you'd probably be failing that too!

LOU: What is this? Make Lou sound stupid day?

ALI: You don't need me for that, usually.

LOU: Ali, you're weird. I'm too tired and hungry to deal with your humor right now.

ALI: Well, as soon as your dipstick boyfriend gets here–

LOU: Hey, he was your friend before I ever went out with him. He's not a very good boyfriend anyway.

ALI: Come on, don't make me drag this outta you, Lou. What's up?

LOU: I don't know! That's just it, I have no clue. He won't tell me.

ALI: How do you know there's something to tell?

LOU: I've been with him for almost two and a half years. Trust me, there's something to tell.

ALI: Have you tried to–

LOU: I've tried everything! I asked nicely, I asked repeatedly.

ALI: Yeah but–

LOU: I laid a guilt trip, I demanded.

ALI: But that–

LOU: I even brought myself to tears last night! He's probably cheating on me.

ALI: Hey now, John wouldn't do that. You know he's nuts about you, it's all he ever talks about.

LOU: You mean talked about. All he cares about is his job. Every other sentence is about the restaurant, or the boss, or the damn coat check girls! (LOU jumps suddenly off the couch) That's it! That must be it, he's bangin' the coat check girls!

ALI: (giggles) Listen to yourself. You're overreacting.

LOU: I know! Seriously though, I don't know what to do.

ALI: Don't do anything. Just keep telling yourself that you're paranoid. And just let me tell you, you are paranoid.

LOU: Just because I'm paranoid doesn't mean I'm imagining these problems. I gotta fix it. Ali, fix it for me. You always settle our fights.

ALI: (patronizingly) Yeah, I know.

LOU: So, settle this.

ALI: Settle what? I have yet to see a problem here. No, you know what? I do see a problem– you don't trust him.

LOU: I can't help it. He's gotten so...slick. He used to be so dumb and cute and helpless. Did I ever tell you about our first date?

ALI: You mean lately?

LOU: I remember it so perfectly. Oooo! Ali, Ali be John!

ALI: What?!

LOU: Come on, it'll be fun.

ALI: Fun? For who?

(LOU takes ALI's hand and pulls her up)

LOU: Okay, okay. So we're in the park by my house, right?

ALI: Right, ya freak.

LOU: Come on, do the John thing...

(ALI rolls her eyes and lowers her voice for the game. She acts out the scene with exaggerated nervousness and stupidity)

ALI: Doop - dee - doop - dee - doo.

LOU: So...did you like the movie?

ALI: Um, oh - yeah. I mean Uma Thurman was really good.

LOU: You think so?

ALI: Yeah. She's got great...acting skills.

(LOU grins)

LOU: Acting skills? That's the best you could come up with?

ALI: Well—I...I m-mean, um—

LOU: But, anyway it was a good flick.

ALI: Oh yeah, sorry about the popcorn.

(LOU turns around and ALI makes a disgusted face)

LOU: It's okay, I wasn't hungry anyway.

ALI: Yeah, Me either.

LOU: Besides, Denny's had...good food.

ALI: Oh yeah, sorry about your jacket too.

LOU: It's okay, I'm sure the waitress needed it more than me. She was bleeding and all.

ALI: Yeah, but if I hadn't knocked the tray into her, then–

(ALI smacks her head stupidly and LOU turns back around)

LOU: John, don't worry about it. It's getting late, and the park closes in a few minutes.

ALI: Getting picked up by the cops, that would be perfect ending to the evening.

LOU: Well, it wasn't that bad.

ALI: Yeah, there'll always be others. I mean...well that is to say, uh, I...uh, if you want to...I mean...

LOU: John?

ALI: Y...yeah.

LOU: Are you trying to ask me out?

ALI: Well, it's just that, I mean I... I had a really good time tonight, you know, aside from all the stuff that happened, and–

LOU: So, you are trying to ask me out?

ALI: I guess what I'm trying to say is...I had a good time tonight because of you, and I wanna spend more time with you. A lot more. So yeah, I'm asking you out. If that's okay with you.

LOU: Well, you're pretty cute when you're nervous. I suppose that's enough to base a relationship on.

ALI: Really?

LOU: And, you're sweet and funny and charming, yadda yadda yadda.

ALI: Oh...thanks. Um, do you want me to walk you home?

LOU: I live right there. (LOU points to stage left)

ALI: Oh, right. But I don't mind, I...mean...

LOU: Look, you have my number. Why don't you just give me a call tomorrow.

ALI: Okay, I will. Um, good night then?

LOU: I guess so. (They pause, and LOU looks around coyly. She begins to move in toward ALI to kiss her. ALI's eyes widen and she puts her hand over her mouth to shield herself) Talk to ya later hun.

ALI: Yeah, and you went home all dreamy eyed and happy. Are we done? (LOU nods) See, the problem with you two is you're too cute.

LOU: We were anyway.

ALI You're nuts.

LOU: Leave me alone.

ALI: Good idea. I'm hungry.

LOU: What? I can't believe I have a two year relationship going down the tubes and all you can think about is eating!

ALI: Lou, shut up. Take your own advice and leave it alone.

LOU: I can't. It's my life we're talking about.

ALI: But, I'm really hungry.

(LOU shakes her head)

LOU: Nice friend you are.

ALI: I'm the best thing that ever happened to you and you know it.

LOU: Oh Ali, what am I gonna do?

ALI: I'll tell you what you're gonna do. You're gonna go out there,

get in that car...and go get us some lunch. (The two get up and walk to the door as ALI gets some money from her pocket and hands it to LOU)

LOU: I'll be back in a little bit. If he gets here will ya talk to him for me?

ALI: Yeah, yeah I'll see what's up. If anything's even wrong that is.

LOU: Thanks hun. (LOU exits)

ALI: My friends are lunatics, all of them. And these two are the king and queen. You know, they've never actually had a fight about anything of merit. I hope this isn't a repeat of last Fourth of July. I can't believe they actually fought about whether my breath smelled like bubble gum or cotton candy. I guess that's what I get for asking, but still. I even try to settle the damn thing by going into John's bathroom and eating some toothpaste, and what do I get for it? A mouth full of jock itch cream. (ALI shudders) Man, I still sniff the toothpaste every morning just to make sure. That's what I get for trying to help out. (We hear JOHN's car pull up) And, here's contestant number B. (ALI opens the door and gestures for JOHN to enter. He walks over to the couch and lays down on it)

JOHN: Doop - dee - doop - dee - doo.

ALI: Sure, just make yourself right at home.

JOHN: That's what I love about comin' here.

(ALI sits on the floor in front of the couch)

ALI: What do you think this is, a shrink's office?

JOHN: No, this is a lot cheaper. But...

ALI: But?

JOHN: But, it...serves the same purpose?

ALI: Well, from what I hear you been givin' the lovely Louisa the cold shoulder lately.

JOHN: Is that what she thinks?

ALI: What, you haven't?

JOHN: I don't know, maybe. It's just...

ALI: It's what?

JOHN: Ali, if I tell you something...well, I know I can trust you right? (JOHN sits up a little)

ALI: Have I ever failed you before?

JOHN: Okay, let me tell you a little story about, uh, B-Bob and Laura. Bob and Laura are a couple who've been together for, oh let's

241

say two and a half years. Now Bob and Laura get in a fight about her parents. But, you know, these things happen. They talk it out, and before you know it they're lockin' the bedroom door. But before they get to makin' up, Laura starts with the nit picking, and Bob gets mad and leaves. Now remember, not only is Bob pissed off and lonely, but he's also thoroughly unsatisfied. So, I– Bob ends up back at work, and Veronica, you know the coat check girl, she's just getting off work. Well, she gets to cheering Bob up and...well...Bob and Veronica do a very dumb thing. And...

ALI: And?!

JOHN: We're, well they're still kinda doing the really dumb thing.

ALI: You mean to tell me you're bangin' the coat check girl?!

JOHN: To put it bluntly.

ALI: Oh man, John. John, this bad. This - this is so unbelievably, phenomenally bad.

JOHN: I know. It's like I hate myself for doing it, but I can't stop.

ALI: Yes, you can.

JOHN: I just really love Lou, I do. I don't wanna lose her.

ALI: I think that's out of your hands at this point.

JOHN: Not if she doesn't find out.

(ALI looks at him. There is a brief pause while the two just stare at each other)

ALI: Are you even taking her well being into account at all?

JOHN: What do you mean?

ALI: Oh, I don't know what I could possibly mean. Everyone knows there's no risk involved with sex. It's a great pastime for you to have.

JOHN: It's not like I don't use protection..

ALI: Yeah, I can't think of a single instance of a condom failing. By the way, how are your sister's herpes treatments going?

JOHN: Okay, okay I get it.

ALI: Do you?

JOHN: Help me out here Ali, tell me what to do.

ALI: All I can say is, if you want any chance of salvaging your relationship, then you have to be honest with her.

JOHN: It's just so complicated now. It used to be so easy. I told you about our first date before right?

(ALI smacks her forehead and mouths the words as JOHN says them)

JOHN: I remember it perfectly. (ALI stops mouthing) Ali! Be Lou!

ALI: Oh no, not again.

JOHN: Come on, it'll be fun.

ALI: No it won't.

(JOHN gets up, takes ALI's hands and pulls her up)

JOHN: So, we're in the park by Lou's house, right?

(ALI shakes her head)

ALI: Dear God, man.

JOHN: Come on, start it off. Lou says...

(ALI sighs and begins the scene again. This time she acts extremely ditzy)

ALI: Pretty good movie huh?

JOHN: Oh yeah, that Uma Thurman's a great actress.

ALI: Yeah...Those pants were awful tight though.

JOHN: Really. Hadn't noticed. Oh, sorry about the popcorn.

ALI: Oh, it was my fault. If I had gotten up to let you by, it wouldn't have spilled.

JOHN: Who was hungry anyway? I preferred Denny's myself.

ALI: Yeah, the way you took care of that poor waitress. Wow, all that blood would've made me squeamish.

(JOHN looks away)

JOHN: It was nothing.

(ALI shoves her finger down her throat making gagging motions)

ALI: It's a good thing you had my jacket right there.

JOHN: Yeah. It's getting late you know. I should probably be getting you home.

ALI: Well, thank you for the evening, it was fun.

JOHN: Yeah, aside from all the excitement that is.

ALI: It - it would be nice to, um...

(JOHN turns back to look at her)

JOHN: To do it again?

ALI: Well, I mean if you want, we could...

JOHN: Sssh, I'd love to do it again. In fact, I'd like to do it a lot.

ALI: (surprised) Are you asking me out?

JOHN: Well, yeah. I like spending time with you. I think we'd be good together.

ALI: Yeah.

JOHN: So, you're accepting?

ALI: Of course! You're so cute and sweet and funny and charming.
How could I say no?

JOHN: Awe, stop.

ALI: No, I mean it.

JOHN: I think we'd better go. Come on, I'll walk you home.

ALI: Oh, that's okay. I live right over... (ALI points to stage right)
there.

JOHN: Okay then, if you're sure. I'll give you a call tomorrow?

ALI: Okay. (JOHN grins) uh-oh. (ALI slaps her hand over her
mouth again, as JOHN comes at her tongue and all)

JOHN: I'll check ya later hun.

(ALI wipes her hand off on her pants)

ALI: Oh, my, God. Is this over? (JOHN nods at her with a self-sat-
isfied smile) You smooth young stallion, you.

JOHN: Shut up. I miss those days though.

ALI: Well, I think you know what you have to do.

JOHN: All right. Listen, I'm gonna go over to Veronica's and break
it off.

ALI: Okay, but—

JOHN: Thanks, and don't mention it to Lou? (JOHN is up and out
the door before ALI can protest. We hear tires squeal and a cat cry)

ALI: God, what the hell am I supposed to do now? Not tell Lou her
boyfriend's cheating on her? I can't not tell her. For all I know he's
gonna go over to little miss coat check girl, and check her coat.
He's just dumb enough to do that. Even if he does break up with
this girl, he's not gonna tell Lou. Once again Alison's left holding
the ball.

An excerpt from

Tofu Ham

by Donald Stewart

ABBY: Have a seat everyone! Dinner'll be ready in ten minutes. How are you dad? Florida treating you well?

WILL: Oh yeah, it's treatin' me fine. Gonna open that war museum soon, just need to get the builder's permit.

SUSAN: Lord knows you have plenty of that war junk, enough to stock it just fine.

WILL: Hah. You might call them my other set of children.

CHRIS: Speaking of children, how goes the "war effort" Susan?

SUSAN: Not good...

CHARLIE: We've tried everything almost. Nothing has worked.

SUSAN: Yes. There is only one option left, Charles.

CHARLIE: What's that?

SUSAN: Well, I've decided to adopt.

CHARLES: Finally.

SUSAN: You're not upset?

CHARLES: Of course not. I've been waiting for you to suggest it, actually.

SUSAN: I woulda said something sooner, 'cept, well, I thought...

CHARLES: It's okay honey. I am perfectly fine with it. And so, I imagine, is the rest of your family? (He looks at ABBY and WILL)

ABBY: Why should I have a problem with it?

WILL: You think I play favorites among my daughters, Charlie? Of course it's fine.

SUSAN: I brought it up here, now...because...well you know. I thought you might be able to advise us in the matter.

CHARLES: Yes, which agency did you use?

ABBY: Oh...Gee, it's been so long. Do you remember dear? (She looks at CHRIS)

CHRIS: I can't remember, though we still have the adoption papers. Would you like to take a look?

CHARLES: That would be appreciated.

ABBY: Not now. Maybe after the boys go to bed. Should be pretty early, it being Christmas after all.

CHRIS: Yes, I hope I don't make a buffoon of my self like last time.

ABBY: Oh...Please turn on the lights when placing the presents tonight. Ok?

WILL: What's all this?

ABBY: Oh, it's silly. Christopher was putting the presents under the tree in the dark last year...and then he banged his shin on the piano, causing him to shout out an expletive, which I will not repeat, and fall into the tree.

CHRIS: It's a good thing they didn't wake up, though they did question us about the missing ornaments.

CHARLIE: Good thing? Haven't you told them about the real Santa yet?

ABBY: Er, well. Simon knows, but John...

WILL: You are way too protective of that boy. He's what now? Twelve?

ABBY: Yes, I know it's silly, but he is the last, well the first too, that I could have...and I...I just don't know.

CHRIS: Dear, I think we should tell Johnny.

ABBY: About Santa? That's just a harmless myth.

CHRIS: No, about the other thing. (Silence for a few moments)

WILL: Abby, I know its hard...

ABBY: But what if...what if his life is ruined? What about the family? I can see him now...Purple hair and more holes in his body than Clinton's story.

WILL: Nothing is gonna happen, I tell you he is, er, will be, fine with it.

SUSAN: Yes, Abigail, you're over reacting.

WILL: If you want to tell him tonight, you have everyone's support.

(JOHN and SIMON enter from stage left)

JOHN: Tell who, what?

CHRIS: If we wanted you to know we would have told you.

JOHN: A secret huh?

CHRIS: You could say that. (Silence for a few seconds)

ABBY: Ok, I will.

JOHN: Will what?

ABBY: I'll...well you see...After dinner, Johnny. I'll tell ya then.

JOHN: If this is about Santa...I already know.

CHRIS: Really, how did you stumble upon this shocking knowledge?

JOHN: Well, I came downstairs last Christmas...after hearin this loud crash-type sound. And, well, I couldn't see all that good, but I definitely could tell Santa has lost a lot of weight. It must be these new low fat cookies everyone is eating. (Family looks at each other and bursts out laughing) What? Was it something I said?

CHRIS: (Between laughs) No, no...you're right though, he must be getting thinner. (Looks at belly)

(An oven bell goes off from stage right)

ABBY: That must be the "ham." Susan, can you help me in the kitchen? The rest of you just take a seat.

JOHN: Wow! Real ham this year?

(ABBY and SUSAN exit stage right)

ABBY: (From offstage) That depends on your definition of "ham."

SIMON: Ahhhh crap. Not another Tofu Ham.

CHARLES: What's wrong with that?

SIMON: Cause I don't want another broom chase...Nothing is wrong with it. (He grins toothily)

CHARLES: Hah hah. If you had been a little more considerate to your aunt none of that woulda happened.

WILL: No, if your wife, my daughter, would let other people eat meat...

SUSAN: (From offstage) It's bad enough slaughtering animals, let alone eating them.

ABBY: (From offstage) Hey! We have this argument every single year. Can't we just have a peaceful evenin'?

WILL: What'd I do wrong...It must been that damned Botanical Garden you were always visiting. Growin' up around all those plants.

SUSAN: (From offstage) For your information–

ABBY: (From offstage) ENOUGH! Did anyone listen to me? For once we are all gonna get along and be QUIET!

(SUSAN walks on stage with a large plate on which is a huge block of Tofu, or tofu looking substance. She sets it down in the center of the table. ABBY walks on with a plate in each hand, each with some sort of side dish. She places one on each end of table. They take seats.)

ABBY: Dad...?

WILL: Oh yes, of course. Bless this meal, oh Lord, and all gathered here today. Amen. Merry Christmas everyone!

ALL: Merry Christmas!

(Table descends into eating and chatter, multiple conversations at once.)

ABBY: Oh jeez. I hope I haven't decided to ruin this holiday. This family.

SUSAN: You are over reacting Abigail.

ABBY: How'd you know? You don't have kids.

SUSAN: (mumbles) Two boys AND a lawyer. No wonder you're so touchy.

ABBY: What if he hates me for not telling him? What if he hates Simon? You ever seen the movie "Chuckie"?

SUSAN: ABBY! Stop it. He is not gonna go all psycho on you. He probably won't even care.

ABBY: But what if he does? I better lock the knife cabinet.

SUSAN: What do I need ta do? Jam Prozac down your throat?

ABBY: I know it's silly but I kept it secret for a reason.

SUSAN: What might it be?

ABBY: Well it's quite simple really. I just wanted to... to... my god. I can't even remember.

SUSAN: (giggles) Then what reason do you have to keep it from him NOW?

ABBY: I don't... I guess... I don't have one. I'm ready. I'll do it. Chris dear!

CHRIS: (Unfreeze) Yes, my sweet? I am currently engaged in the most marvelous conversation with your father. Would you mind waiting a few more moments? Thanks, you are a dear.

ABBY: But–

(Tableau once again, spotlight on CHARLES, WILL, and CHRIS)

CHARLES: (to WILL) It's not my business... but why are you critical of my wife?

WILL: She's a herbie-vore. She eats this Tofu crap non-stop. (Shovels Tofu into his mouth) It's not healthy I tell you.

CHRIS: I thoroughly agree, Mr. Lawson. Up with flesh eaters!

(WILL continues to hastily eat the Tofu. He appears to be enjoying it)

CHARLES: Wait a minute... It's not healthy? I would love for you to explain why. Besides, you seem to be enjoying the food.

WILL: What? This crap?

CHARLES: Yes, that "crap."

(WILL shovels one last mouthful into his mouth and then puts fork down)

WILL: Well that tasted terrible. Is there any left?

CHRIS: I believe so. (He looks at the Tofu block in center of table, then looks back) Yep, its still there.

CHARLES: Now you want more? I don't believe this. Admit it. You like it.

WILL: No.

CHARLES: Yes.

WILL: No.

CHARLES: Yes.

WILL: Yes.

CHARLES: No.

WILL: Hah! You admitted I didn't like it.

CHARLES: What? Argh. How can someone your age be immature?

WILL: I'll ignore that. (He grins) Whew. Better rest a bit before I start in again... Bad heart ya know.

CHARLES: Because of meats. Sausages and the like.

WILL: No, because I have a bad heart.

CHARLES: Right, caused by meat.

WILL: Look, I'm old, crotchety, and hungry. You ain't gonna change any of my opinions.

(They all laugh. Tableau unfreezes, chaos as everyone talks.)

ABBY: Chris!

SIMON: It's nine o'clock! We better get to sleep, Johnny.

CHARLES: Well I know about old and crotchety, but I'm not sure about hungry. What with all that food you've put away...

(CHARLES, WILL, and CHRIS laugh some more)

JOHN: Yeah, the sooner we fall asleep-

JOHN and SIMON: The sooner we wake up!

CHRIS: Wanna see something really funny? Check out my latest work.

(CHARLES, WILL, and CHRIS are cracking up)

ABBY: But-

SUSAN: Where is the...oh my god! I left the pie in the freezer! (She stands and starts toward kitchen, offstage right)

CHRIS: (still laughing) Tell ya what fellas. I have this bottle of scotch up stairs in my study, care to join me in a night cap?

ABBY: Dear, don't you think we should-

WILL: Ah scotch. The drink of the Scotch.

(They are almost crying with laughter when they stand and start to move towards offstage right)

ABBY: Wait, I have to–

SIMON: C'mon John. God dang. I hope I get that stick. (SIMON and JOHN stand and start to run for offstage right)

ABBY: (Stands and screams) DOES ANYBODY CARE THAT SIMON WAS ADOPTED? (Everyone stops dead in their tracks and turns.) WELL? (They stand silent looking at each other. Slowly everyone's eyes focus on JOHN)

JOHN: (Fidgets) Can I go upstairs now?

ABBY: Don't you want to talk about it dear?

JOHN: No.

ABBY: But–

JOHN: Ma, it's kinda late.

ABBY: I really think we should discuss this. Now have a seat. (JOHN is reluctant. He stands looking around at the other family members as if for help, before getting nudged into a chair. ABBY takes seat across from him.) Now... your father and I did this for you. We wanted you to have a brother. I can understand your hesitation to talk about it...

WILL: (mumbles to CHRIS) I'm not sure she does.

ABBY: (Showing no sign of having heard that) But it's important to talk out your problems.

JOHN: I'll talk in the morning, but for now can I please go to sleep?

ABBY: Johnathan, why are you so hesitant?

JOHN: Because I–

ABBY: Go on.

JOHN: Well Mom–

ABBY: I'm here for you.

JOHN: I know, its just–

ABBY: Don't worry one bit. Everything's gonna be fine.

JOHN: Of course it will. It has been for six years.

ABBY: Please go ahead and... what? (WILL laughs) You... You... (WILL is joined in laughing by the rest of the family save ABBY)

JOHN: Grandpa told me Mom.

ABBY: (Shocked, turns on rest of family) You all...all of...you knew?

CHRIS: 'Twas the greatest secret of all.

ABBY: But...why? Why not tell me?

SIMON: Mom, you're always stressed. Work and all. We didn't wanna push ya over the edge.

An excerpt from

Negatives
by Allison Staiger

OLIVIA: Well, here it is. Another beginning of another year.
Another year to claim that you've grown and matured. Another
year to do all the work that they throw at you in hopes that it'll
make you a better person. Another chance to swear on all your rel-
ative's graves that this time you're gonna do good. That you're
gonna be the perfect kid– get straight As while maintaining
a healthy balance of friends, activities and family. All eventually
leading to another year to screw up. (Exit OLIVIA, stage right.
Lights fade on hallway, lights up on darkroom) Normally, it wasn't
like that. But just standing there listening to JJ babble on and on
about being seniors made me realize that, no, we really hadn't done
anything to be proud of. I mean sure, we might have won the occa-
sional science fair, or we might have learned new scholarly things,
or we might have grown boobs, but plainly, we were still the same
little brats that we had always been. I, who once considered myself
independent, finally realized that in actuality, I was just a groupie
who went along with whatever anyone said. And that, that was the
shock of my life. (OLIVIA goes on with the pictures, until she finds
one that makes her stop) (softly) Here it is. Our crapeteria. Wow.
This brings back some memories. (Lights down on darkroom, up
on scrim, revealing a cafeteria bench. OLIVIA, KIRSTEN, and
JACINDA are sitting, picking at their food)
JACINDA: God, this is so bogus! Detention on the first day.
KIRSTEN: I know, I could kill Mr. Stephanson.
OLIVIA: Well, we were late.
JACINDA: That is so not the point, Olivia. You just DON'T give
detention on the first day of school. Teachers aren't even supposed
to notice any wrongdoing. It's like, an unspoken rule.
OLIVIA: Yeah, a lot of teachers are like that, but we've never had
Mr. Stephanson before. We took a risk getting to his class late.
Besides, it's just a stupid detention. We'll probably get out early.
Deal with it.
KIRSTEN: What is up with you? You seem almost anxious to get to

detention. (slyly) What, is there a new hot teacher or something?

JACINDA: Or a new hot guy?

KIRSTEN: (knowingly) Oh, it's probably Jack, right? You're still into Jack, aren't you?

JACINDA: Go Liv! Hey, I think he was eyeing you today. You should ask him to Homecoming, 'cause I saw the cutest dress at Express–

KIRSTEN: Hey, yeah, I think I saw that too! It's velour and purple–

JACINDA: No, no, no, it's black and slinky, and it just screams sex.

KIRSTEN: Okay, I didn't see that, but you can borrow my black beaded purse, and JJ's black platforms and–

JACINDA: Oh, but wait, do you think you should wear platforms, cause–

KIRSTEN: Right, she's already just an inch shorter than him, and so-

JACINDA: So, she might tower over him, and–

KIRSTEN: And call me old fashioned, but I–

JACINDA: Yeah, I know, I don't like it when the girl's taller than the guy, so–

KIRSTEN: SO, maybe she should wear black ballet slippers for–

JACINDA: For a look that's both comfy and chic!

KIRSTEN: There! The perfect homecoming outfit for–

OLIVIA: For a nonexistent date! I have never heard two people fantasize so vividly about something that's not gonna happen! I don't like Jack or any new teachers or guys! I don't want to go to detention, I'm just telling you to shut up and deal with it, cause it's not the end of the world! God! Shut up! (OLIVIA resumes eating, while KIRSTEN and JACINDA stare at each other for a minute, then begin eating in an embarrassed silence)

KIRSTEN: Speaking, sort of, of crushes... (She shoots OLIVIA a look. OLIVIA rolls her eyes and pretends not to notice)...I heard that Shawn DeBeque has taken an interest in none other than– (Raises her voice) Abigail Chester, Dog of the World!! (ABIGAIL enters, stage left, with a tray of food, and looks around for a table)

OLIVIA: Keep your voice down!

KIRSTEN: (annoyed) What's the matter? Can't you even let us have our fun?

OLIVIA: Well, yeah, but–

JACINDA: Hey Abigail, I heard you had a hot date last night! (ABIGAIL turns, and looks wordlessly at their table) What was her name again? Lizzy Lezzy? (KIRSTEN and JACINDA laugh)

OLIVIA: (under her breath) Oh my God.

JACINDA: You know, Abigail, that outfit looks familiar–

KIRSTEN: Yeah, haven't you been wearing it for the past four years? What? Are you too poor to afford anything else? Or has your mom been drinking the money away again?

OLIVIA: Kirsten–

KIRSTEN: (taking no notice of OLIVIA) What's wrong Abigail? Haven't you noticed that your parents are the way they are for a reason? They don't love you. They're sorry that they ever had you. Your mom became a drunk because she was so ashamed of you. Ashamed that your dad knocked 'er up and left. Read between the lines, Abigail! She didn't want you! You were a mistake!

OLIVIA: STOP IT!!!! (Dead silence. ABIGAIL exits, STAGE LEFT)

KIRSTEN: (threateningly) What did you say?

OLIVIA: Shut up, shut up, shut up, shut up! What the HELL is wrong with you? Have you lost your damn mind?

KIRSTEN: What?

OLIVIA: Wake up, Kirsten! God, I'm so sick of all this. Those things you said, they crossed the line!

JACINDA: (amazed) Wow, I've never heard you act like this.

OLIVIA: No kidding. You've been acting the same way for twelve years, and frankly, I'm goddamn sick of it! Since kindergarten, Kirsten, I've been following you around, thinking that I had a mind of my own. But let's face the facts! I'm completely dependent on you!

JACINDA: (slowly) Sooo...what are you trying to say?

OLIVIA: Aaaugh! Jacinda, is your head so thick that you really, TRULY don't know what I'm saying? I'm telling you that none of us have minds of our own! None of us have grown up!

JACINDA: Why do you keep saying that?

OLIVIA: Because it's TRUE!

JACINDA: But I don't see–

KIRSTEN: (coldly) Cut it out, Olivia. What are you talking about?

OLIVIA: (takes a deep breath, looks KIRSTEN right in the eye) I'm trying to say that I'm through. I'm sick of this. I don't want to live

the rest of my life in total dependency and tyranny. I have to get out of this friendship, cause I'm not living my life like this. I'm sick of taking it from you and dishing it out so cruelly to other people. I'm through.

KIRSTEN: (angrily) You know what, Olivia? I don't give a damn what you think–

OLIVIA: I know. (KIRSTEN opens and closes her mouth a few times, at a loss for words) Look, don't you see that what we're doing is wrong? That there's so much tension between us all that all it takes is a little spark to ignite it?

JACINDA: Bull, Olivia! I'd hardly call these lies that you're throwing at us, a "little spark." You're a friggin' fire-breathin' dragon!

KIRSTEN: (suddenly very amiable) She's right. What is it?

OLIVIA: (suspiciously) What is what?

JACINDA: The reason why–

KIRSTEN: There's something wrong. What is it?

OLIVIA: (nearly in tears from exasperation) I've told you, like twenty times!

KIRSTEN: (almost pityingly) Is it stress?

JACINDA: Gonna crack up?

OLIVIA: (trying to compose herself) I'm perfectly relaxed.

KIRSTEN: Or is it problems at home?

OLIVIA: Excuse me?

KIRSTEN: You know what I mean...is someone beating you? (KIRSTEN punches her fist into her hand)

OLIVIA: (incredibly angry) You're sick! My parents don't do that crap!

KIRSTEN: What happened this summer? Did ya get knocked up, or something?

OLIVIA: (covering her ears) Stop it. I can't believe I'm hearing this. Cut it out, Kirsten.

JACINDA: (slightly worried) Yeah, maybe you should just–

KIRSTEN: NO! Shut up, Jacinda! Don't you dare stick up for this freak! Or are you gonna be on her side now? Gonna form a goddamn club or something?

JACINDA: (defensively) No, why would I do that?

KIRSTEN: I don't know, why would you? (KIRSTEN and JACINDA stare at each other for a moment)

OLIVIA: (slowly) Sooo...I guess I'm gonna go. (OLIVIA stands and

picks up her tray)

(JACINDA meets OLIVIA's eyes, looks at KIRSTEN, back at OLIVIA, and turns coldly away)

JACINDA: Go to hell, Olivia. (OLIVIA nods slightly, in understanding. KIRSTEN stands challengingly)

KIRSTEN: Where are you gonna go, huh? To sit with Abigail?

(OLIVIA shrugs)

OLIVIA: Why not?

(KIRSTEN and JACINDA's mouths drop open)

JACINDA: (amazed) I never thought you'd stoop so low.

(OLIVIA looks at them both)

OLIVIA: Believe me. I've stooped lower. (Exit OLIVIA, stage right. Lights down on cafeteria, up on darkroom) So that was it. A recognition leading to the end of some really long friendships. Yet, in a sense, I felt a major catharsis. Like I just let out a whoosh of air that had been pent up in my lungs for twelve years. I felt like I was free– free to do whatever activities I wanted to do, wear what I wanted to wear, and overall, associate with who I wanted. To go against what had been dubbed "loserish" in the past. (OLIVIA picks up a picture) Of course now I was being dubbed a loser. (Lights go up on scrim to reveal KIRSTEN and JACINDA in school hall) By them. (Lights down on scrim. OLIVIA enters, STAGE RIGHT, and goes to her locker. KIRSTEN and JACINDA corner her)

KIRSTEN: (dangerously nice) How's it goin', Olivia?

JACINDA: Having fun by yours–

KIRSTEN: What's it like being all alone? Being a reject?

(OLIVIA ignores them)

JACINDA: Oh, so she's not gonna answer you. Maybe we can teach her a lesson.

(OLIVIA looks them right in the eye)

OLIVIA: Oh please. You're not gonna do anything.

KIRSTEN: Oh really?

OLIVIA: Yeah, really. Have you forgotten that I know all your little tricks? I used to do them too, ya know. I can call your bluff easily.

JACINDA: That's not the wisest decision when you have no friends.

OLIVIA: What's that got to do with anything?

KIRSTEN: I think what she's trying to say is that you should probably suck up to us a little harder, cuz we're your last chance at

255

friends. (Pause. OLIVIA stiffens, turns, and stares into her locker) Hm. JJ, I think we got her. She knows that she's gonna be the social reject.

JACINDA: So, what's it gonna be, Olivia? Gonna come crawling back?

(OLIVIA turns to face them)

OLIVIA: And if I do?

KIRSTEN: What?

OLIVIA: If I do? Will you take me back?

KIRSTEN: Nice to see you've fallen off your pedestal, Olivia. Yeah, we'll take you back. With minimal hassling.

JACINDA: Come on, Olivia, make your choice. Gonna coast freely through the year–

KIRSTEN: Or are you gonna make it hard on yourself?

(Pause. OLIVIA turns back to locker, and sags)

OLIVIA: Yeah guys, I'm, um, I'm with you.

JACINDA: Very good. I must applaud you on–

KIRSTEN: Glad to have you back. Liv. I knew it was just a matter of time before you realized that without us, you're lost, and–

(OLIVIA suddenly whirls around to face them, slamming her locker shut)

OLIVIA: And I'm lost with you too! God, what was I thinking? It's a no-win situation, isn't it? I'd rather be lost without you.

JACINDA: Once again, not the wisest decision.

OLIVIA: Stop telling me what's right and what's wrong. The last thing I need is your screwed up code of ethics.

KIRSTEN: If I were you, Olivia, I'd stop with the insults, and start getting a little scared.

OLIVIA: Oh, don't get me wrong. If it was any other two people, I'd be deathly afraid. I probably wouldn't even come to school. I'm a wimp, you know that. But see, I know something about the situation that puts my mind at ease.

KIRSTEN: Oh, what's that?

JACINDA: Yeah, please tell us. Enlighten us as to why you aren't cowering in fear right now. Come on.

OLIVIA: I'm not afraid, because I know that the big-headed, power-driven group that we once had is no more without me. I mean, come on. You two aren't even friends. I was the one holding the

256

group together. Without me, you're just two immature little brats desperately clinging to the last scrap of superiority you'll ever have.
JACINDA: That's a lie! That's not true. (JACINDA stops and looks at KIRSTEN, who is staring at OLIVIA) Is it?
OLIVIA: (triumphantly) You see? You see how it is, Jacinda? Kirsten's finally seeing the truth. She knows what's going on. Not so pretty, is it?
(KIRSTEN suddenly move in close to OLIVIA)
KIRSTEN: (hissing) Rot in Hell, Olivia, and see if I care. (KIRSTEN turns and exits STAGE LEFT with JACINDA close behind her. OLIVIA watches them go, then leans her head against the lockers, breathing deeply. Lights down on school hall, up on darkroom)
OLIVIA: After that, life went on, and they didn't bother me. In fact they completely ignored me. I didn't know which was worse. I seemed to have crossed that line between being a cool rebel chick, and being a flat-out rejected loser. It was a bit of a shock to realize that in the blink of an eye, I had severed all connections with some very old friends.

An excerpt from

We Still Have Daddy

by Bela Sarah Resnicoff

HELEN:(haltingly) I don't know. I don't know what Mom's job was. Maybe it was just to give birth to us and be our Mom till we're this age. Maybe our job is to not have a Mom, to be orphans. We still have Daddy. (HANNA exits center-stage right, and DADDY collapses on the couch as a car's motor is gunned outside but immediately lowers to a purr and pulls away. HELEN and ELEANOR move slowly from the bedroom, which gradually darkens, to the family room, where they stand before the couch.)

ELEANOR: Are you okay, Daddy?

HELEN: Daddy? Do you want something? Coffee?

ELEANOR: Daddy? Daddy, what's wrong? You're so mad that it doesn't even look like you're sad for Mommy.

DADDY: Oh, no, not you too!

ELEANOR: What do you mean? Daddy, what did I do wrong? (When DADDY doesn't answer, HELEN draws ELEANOR to the side.)

HELEN: Eleanor, Daddy's very sad. Sometimes when people are very sad, they act funny. I've never seen you half so quiet as you were today, and I've never seen Daddy half so mad as he was today. It comes together– being sad and acting different.

DADDY: Helen? I think I'll take you up on that coffee.

(HELEN exits upstage left, and DADDY and ELEANOR look at each other. ELEANOR approaches the couch.)

ELEANOR: Daddy, are you sad?

DADDY: Yes, I'm very sad.

ELEANOR: Is it 'cause Mommy died?

DADDY: Yes, sweetie. I'm very sad about your Mommy. I'm sure you're sad too.

ELEANOR: Yes. (ELEANOR sits near DADDY, who cuddles her close.) Daddy, what's it gonna be like without Mommy?

DADDY: I don't know, sweetheart, I don't know. It's going to be awful hard, I'll tell you that, but we'll have to muddle through. (ELEANOR sniffs the air.)

ELEANOR: Daddy? You smell funny. What's that smell?

DADDY: (shamefully) I know. You see, when men are very sad, sometimes they drink something called "liquor." (ELEANOR recoils) They drink it because it makes them feel a little better. Sometimes they forget what made them sad for a little while.

ELEANOR: But, but Aunt Hanna, an' Mommy, an' Granma - they say it's bad!

DADDY: It is.

ELEANOR: But– if you knew it was bad, why'd you do it? Why'd you drink it?

DADDY: I don't think about it being bad when I'm doing it. I just feels like, well, like I need to forget about how much it all hurts me, so I drink. I used to do it a lot when I was a boy. Your Mommy managed to keep me from it (DADDY withdraws his arm from ELEANOR and cradles his head in his hands.) What am I going to do without that woman? She was my reason for being alive, she was the one person who could keep me going through all the things that happened to me. She always trusted me. I don't understand how she and Hanna could be sisters, they're so different. What am I going to do, now that I'll never see her again?

ELEANOR: But you will see her again, Daddy. Helen says you'll see her when you go to Heaven, 'cause–

DADDY: What is it with this infernal Heaven business? Hanna was only here for a few hours, how has she managed to corrupt my kids already? Damn you, woman, damn you! (raising voice) Helen! Forget the coffee, I need a real drink. Bring me the whiskey!

HELEN: (offstage) But Dad, we don't have any whiskey.

DADDY: Yes, we do. We have one bottle on the top shelf– we keep it for guests. Bring it to me, now! Hurry up! How long does it take to get a bottle of whiskey?

(HELEN comes in holding the bottle of whiskey and a cup.)

HELEN: Are you sure you don't want a coffee?

DADDY: If I wanted a coffee, I'd say so! (DADDY pours a shot of whiskey and gulps it down. He pours again, looking entirely preoc-cupied with his cup. The girls move to the side of the room.)

ELEANOR: Helen, Daddy hates me. Why did Mommy have to die– it's 'cause of that.

HELEN: Daddy doesn't hate you. He's just sad.

ELEANOR: I'm sad, but I don't hate him!

HELEN: (helplessly) That's different. People are different. Just like

you're very quiet when someone teases you and I yell at them, you're very quiet when you're sad and Daddy acts–

DADDY: You girls talking about me?

HELEN: No, Daddy.

DADDY: So that's what comes of this Bible talk. She teaches you to lie, does she? And how does that mix with God, and good, and holiness?

(ELEANOR looks stricken)

HELEN: Daddy– Eleanor.

DADDY: So, she can leave if she wants to. Eleanor, go to bed.

HELEN: Eleanor, please.

(ELEANOR stands a moment, her eyes filling with tears and then moves to the bedroom, leaving the door ajar. She resolutely shakes the tears away, and collects the two dolls and sits in front of the bed to play with them. She holds one doll in each hand, moving her lips as if they are talking. The jerkiness of their motion and the expressions on her face are in direct correlation to the conversation going on in the family room– when it becomes loud, she grows very expressive almost as if she is trying to drown them out with her imaginary world, and the dolls jerk around, but when it is quiet she calms down.)

DADDY: How does that mix with the religion you've acquired today, huh? (pause) I notice you're not answering me. Do I detect some embarrassment? Maybe even shame? Perhaps you're not so deep into this religion business as you thought?

HELEN: I wasn't lying.

DADDY: Oh really, now. The fact I heard my name spoken and that you said you weren't talking about me at that self-same minute my name left your lips is not a lie? Then what, pray tell, is one?

HELEN: A lie is when you don't tell the truth. We weren't talking about you, I was just mentioning your name as an example.

DADDY: Now isn't that sweet. She's just using me as an example. An example of what? Who never to become?

HELEN: You don't trust me, do you? If you did, you would just believe me, not need a deep explanation. Well, if you won't trust me when I've never given you reason not to, I don't see why I owe you an explanation.

DADDY: Excuses, excuses. When you can't come up with a good enough lie on the spot, you just find some way of avoiding the

260

topic. Grown-up tactics, do you not agree?

HELEN: (exasperated) We were talking about how people are different, for Heaven's sake!

DADDY: Uh, uh, uh, uh. You've taken the Lord's name in vain, you silly child. You are now doomed to burn in Hell all your days. (HELEN colors.)

HELEN: "Heaven" is not the Lord's name, Daddy. I wouldn't take His name in vain.

DADDY: Don't tell me you actually believe all that crap your aunt's been filling you up with? You're much too intelligent to ever be pulled in by her.

HELEN: (quietly) It was what Mom believed.

DADDY: Your mother was a wonderful woman, but even she had a few failings! The most obvious one was her God.

HELEN: As I recall, you were the one who taught me about Heaven.

DADDY: Well...well...I did it because I didn't want to oppose your Mom. I knew what a bad effect it could have on you two to see us arguing.

HELEN: You argued with her in private?

DADDY: No...God is an easy way to explain the world to kids. It makes tragedy much easier to understand.

HELEN: Then why are you trying to tell Eleanor he doesn't exist?

DADDY: Don't take that tone of voice with me, young lady.

HELEN: I'm sorry Daddy.

DADDY: You can't protect the girl forever. In fact, for her own good, I should probably bring her in here right now to hear exactly what I did and did not mean when I taught her about God.

HELEN: Don't you dare!

DADDY: Excuse me? I don't dare because you don't want me to? I see how much you believe in your God-given injunction of "Honor thy father and mother." I always wondered how it is you Bible people think you can pick and choose when you do and don't believe.

HELEN: And you don't call what you do picking and choosing? Either you think it's in your children's best interests to believe or you don't, but you decide depending on what's convenient for you. When it's more comfortable to just go along with–

DADDY: Shut up! My actions are not on trial here! You pick and choose just as much as I do– when you have nothing to gain it's "Sorry, Daddy; yes, Daddy; I love you, Daddy," but as soon as you don't like what I say you lose all that "respect!" That's not

picking and choosing?

HELEN: No, that's not picking and choosing. That's self-preservation. Don't you remember what it was like to be a kid? The adults can do what they want with you and you don't dare disagree unless it's important.

DADDY: And this is important? She'll figure it out eventually.

HELEN: Eventually! Precisely, eventually! And who's to say whether eventually is tomorrow or twenty years from now? As you say, I can't protect her forever, but neither do I have to throw stones at the girl! I don't have to tell her she'll never see her mother again. Let her figure it out when the time has come!

DADDY: (thoughtfully) Eventually? So you do believe she'll "figure it out." You don't believe the lies either! You put on a good show, girl, but you're just like me— when it makes things easier to explain them supernaturally, you do so even though you don't believe a word of it! You don't love your sister enough to tell her the truth, do you? (The dolls drop.) You don't have the courage to tell her she won't ever see her mother again, do you? You can't find the energy to explain to her that when she dies she'll be gone forever, no?

HELEN: Don't you dare insinuate that I don't love my sister! It has nothing to do with how hard it is to explain things, it's all for her good! How easy do you think it is to sit here with a serious face and say all the things you know are ridiculous? How easy? I remember what it was like to believe in God— there was that feeling that you were never alone. There was no worse time in my life than when Mom and God were stripped from me at once! That was months ago, way back when we first knew she was going to die, and the wound's still raw! I don't want that to happen to Eleanor, I don't want her to hurt that way. Besides, you're in no position to comfort her, and if believing in God helps her, all the better! Let her find out the truth some day when she's not already devastated.

DADDY: Oho, so now you think you know better than me what's good for my own daughter?

HELEN: She may be your daughter, but she's my sister, too. You're too blind to know what she's like, what she wants, what she desperately needs. All you've ever seen is that your wife loved her so you did too. She was a pretty little girl to showcase and to make you proud whenever you needed a boost. She was someone to practice your fathering skills on. When you got confused, you just did

whatever came easiest. I'm the one who spent long nights with her when she needed to talk about Mom's being sick. I'm the one she told her secrets to, I'm the one who knows her best. Me, not you.

DADDY: You think you know my daughter better than I do? You think you can sit here and tell me what an awful father I've been? You (growl) (DADDY lifts his hand as if to strike her and then looks at it in horror. He lowers a suddenly shaking arm and sits down heavily.)

DADDY: Oh God, oh God, oh God. What's happening to me? I would really hit the girl, I was ready to! God, why? Why'd you take her, why? She was my life, she was their life, she was us all! What good can she do you up in Heaven? How could I...why... (DADDY continues mumbling in anguish as HELEN slips to the bedroom. She sits down beside ELEANOR and puts an arm around her. ELEANOR shrugs her off, picks up HELEN's doll, and throws it through the door. ELEANOR picks up her own doll and hugs it.)

ELEANOR: She lied to us! She lied to us! She said we'd see Mommy again! She said we still have Daddy! She said God loves us! She's a liar! (HELEN tries to embrace her sister again, but ELEANOR curls up, muttering darkly to the doll.)

HELEN: I didn't lie to you, Eleanor. Believe me - you will see Mommy again in Heaven.

ELEANOR: She says we'll see Mommy again, but she also says Daddy's right, there is no God or Heaven or any more Mommy. She's a liar! (Both girls look up, listening. Lights dim a little on bedroom, brighten on family room.)

DADDY: Why am I blaming this on you. Sarah, and on you, God? It's my fault I'll wake up tomorrow and I'll be all alone. I did it! Me! You took my Sarah, but I took my daughters. Good-old-father-of-the-year himself. I thought today would be hard, but it's nothing to tomorrow! Helen, forgive me! I love you baby, I do! Forgive me! Believe me!

(ELEANOR pointedly turns away again as lights dim slightly on family room and brighten on bedroom.)

HELEN: (desperately) I'm so sorry, Eleanor. I didn't mean what I said to Daddy– I just wanted him to leave you alone!

ELEANOR: She's sorry, she says. She didn't mean it. She doesn't mean anything! She's just a big liar! (HELEN looks off, seemingly into space, but facing the open door. Long pause.)

HELEN: (bitterly) We still have Daddy.

Gallery 37 Apprentice Artists and Teaching Artists

Poetry
Kelly High School
Schools Program, Spring 1998
Teaching Organization: Independent
Principal: Dr. John Gelsomino
Teacher Liaison: Algrid Pretkelis
Lead Artist: Ida Steven
Teaching Assistant: Raul Jaimes

Apprentice Artists:
Monica Alcaraz
Edgar Amaya
Jorge Davilla
Adriana Diaz
Georgene Ford
Ana Garibay
Marissia Garno
Miriam Medina
Cynthia McKissick
Melodie O'Dowd
Guadalupe Ortega
Raul Rangel
Lucica Repta
Jamesa Rhodes
Loretta Trevino
Rebecca Vargas
Lisa Varney
Angela Zakrzewski

Poetry
Neighborhood Program, Summer 1998
Teaching Org.: Beacon Street Gallery
Lead Artist: Sonya Shah
Teaching Assistant: Margaret Stover

Apprentice Artists:
Victor Duprey
Mom Dy
Luz Maria Navares
Semha Ogorinac
Seth Sher
Keo Sok
Saveth Som

Creative Writing
Neighborhood Program, Summer 1998
Teaching Organizations:
Boulevard Arts Center, Gallery 60
Lead Artist: Rita Lewis

Apprentice Artists:
Erica Early
Falyn Harper
Xica Henley
Marilyn Piggee
Martin Pumphrey
Shateila Slater
William Watson
Antoinette Wiley

Creative Writing
Downtown Program, Summer 1998
Teaching Organization: Columbia
College Chicago
Co-Lead Artist: Patricia McNair Lewis
Co-Lead Artist: Keturah Shaw-Poulos
Teaching Assistant: Lott Hill

Apprentice Artists:
Patrick Babbin
Sheryl Bacon
Nova Benway
Edith Bucio
Brian Burton
Jessica Carillo
Andrea Chinnaswamy
Keinika Cooper
Kareema Cruz
Scenecia Curtis
Onome Djere
Molly Dunn
Janet Feder
Paul Fitzgerald
Maria Gonzalez
Shon P. Harris
Rufus Jackson
Temeka Johnson
Laurel Kaish
Allison Long
Robi-Nichole Mraz
Albert Murphy
Samuel Negron
Angela Pena
William Reilly
Richard Roberts
Donni Saphire-Bernstein
Yelena Shterm
Marijke Stoll
Selly Thiam
Andrea Thomann
Rocio Vallejo
James Vickery

Playwriting
Downtown Program, Summer 1998
Teaching Org.: Robert Morris College
Co-Lead Artist: Eugene Baldwin
Co-Lead Artist: Genevive Ven Johnson
Teaching Assistants: Jason Lee,
Michelle Luellen

Apprentice Artists:
Najah Charlton
Olga Chavez
Tyron Davis
Judith Disterhoft
Joanna DuFour
Andrea Gargano
Jennifer Gorman
Chasiah T. Haberman
Moses Harris
Brandi Jackson
Jessica Johnson
Jarad Kings
Sarah Koteles
Alan Lawrence
Margaret McCloskey
Brian Patrick Norton
Laura Nunez
Veronica Owens
Bela Sarah Resnicoff
Allison Staiger
Donald Stewart
Kyra Termini
Mandy Vainer
Amber Wilson
Onzsalique Wright

Screenwriting
Kelly High School
Schools Program, Fall 1998
Teaching Organization: Chicago
Center for Film Development
Principal: Dr. John Gelsomino
Teacher Liaison: Marianne Marchiafava
Co-Lead Artist: Valerie Mrak
Co-Lead Artist: Dan Decker

Apprentice Artists:
Jesse Arrendondo
Crystal Carlson
Jose Castileja
Juan Cortes
Juan Feliciano
Emmanuel Frutos
Abel Gutierrez
Isabel Jimenez
Joshua Krause
Noel Lopez
Miriam Medina
Mary Mikel
Jessica Moreno
Lucy Pelayo
Araceli Rios
Aracely Sandoval
Jose Toledo
Jesus Trzek
Rebecca Vargas

Third World Press
Third World Press is one of the oldest, independent African American
publishers of creative thought and literature in the country. Founded in
1967 by Haki R. Madhubuti along with Johari Amini (Jewel Latimore)
and Carolyn Rodgers, TWP is dedicated to publishing culturally pro-
gressive and politically insightful works of fiction, nonfiction and poetry.
TWP publishes works by literary figures such as Illinois Poet Laureate
and Pulitzer prize-winner Gwendolyn Brooks, Amiri Baraka, Sonia
Sanchez, Haki R. Madhubuti, John Henrik Clarke, Derrick Bell, Frances
Cress Welsing, Sterling Plumpp, Chancellor Williams, and many others.
For thirty-two years, TWP has served as an important part of Chicago's
South Side business community.

Haki R. Madhubuti
As poet, publisher, and educator, Haki R. Madhubuti is a pivotal figure
in the development of a strong Black literary tradition that emerged
from the era of the sixties. Madhubuti, a widely anthologized poet and
essayist, is the author of twenty-two books including the best selling
Black Men: Obsolete, Single, Dangerous? His latest books are *Claiming Earth:
Race, Rage, Rape, Redemption: Blacks Seeking a Culture of Enlightened
Empowerment, Groundwork: New and Selected Poems, 1966-1996 and
HeartLove: Wedding* and *Love Poems.* He is a professor of English and the
founder and director emeritus of the Gwendolyn Brooks Center for
Black Literature and Creative Writing at Chicago State University.
Haki R. Madhubuti serves as the publisher at Third World Press.

Gwendolyn Mitchell
Gwendolyn Mitchell, poet, editor, and community arts administrator
recently relocated to Chicago from Pittsburgh, Pennsylvania. She is the
recipient of a 1994 Pennsylvania Council of the Arts Fellowship in
Poetry and is the author of *Veins and Rivers,* a book of poems. Her
works have appeared in a number of journals and anthologies including
American Review, Prairie Schooner, and *Say that the River Turns: The Impact of
Gwendolyn Brooks.* Ms. Mitchell served as one of the co-chairs for
Chicago's 1998 Power Poets Twenty-four Hour Poetry-Thon. She cur-
rently works as an editor for Third World Press.

Picture Credits

The artwork contained within this book was created
by apprentice artists employed by Gallery 37